GRAPHIC NOVELS
EVERYTHING YOU NEED TO KNOW

"The graphic novel is not literary fiction's half-wit cousin, but, more accurately, the mutant sister who can often do everything fiction can, and, just as often, more."

Dave Eggers

"The world of comics may, in its generosity, lend scripts, characters, and stories to the movies, but not its inexpressible secret power of suggestion that resides in that fixity, that immobility of a butterfly on a pin."

Federico Fellini

"Comics will be the culture of the year 3794."

Salvador Dali

Image from *Hicksville* by Dylan Horrocks

GRAPHIC NOVELS

EVERYTHING YOU NEED TO KNOW

Paul Gravett

COLLINS | DESIGN

An Imprint of HarperCollinsPublishers

For my brother Tony for typing my first fanzine *Monolith*
and also in remembrance of Alan Gaulton, Andy Roberts,
and Robert Marshall Sturgeon

**Cover story: Theda, from *Caricature*, the title story
of a short-story collection by Daniel Clowes.**

**At the Twin Lakes Craft Festival, caricaturist Mal Rosen is
called a genius by Theda. "She was no prize… ratty 'punk' hair-do,
secondhand clothes… just awful! But what can I say?
Her taste was impeccable!"**
 Of Theda's eye, Mal asks, "Did your boyfriend give that to you?"
 **"I don't think so! In his dreams maybe!" she laughs and replies,
as she wipes away the black make-up.**

GRAPHIC NOVELS: Everything You Need To Know

Copyright © 2005 by Paul Gravett
Concept © 2005 by Paul Gravett and Peter Stanbury
Designed by Peter Stanbury

HarperCollins books may be purchased for
educational, business, or sales promotional use.
For information, please write: Special Markets Department,
HarperCollins Publishers Inc., 10 East 53rd Street, New York, NY 10022.

First Edition

First published in the United States in 2005 by:
Collins Design
An Imprint of HarperCollins*Publishers*
10 East 53rd Street, New York, NY 10022
Tel: (212) 207-7000. Fax: (212) 207-7654
collinsdesign@harpercollins.com
www.harpercollins.com

First published in the United Kingdom in 2005 by:
Aurum Press Limited
25 Bedford Avenue, London WC1B 3AT
www.aurumpress.co.uk

Distributed in the United States by:
HarperCollins*Publishers*
10 East 53rd Street, New York, NY 10022
Fax: (212) 207-7654

Library of Congress Control Number: 2005929223

ISBN 0-06-082425-5
ISBN13 978-0-06-082425-9

Printed in China
First printing, October 2005

Contents

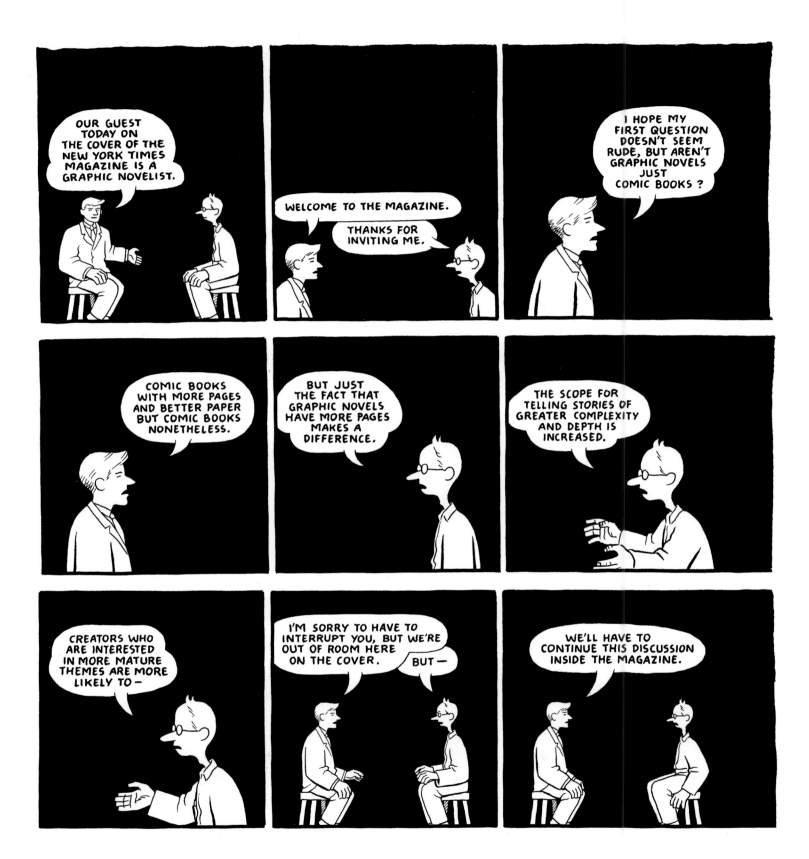

Chester Brown, Canadian author of the biography *Louis Riel*, drew this two-page strip for the *New York Times Magazine* of July 12, 2004.

Things to Hate about Comics

What are graphic novels? You might think they are easy to define, but the term has become distorted with prejudices and preconceptions, riddled with confusion among the media and public, and a topic of dispute among "graphic novelists" themselves, some of whom reject the label outright.

Ask people about graphic novels and some will say immediately, "Oh, you mean porn." That's not entirely wrong. There are erotic ones for adults only, but graphic is not short for pornographic. Others perceive graphic novels only as gaudy escapism, whether superheroic, fantasy-based, science fictional, or hard-boiled, for adolescent males, all furious spectacle and special effects and little depth or humanity, like their movie counterparts. There is some truth to this too; because so much fantasy and action material is pumped out by publishers of comic books and manga, or Japanese comics, these tend to crowd the shelves in many bookstores and libraries, often near the science-fiction and role-playing game books. But graphic novels are not limited to one genre category, or only a few; they embrace enough subjects to put them into every section of a library or bookstore. The word graphic does not have to mean disturbing, extreme, and in your face, shown in hard outlines, grotesque caricatures, or lurid coloring. There is room for very different styles of art. In fact, graphic does not narrow down to drawing and illustration, as in graphics, since some artists create their comics using photos, 3D models, or found objects.

The term novel can make people expect the sort of format, serious intent, and weighty heft of traditional literature, as if a graphic novel must be the visual equivalent of "an extended, fictional work." True, some individual graphic novels can run to hundreds of pages, while others stretch to thousands across multiple volumes—but many are much shorter, or consist of collections of short stories, and they can come in all shapes, square, oblong, from miniscule to gigantic. Even more importantly, a great many are definitely not fictional at all but belong in the categories of non-fiction—history, biography, reportage, documentary, or educational.

So in several ways graphic novel is a misnomer, but, unlike other words invented in the past in an effort to overcome the stigmas of humor and childishness of the word "comics," like Charles Biro's "Illustories," Bill Gaines' "Picto-Fiction," or even Will Eisner's "Sequential Art," this term has caught on and entered the language and dictionaries, for all its inaccuracies. It has been around since 1964, when American comics critic and magazine publisher Richard Kyle coined it. Kyle was among the first to import and champion European comics, especially French bandes dessinées in color hardback albums, and thick Japanese paperbacks of manga. These came as revelations to him compared to the disposable, monthly stapled pamphlets on cheap newsprint that made up most of the American comic book factories. Here he had evidence of more of the medium's potential being realized abroad. Kyle came up with "graphic story," and from that the "graphic novel," to galvanize American creators and readers to aspire to similar ambition and sophistication.

In America and internationally, this process has taken a long, long time. In 1969, novelist and once-aspiring cartoonist John Updike came to England to address the Bristol Literary Society about "the death of the novel" and, among the new forms he envisioned for it, he speculated: "I see no intrinsic reason why a doubly talented artist might not arise and create a comic-strip novel masterpiece." Many have tried to achieve this, often in the face of social and critical disdain. Comics in book form have existed for at least two centuries, enjoying sporadic flurries of success, such as a vogue in 1930 for wordless "pictorial narratives" sparked by Lynd Ward's *God's Man* in 1929, a fad stifled by the Depression, or more recently the media frenzy around *Maus*, *Watchmen* and *Dark Knight Returns* in the mid-1980s.

It has always been a fragile history. Looking further back, some of the 19th century's pioneering antecedents of graphic novels might never have seen print at all without the admiration of the German poet, novelist, and dramatist Goethe. A year or two before his death in 1832, Goethe was shown the unpublished books by a boys' boarding school teacher from Geneva, Rodolphe Töpffer. He called them his *histoires en estampes* or stories told in prints. His *Adventures of Dr. Festus* was said to have given Goethe in his eighties "extraordinary pleasure." Reportedly, he kept repeating, "That is really too crazy," and then continued: "But [Töpffer] really sparkles with

talent and wit; much of it is quite perfect; it shows just how much the artist could yet achieve, if he dealt with modern [or less frivolous] material and went to work with less haste, and more reflection. If Töpffer did not have such an insignificant text [i.e. story] before him, he would invent things which could surpass all our expectations."

Despite this praise, Töpffer was wary of tarnishing his respectability as a newly appointed professor if he made his books publicly available, so he held back until 1832 from publishing *Monsieur Jabot*, and then only among friends, and waited until 1834 before arranging bookshop sales. His embarrassment at being a comics creator is nothing new. Nor is impoverishment, which drove young Gustave Doré to abandon the medium after the failure of his *History of Holy Russia,* for which he produced 500 engravings in 1854. If only Doré had done more. Missed opportunities, unrealized dreams, thwarted possibilities have always dogged the graphic novel and its predecessors. In *Hicksville*, New Zealand cartoonist Dylan Horrocks imagines a library, fittingly within a lighthouse, which contains the only copies of all those dreamt but unseen projects that were abandoned or never started, all those contenders for the "comic-strip novel masterpieces" that Goethe and Updike had predicted. Among them, the librarian pulls out, "a 48-page comic [Picasso] did with Lorca. Etchings mostly. I reckon it's one of his best."

When Will Eisner stepped off America's endless assembly-line of daily strips or monthly comic books, he threw down the gauntlet to his peers in 1978 with his graphic novel, *A Contract with God*. From experience, he knew that, against all odds, creators could produce good, sometimes great, work under those conveyor-belt conditions. He understood why many were reluctant to sacrifice their steady, work-for-hire paycheck, but Eisner's self-driven opus shone like the lighthouse-library, a beacon of inspiration to his peers. Eisner left us in 2005, but he did get to see graphic novels resurface in this new century. This time it seems different. Their diversity and quality are stronger, the readership more curious and receptive, the media less hyperbolic. No passing craze or graphic novelties this time; a medium is coming into its own.

To guide you to those that may appeal to you, my overriding emphasis in this book is on story, on content, because I think these are what people are seeking most in graphic novels. I filtered my first, long shortlist through a number of criteria. First, they should be in English. Fortunately, a good number from Europe, Japan, and elsewhere have been translated. Second, they should be compiled into books. I know that graphic novels need not be in book form. They can exist as uncompiled part works, serials in magazines and papers, even in unpublished

manuscripts, but only collectors have the tenacity to hunt down back issues. My emphasis is on easy availability. Third, these books should be currently or recently in print. If not, then they should not have become expensive rarities. They should be reasonably easy to find and affordable via dealers, libraries, or online. Fourth, my focus is mainly on original graphic novels, meaning works first created for and in comics, and not based on or adapting other media and licensed properties, like video games, TV shows, toys, films, or sources like plays and books. There are quite enough exciting stories unique to comics. Fifth, I have favored stories with a "beginning, middle, and end," rather than serials that will never reach a conclusion. A few multi-volume stories here have not reached completion yet, but they have an end in mind, even in sight. Of the few graphic novels chosen in ongoing, open-ended series, each tells a solid, self-sufficient tale in every volume. Finally, I wanted to show you the real variety of subjects and voices out there now. To that end, the graphic novels are organized into broad thematic chapters, each work linking to others by "secret reading lists" at the foot of their pages. This

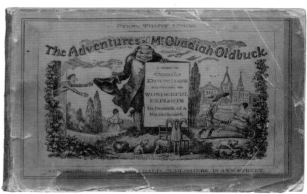

way you can explore them as your interests and tastes change. And rather than tell one big history of the graphic novel, I open each chapter with a thematic overview to give you some background and context.

So what are graphic novels? This book will give you lots of answers. As for a definition, I think Eddie Campbell, author of *Alec* and artist on *From Hell*, may be right when he says in his manifesto that the term "graphic novel signifies a movement rather than a form." Consequently, "there is nothing to be gained by defining it." Campbell says this movement's goal is "to take the form of the comic book, which has become an embarrassment, and raise it to a more ambitious and meaningful level." It is "forging a whole new art which will not be a slave to the arbitrary rules of an old one." Listen carefully. Can you hear them? The scratching of their pens and pencils, the clatter of their keyboards? At this moment, all over the world, people are preparing more comics, more stories, and defining a movement. Are you sitting comfortably?

If not, then on the following pages I have tried to respond to those hoary old chestnuts that always seem to come up when people talk about comics. Maybe I can help to scotch some of these pet hates from the outset.

An American edition of Rodolphe Töpffer's 1827 satirical story *The Adventures of Mr. Obadiah Oldbuck*, published by Dick & Fitzgerald, New York, from the 1870s till 1888.

Things to Hate about Comics

Oh, those speech balloons!

I know how those balloons can appear unnatural and unnerving, hovering like Zeppelins over people's heads, floating all over the page, their tails pointing down to each speaker's mouth. For some people, opening a graphic novel is like bursting into a cacophonous party where everyone seems to be speaking at once.

But look again and you will see that they are not all speaking at once. Tune out the babble and tune in to one balloon at a time, so that the drawn figures acquire their voices and communicate, with each other and with you.

Hear them and you'll find that, for a medium without sound, comics adopted an effective graphic solution, one with a long lineage and real flexibility. As well as the lettering forms, the shape, color, and style of a balloon can tell you a lot, from jagged edges for alarm or anger to icicles for coldness.

Comics are just funnybooks

Never underestimate the low art of mime and foolery to puncture pomposity and to speak truths in jest. But there is nothing inherent to comics that prevents them from tackling whatever subject you like, in whatever style and manner you choose. The medium is not limited; it boils down to the skills and ambitions of the creators. Harvey Pekar had an epiphany when he realized, "Comics are just words and pictures. You can do anything with words and pictures."

They take no time to read

Slow down, you read too fast, you've got to make the comic last. Comics might look as if they are "movies on paper" but there is no need to read them like a flip-book. Take more time before leaping across that gutter to the next panel or you might just miss something.

I heard of someone who began to read *Watchmen* and when he got to a sequence of several pages with hardly any words, he skipped ahead until he found the next text to read in a caption. If anything, when the words vanish, you need to slow down all the more to decode the purely visual messages in the panels. You can't properly skip read graphic novels; make them last, savor them, re-read them.

How are you supposed to read comics anyway?

You're not alone. Not everyone has grown up reading comics. Maybe your parents, teachers, librarians, frowned on them and discouraged or prevented you from reading them. Maybe you never liked them yourself as a youngster. You might be an avid book reader, but still be genuinely "comics-illiterate."

But don't let your inexperience about comics discourage you or turn into an excuse not to try them. Nobody expects you to leap into enjoying something unknown like ballet or modern art from the word go. We all need ways into unfamiliar territory, so use this book to explore how to read comics and find what appeals to you in graphic novels.

The novelist Philip Roth once described the act of reading a novel as like "being in the presence of an alien artifact." For some people, that can be even more true confronted by a graphic novel. *Persepolis* author Marjane Satrapi only came to comics when she was 25. She advises, "Like anything new, you have to cultivate your interest. It's like in opera. You have to go a couple of times to appreciate it."

Comics leave nothing for the imagination

While it is true that in comics you are frequently shown what the characters and settings look like, you're still going to need your imagination to help you to read what else those pictures are showing and telling you, and to fill in the gaps as you move from one panel to the next. Luckily, pictures can stimulate the imagination every bit as much as words, as a visit to any art gallery proves.

Don't worry, there are words to read and think about too in almost all graphic novels. There is less space for words than in a novel, so they have to be all the more precise, economic, and should be savored.

Remember the words don't always literally describe or reinforce the pictures; one can clarify and amplify the other, or they can be entirely separate. They can contrast, counterpoint, even contradict each other. Their interaction can shift from page to page, panel to panel, within a panel. Comics will keep your imagination on your toes.

I don't like the drawing

Hardly anybody makes an instant judgement based on the typeface when you open a prose novel, but the artwork in graphic novels is as varied and individual as the personalities of the artists, almost like their handwriting. The drawing is the first thing you see and it can put you off if it doesn't appeal to your tastes.

Drawing in comics does not have to be realistic or naturalistic. Sometimes, the most technically polished illustration in comics fails to communicate or involve the reader, whereas less "accomplished" drawing comes alive on the page and in your mind, if you give it a chance.

A good deal of the art in mass-produced comics seems to rely on repeating received ideas and formulas and so becomes slick but dead. As a rule, great-looking art can never save a poor story, but rough, even raw art can serve a great story perfectly. It's the story that counts.

They're so depressing

It can seem as though, in a desire to be taken more seriously, graphic novelists have fixed on very serious, sometimes tragic, subjects. But their books are not all gloom and doom; they're often wonderful, life-affirming stories. And if you prefer to relax, laugh, or escape, there are still plenty of fantasies and comedies to enjoy as well.

What are all those weird symbols?

Not every graphic novelist chooses to use them, but there is a large cartoon "lexicon" of symbols, "emoticons," speed lines, sound effects, and other elements that can seem artificial and unnatural. They are useful graphic devices to add an extra "track" of sound, motion, and emotion to the page. Several of them are pointed out in the samples in this book.

Just for fun, American comic strip creator Mort Walker came up with some delightfully silly names for some of them: "plewds" for sweatdrops to show anxiety or anger; "squeens" for the spirals to represent confusion; "briffits" for the clouds of dust when someone is running. Don't worry about these symbols. The more you encounter them, the more their meanings will become clear and you will adjust to them.

Characters are made of cardboard

Comics have always used the shorthand of physiognomy, the theory that what you look like represents your character, much as we make judgments about people from our first visual impressions. Baddies were always ugly, good guys always handsome. That is not so different from conventions in theatre or cinema. But even within these simple codes, it has always been possible for comics creators to find ways to deepen the inner lives of their protagonists, so that they become more complex, contradictory, flawed, and multi-dimensional, more like us. Recent graphic novelists have given us memorable characters like Luba from *Palomar*, Gemma Bovery, and Corto Maltese, as well as the many autobiographical representations of themselves.

Which do I to read first —words or the pictures?

A friend of mine used to have that trouble even with a "simple" newspaper strip. She would read only the text balloons first all the way through, and not understand it. Then she would go back and look only at all the pictures, and still not understand it.

Images and text arrive together, work together, and should be read together. There's no one rule, but in some combination you read words and pictures in tandem and in cross reference, one informing the other. It's not so hard, but it is different from reading neat, uniform columns of type.

Part of the knack of reading comics is being able to enter and move your eyes around inside each panel, the equivalent to one sentence or more. You scan the text in every caption box, speech balloon, and thought cloud, moving within from top left to bottom right (unless, of course, it's a Japanese comic that reads right to left!). But you also scan each picture in various directions for cues and clues: where are we? who is speaking or acting? It's a bit like reading a map, diagram, or painting.

Close in and concentrate on what's inside the first panel, then look for the connections to the next panel. You do the same again here, on through the page. Remember, you can look back anytime to check. And yes, you're bound to peek ahead, but not too far or you might spoil surprises to come.

Comics are a great way to get kids reading real books

Yes, that's true, comics can encourage even the most reluctant reader, but this backhanded compliment, often from teachers, librarians, and other "cheerleaders for the cause," implies that comics and graphic novels are useful primers, stepping stones to literacy, but not worth reading in their own right as "real books" themselves.

So enough already, let's get on with the good stuff ...

Stories to Change Your Life

CERTAIN BOOKS, paintings, films, plays, or pieces of music can come into your life at just the right place and time, so that they help you see the world in a different light, and perhaps affect how you think and feel. I have found that the same can also be true of the very best graphic novels. To start you on your journey of discovery, I have shortlisted thirty personal favorites that struck me profoundly at the time I first read them and have stayed with me ever since.

Among these books may well be one or more that you are aware of already. Perhaps *Maus* is the only graphic novel you have ever heard of. Perhaps someone once lent you a volume of *Sandman*, or you've seen the movies based on *From Hell*, *Ghost World* or *Sin City*. There is no predicting what will be someone's first encounter with a graphic novel, for better or worse, but, whatever your reaction has been, one of these masterworks should be a good place for you to start.

After browsing through these thirty titles, pick one you know or one that intrigues you, and turn to the "In focus" spread to read more about it. Here you will find background notes and useful closer readings of key pages and scenes, all designed to help you explore that particular story. From there the "Reading on" directions can lead you to discover other works that inspired or preceded it, and those that follow it more or less directly. In this way, every graphic novel in this book serves as a portal leading you to further discoveries. For still more information, each chapter opens with an overview to put all the works in context and highlight still more graphic novels on related subjects. You never know, maybe one of them will change your life too?

How to Use this Book

First, choose one of the thirty key graphic novels introduced in this chapter.
To discover more about it, turn to the page indicated for an "In focus" spotlight.

In focus

This two-page spread appears later in the book within the relevant thematic chapter. Here you can step inside the story and read sample extracts, starting on the left with one large page.

What's going on?

Captions help you read the page. Captions around the extract explain the scene, its context, and what to look out for. Special features in the panels are pointed out.

What's it called?

Title, author(s), date of first publication in English in book form, number of volumes, number of pages.

Reading on keywords

If you'd like to explore some of the themes dealt with in this graphic novel further, choose one of the themes from the "Reading on" list at the foot of the page. Turn to the page indicated and you'll find samples from related stories. Where two books appear on the same page, the two keywords for the top book appear first.

Scene by scene

To get more of a flavor of the book, you can read further scenes shown on the right page. These are either single page extracts or, when they are joined together, sequences of two pages.

Background detail

Captions and illustrated Sidebars give you extra details and useful background to enhance your enjoyment.

Following on pages

You can also turn the page and after each "In focus" spotlight you will find two "Following on" pages with samples from four stories on the same or similar themes. These in turn have "Reading on" keywords to direct you further.

The Airtight Garage

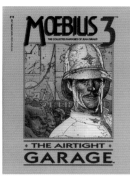

Expect the unexpected when you enter the strange and beautiful fantasy worlds imagined by France's Moebius, alias Jean Giraud. Eccentric explorer Major Grubert is a charmingly unreliable guide to his wanderings through multi-layered alien civilizations and technologies. There is a hypnotic dream logic to this science fiction tale, the result of the way Moebius devised this serial in the magazine *Metal Hurlant* as an exercise in total improvisation and freedom from conventions and constraints. Here the author can be as surprised as the reader by what comes next. Like Moebius, abandon expectations and delight in the inventing of a universe.
IN FOCUS 90

Maus

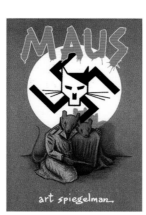

The intimate and unflinching history of Art Spiegelman's father Vladek, a Polish Jew and survivor of the Auschwitz concentration camp, combined with the present-day life of the author in New York, just turned thirty, as he tries to rebuild his relationship with his father and to understand himself. Why portray Jews as mice and Nazis as cats? Spiegelman is harking back both to the cat-and-mouse antics in early animation and comics, and to the legacy of racist propaganda that used such imagery. *Maus* not only gives a firsthand account of the Holocaust, but is also a brave attempt to address the pain of today's children of survivors.
IN FOCUS 60

The Dark Knight Returns

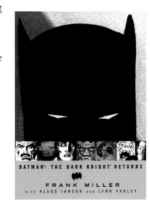

In a near future Gotham City where crime is running out of control, an older, battle-scarred Batman with middle-age spread comes out of retirement to restore order to the streets. Frank Miller restored the brooding romanticism of this archetypal vengeful superhero, while questioning the role of the vigilante in a supposedly democratic system. His satire assaults wet liberals as savagely as the extreme right, by showing Superman used as a naive government lackey and bleeding heart liberals adopting the homicidal Joker as a worthy cause. This "Dark Knight of the soul" is a very different creature of the night to the camp pop art Batman of the sixties.
IN FOCUS 78

When the Wind Blows

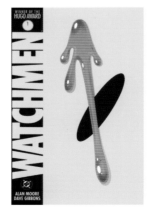

An elderly English couple, Jim and Hilda Bloggs, never think to question the government's hopelessly inadequate guidelines for surviving in the event of a nuclear attack. They try constructing a makeshift shelter and cheerfully muddle through, trusting that normal service will resume shortly, while the radiation poisoning slowly takes effect. This was not the sort of subject people had associated before with Raymond Briggs, author of the children's books *The Snowman* and *Father Christmas*. His quietly chilling indictment created public uproar and debate in Parliament in 1982 and went on to be adapted for radio, stage, and as an animated movie.
IN FOCUS 148

Palomar

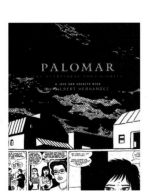

Among the varied characters created by the Hispanic-Californian Gilbert Hernandez, his women are especially strong, sensual, and fully realized. Most notable of these are his indomitable heroines and matriarchs, Luba, the bath-house keeper, and Chelo, the sheriff, who together struggle to preserve their rustic way of life and fend off the threats of outside forces and unstoppable change. Hernandez takes time to elaborate the closely related lives of the townspeople of Palomar, enabling the reader to get to know them intimately through the years. Part social document, part magic realism comparable to Marquez and Allende, *Palomar* is epic on a human scale.
IN FOCUS 48

Watchmen

Watchmen takes its title from the warning "Who watches the Watchmen?" In a parallel Earth that is close to ours yet subtly altered, British creators Alan Moore and Dave Gibbons ask how far we should trust unaccountable guardians, whether they be outlawed superheroes coping with midlife crises or superpowers intent on unleashing global war. *Watchmen* is about ordinary people, not just those with extraordinary powers and colorful costumes, and examines the ways they try to make a difference and make sense of their lives, while the world lurches towards a nuclear armageddon.
IN FOCUS 82

Stories to Change Your Life

The Frank Book

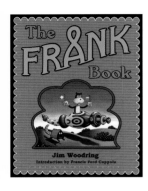

With barely a word or a sound effect, Jim Woodring conceives an hypnotic otherworld as "pure" cartoon in sharp, quivering lines or a rainbow of old-time, painted animation colors. With his four-fingered gloves, big feet and two front teeth, Frank resembles a generic hybrid of classic critters Mickey, Felix and Bugs, but his bewildered escapades are stranger and deeper. These occur in a mystical, force-laden landscape, governed by its own bizarre logic. Here Frank encounters the pitiful, pink Manhog, the "jivas" or ornate, ever-changing souls, his testy pet demi-god Pupshaw, and his Real and Faux Pa. Frank's stories are a cross between fables and allegories, disturbing lessons with a playful wink.

IN FOCUS 136

My Troubles with Women

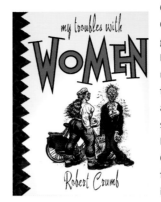

Out of all his characters, from lecherous Fritz the Cat to mystic Mr. Natural, perhaps Robert Crumb's greatest cartoon creation is Robert Crumb himself. Riddled with lust and Catholic guilt, "your favorite neurotic cartoonist" treats comics as an unbridled fantasy outlet and a confession booth. Middle-aged and married with a kid, he looks back on his rocky sexual career with hilarious anguish and candor. From playing 'footsy' and fixating on Sheena, Queen of the Jungle as a boy, his sixties fame finally got him all the women of his dreams, who ignored him as a shy teen. Understandably bitter, if not twisted, Crumb outrages, annoys and endears with his self-deprecating bluntness.

IN FOCUS 172

Cerebus

What Canadian Dave Sim began in 1977 as a funny animal parody of *Conan the Barbarian* starring an aardvark, metamorphosed, after a year or two, into a massive, and massively daring novel, mapped out over 6,000 pages. Sim narrates the travels and travails of Cerebus, a decidedly unheroic maverick, apparently motivated solely by personal gain, who becomes ensnared in his superiors' political power games. Along the way, figures based on Groucho, Margaret Thatcher, Ernest Hemingway, Oscar Wilde, even Giles's Grandma intervene. In his landmark experiment, Sim conducts a freewheeling questioning of ideologies and philosophies and challenges his own singular convictions.

IN FOCUS 140

Scene of the Crime

Private detective Jack Herriman, a former junkie and the son of a dead cop, is haunted by his past. Now living with his uncle, a crime-scene photographer, he tries to make a fresh start, when his father's former partner hands him a routine missing persons case. But when the young woman he was hired to find turns up dead, Jack discovers some disturbing secrets lurk in her past, when she belonged to a shady sex cult. In his search for her killer, Jack is also forced to face the truth about his own family turmoil. Writer Ed Brubaker and artists Michael Lark and Sean Philips deliver a gritty, updated take on the hard-boiled murder mystery, in the spirit of Raymond Chandler and Ross Macdonald.

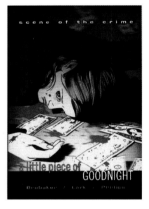

IN FOCUS 118

The Nikopol Trilogy

In 1993, an army tribunal sentences deserter Alcide Nikopol to orbital cryogenic imprisonment. Twenty years later, his capsule plummets him back to an almost unrecognizable world, where a fascist elite rules from plague-ridden Paris, while overhead in a pyramid ship hover the gods of Egypt. On the run from these deities, the falcon-headed Horus takes possession of Alcide's body to carry out his plans. Alcide's fate becomes tied to his son, who shares his name and appearance, and to reporter Jill Bioskop with her blue hair, lips and tears. Yugoslav visionary Enki Bilal paints a tangible, lived-in dystopia, blackly absurd in its web of geopolitical intrigues, temporal anomalies, and promises of immortality.

IN FOCUS 94

A Contract with God

In the vein of recollections by Isaac Bashevis Singer and Philip Roth, this set of dark, poignant vignettes of Jewish immigrant life set in a Bronx tenement draws on Will Eisner's Depression-era youth. In the title story, a devout businessman feels betrayed by God for allowing his adopted daughter to die. Other tenants include an alcoholic gigolo seducing a lonely, faded opera diva for her money to pay for his addiction, and a scheming under-age temptress who drives the building's superintendent to suicide, after she steals his savings and poisons his only friend, his dog. In 1978, Eisner, aged sixty, reinvigorated his career and the medium with these tough yet compassionate urban fables.

IN FOCUS 40

It's a Good Life...

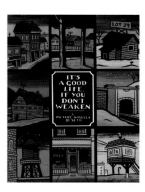

Feeling displaced from the speed and excess of the present, Seth is a young Canadian cartoonist, bibliophile and daydreamer who longs for the simpler, less ugly days of the past. His discovery of some forgotten gag cartoons from the 1940s signed "Kalo" sets him on a personal mission to find out more about this obscure mystery penman. The process of piecing together Kalo's career and life prompts him to examine his own past and to reconsider his work and relationships. There is a gentle, exquisite sadness to Seth's haunting images of old buildings, winter woodlands and passing trains, and in his musings on the meaning that remains from a vanished life.

IN FOCUS 52

From Hell

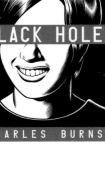

Those expecting to learn Jack the Ripper's true identity may be surprised that *From Hell* is less a "Whodunnit" and more a meditative "Whydunnit". While writer Alan Moore uses exacting research and informed guesswork to reconstruct the murders of five prostitutes in Victorian London's East End, captured by artist Eddie Campbell's vigorous, textured renderings, his aim is to dissect the body of evidence more imaginatively, probing for its meanings and mythology. He reveals the period's patterns of power, class, society, and sexuality and how they persist through time. The horror of The Ripper is that he is the harbinger of the 20th century and is still with us today.

IN FOCUS 164

American Splendor

In the words of Cleveland everyman philosopher Harvey Pekar, "Ordinary life is pretty complex stuff." For nearly thirty years he has been finding the magic in the mundane and transcribing his everyday experiences, and those of his friends and acquaintances, into his self-published comic book *American Splendor*, illustrated by his record-collecting pal R. Crumb and many others. It was not quite overnight, but thanks to an award-winning movie adaptation of his life and work, Pekar has gone from a marginal pioneer of slice-of-life comix to something of a cult cultural figure. From his victory over cancer to his brush with fame, Pekar shares the 'splendors' of his life with everyone.

IN FOCUS 144

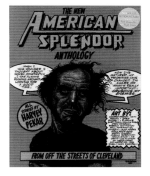

Black Hole

In a small American town in the mid-1970s, an unknown, sexually transmitted virus is causing unique, irreversible mutations in adolescent high school students: hair covers the face; webbing appears between fingers; a tiny second mouth opens over one boy's adam's apple; a girl grows a preternatural tail and sheds her skin. With their hormonal bodies seemingly out of control, some try to conceal their deformities, but others become ostracized and form a fragile community hiding in the woods. Charles Burns is a modern horror master, never gratuitous or cheap, slowly dissecting the American nightmare in luscious swathes of ink and brushmarks of almost inhuman precision.

IN FOCUS 110

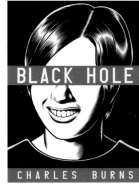

Palestine

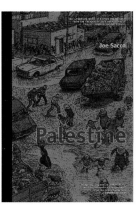

Joe Sacco spent two months in the West Bank and Gaza Strip during the winter of 1991, witnessing the daily lives of Palestinians under the repressions of prolonged occupation. Back home in America, Sacco transformed over one hundred interviews with Palestinians and Jews, eyewitness photos and research, and personal responses into a new form of New Journalism: autobiographical comics reportage. Quoted accounts of detention, harassment, torture, land confiscation, and killings, and the pernicious mood of powerlessness are given added dimension by Sacco's scrupulous renderings and freewheeling internal commentary. More graphically than any TV or press report, Sacco grounds us in a lived reality.

IN FOCUS 68

Ghost World

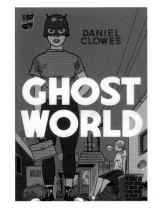

Confused Jewish extrovert Enid and quiet, prettier blonde Rebecca are teen outsiders and opposites, united by their listless thrill-seeking and contempt for conformity. Their contradictory closeness is tested by the pressures of life after high school, which force them to grow up and grow apart. Daniel Clowes's original graphic novel drops the movie's subplot with record-collector Seymour to keep a closer, darker focus on Enid and Rebecca. Clowes distills tender yet unpatronizing portraits of this unlikely couple, as they face the self-destructive bewilderment of adolescence and the fragility of friendship in the "ghost world" of suburbia's soulless sprawl.

IN FOCUS 32

Stories to Change Your Life

Lost Girls

Three very different women gather in a luxury English hotel on the eve of the First World War: a bubbly Kansas redhead named Dorothy, a prim, reserved Londoner called Wendy, and the eldest, Alice, a pale opium addict. As they become closer, they confide in each other their first erotic awakenings and fantasies, which bear uncanny resemblances to well-known children's stories, respectively *The Wizard of Oz*, *Peter Pan* and *Alice in Wonderland*. The symbolism and subtexts of these books are sensitively explored by Alan Moore and his partner, artist Melinda Gebbie, who redefine the tired pornography formula into an elegant, arousing celebration of the discoveries and pleasures of sex.

IN FOCUS 180

Buddha

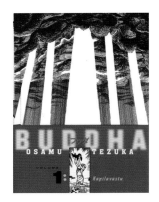

A part-fictional life story of Prince Siddhartha's quest to find the path to enlightenment as the Buddha is told across nine volumes totalling nearly 3,000 pages by Japan's 'God of Manga' Osamu Tezuka. His distinctive approach can seem incongruous if you expect comics with a serious theme to be unremittingly serious. He combines great depth with light-hearted comedy, detailed, realistic landscapes with cartoonish characters and animals, and a meticulous recreation of history with shameless anachronisms. But Tezuka's seeming opposites work together and his inventive sequences, especially those conveying spiritual awakening, carry a breathtaking emotive charge.

IN FOCUS 160

Sin City

Noir doesn't come much blacker than this series of brooding, violent rites of redemption and revenge off the mean streets of the aptly named Sin City. A battered bruiser named Marv spends one night with a beautiful girl, only to wake up with her dead body and accused of her murder. An ageing cop, framed for the crimes of a senator's pedophile son, has one last case to close. Frank Miller plunges his granite-like tough guys and curvaceous badgirls into deep shadow and blinding, artificial light, rain and bullets slicing up the page, abstracted into brutal black and white. His prose is terse, feverish, recalling Mickey Spillane and Jim Thompson; his layouts are kinetic, designed for maximum impact.

IN FOCUS 122

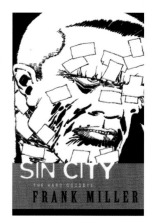

Strange Embrace

Old sins never die. Sexual repression, dysfunction and disease are at the heart of this gothic chiller. Alex is a malicious mind-reader, who preys on tortured souls to add to his collection of stories. Addicted to ever more intense psychic images, he breaks into the mind of ailing lodger Anthony Corbeau. He unlocks dreadful suppressed memories of Corbeau's youthful obsession with carved African masks, his loveless marriage and his self-mutilation. In ever darker twists of fate, author David Hine unravels this family tragedy, rooted in the scandals of syphilis and the madness it spreads, and in Victorian religious extremism and hypocrisy. As Alex sneers, "All the best stories end in the grave."

IN FOCUS 106

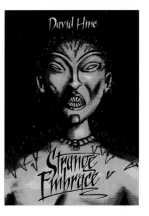

Barefoot Gen

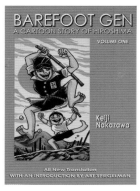

Keiji Nakazawa was six in 1945, when an atomic bomb exploded above his hometown, Hiroshima. He miraculously survived, but was unable to save his family from their burning home. Nakazawa never forgot the hellish aftermath of radiation poisoning and starvation he and his mother endured. In 1972 he began recording it as a weekly manga serial, starring his alter ego, Barefoot Gen. Nakazawa takes the first 250 pages before the bomb drops to show the brutality of the Japanese war machine and its humiliation of his pacifist father. He then pulls no punches showing the harrowing human costs of the blast and its fallout. His ten-volume memoir is a passionate, moving indictment of nuclear weapons.

IN FOCUS 64

Epileptic

How do you survive as a child when your older brother Jean-Christophe, aged eleven, starts to suffer repeated epileptic fits? In 1960s France, young David B. seeks answers in books of history and mythology and protects himself with his imagination and dreams. He draws himself in armor battling his brother's disease, while their parents latch onto a parade of quacks and gurus, none of whom offer any cure. Afraid that epilepsy is stalking him, David as an adult turns to comics to record his childhood overshadowed by the illness, and its ongoing effects on his life and family. This is an angry yet loving plea for understanding from a son to his family, from brother to brother.

IN FOCUS 28

Gemma Bovery

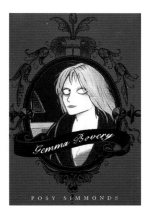

A sharply observed, satirical updating of Flaubert's *Madame Bovary*, literature's most notorious adulteress. Gemma is the discontented second wife of Charlie Bovery and stepmother to his kids. Tired of her life in London, Gemma persuades Charlie to retreat to rural France, where, like her namesake, she is drawn towards ennui, debt, and adultery. Local baker Raymond Joubert is convinced that Gemma is doomed to repeat Emma Bovary's fate and it's from his anxious perspective and his discovery of Gemma's diaries that the tragedy is retold in flashback. Posy Simmonds seamlessly blends this typeset narrative with letters, diary entries, and insightful ink-and-wash drawings.

IN FOCUS 176

Corto Maltese

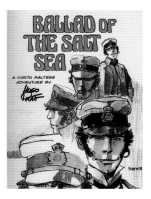

The voyages of the sea-faring adventurer Corto Maltese find him embroiled in some of the most turbulent turning points in early 20th century world history, from the Russian revolution in Siberia to the troubles in Northern Ireland. Italy's Hugo Pratt blends a vivid, closely researched sense of place and period with sweeping romantic adventure, in the vein of Conrad and Hemingway. Widely travelled himself and fascinated by historical secrets and world cultures, Pratt created a sort of alter ego in the elusive handsome sailor in his cap, earring and bellbottoms. Elusive and seemingly detached, Corto steers an unpredictable course between self-interest and selflessness.

IN FOCUS 156

V for Vendetta

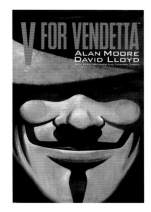

England in the near future has descended into a Big Brother hell, where racial, ethnic and sexual "deviants" are sent to camps to be executed or experimented upon. Orwellian order is absolute, except for the one bane of this totalitarian regime, the shadowy operator known as "V." Disguised beneath a theatrical cloak, hat and grinning mask, he becomes a symbol of anarchy and resistance. His face is never seen, but his identity is revealed to be a survivor of the camps, intent on wiping out the perpetrators of such misery. Angry at Prime Minister Margaret Thatcher's policies, Alan Moore and David Lloyd produced an impassioned eulogy to radicalism and freedom that has become timeless.

IN FOCUS 126

The Sandman

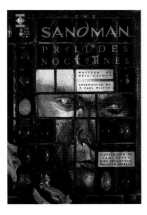

The Sandman is British author Neil Gaiman's most admired graphic novel, unravelling through a series of fantasy tales collected in ten books. With a host of artists, Gaiman constructs a modern mythology centered around the Endless. These are an extended family of seven symbolic beings that includes The Sandman himself, otherwise known as Morpheus, king of dreams, as well as Desire, Delirium, Destiny, and Death herself, personified as a perky, pale Goth. Driven as much by mood as plot, these stories veer from short, sharp shockers and tender character studies to underlying themes, steeped in literary and legendary references, of the roles of dreams and the question of Morpheus's death and succession.

IN FOCUS 98

Locas

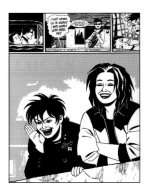

Like an anarchic Betty and Veronica with no time for Archie, Mexican-American Maggie Chascarillo and Hopey Glass, her on-again, off-again lover, are locas or "crazy women," who come of age during Southern California's 1980s punk rock revolution. Jaime Hernandez's experiences of barrio and punk life infuse his characters with authenticity. Maggie comes to define herself amid race, class and gender tensions, evolving from angry punkette to mature adult, while Hopey's fractious free spirit exerts a constant influence on her life. Hernandez's crisp art and naturalistic storytelling drive this emotional rollercoaster of women wrestlers, car engines, loud guitars, gang wars, tight jeans, and heartfelt love.

IN FOCUS 44

Jimmy Corrigan

Jimmy Corrigan, a thirty-six-year-old loner adrift in 1980s small-town Michigan, journeys to the city to meet the father he never knew for the first time. Drawing partly on his own experience, Chris Ware charts every nuance of the awkward interplay between an overly convivial father and a quiet, vulnerable son, forever strangers to each other. Ware weaves in the childhoods of Jimmy's father and grandfather, disclosing the aching void created from one Corrigan generation to the next by the lack of parental affection. Somehow characters simplified into cartoon diagrams become heartbreakingly real and life's ambivalence and cruelty are tempered by passages of melancholic beauty.

IN FOCUS 24

The shadows retreated
 into the roots of each tree,
 but we remained where we were.

Craig Thompson, Blankets

The Undiscovered Country

A child of the early 1960s, American cartoonist Lynda Barry lived in a troubled household with her Filipino Mom, and her Dad, who drank vodka in the basement. As her parents fought and headed towards separation, Lynda found another world and imaginary friends in the funnies that came free inside the newspapers. She would gaze into Bil Keane's circular *Family Circus* cartoons as if they were windows onto a homely nirvana she had never known. "I wanted things like that in my life that were that simple." Later, as an adult, she met Keane's son Jeff, his successor on *Family Circus* and the model for the cartoons' permanently three-year-old Jeffy. "I cried when I shook his hand, because I felt I'd finally been able to step inside that circle."

Comics can exert this sort of a hold because they are often the first pieces of fiction that a young boy or girl chooses for themselves. This printed matter becomes a secret retreat from parents or siblings, a private way of facing fears and fantasies, a trove of big, important tales to read over and over, snuck inside your schoolbooks or under the bedsheets by torchlight. Lynda Barry was not the only young reader for whom early exposure to comics would spark an enthusiasm to draw them for herself. Through her frank and funny strips, Barry can now look back at her childhood with the benefit of hindsight. Her personal *Family Circus* is no simplistic, white, middle-class idyll; hers is raw, raucous and far closer to many people's real experience. Her deceptively naive drawing and large, skewed letters have a childlike directness that gives you the feeling of being privy to a teenage girl's secret diary. Her short reflections acquire a cumulative effect, a mood that is ironic and critical about herself, while never sinking into self-loathing. One of her admirers, the British novelist Nick Hornby, singled out her gift in *The New York Times* Book Review. "What she is particularly good at is resonance. These stories all contain little grenades of meaning that tend to explode just after you've read the last line. One can deduce that Barry had a tough childhood, but she prefers to concentrate on the details that connect rather than those that may exclude."

Connecting with the reader is what the best graphic novelists strive for. They turn the personal and specific into something universal and inclusive. When they re-examine their sometimes painful transitions through infancy and puberty, we can recognize or empathize with our own formative years. Some people fondly recall this period as an age of innocence, but for others it can be far from the sun-filled realm idealized by certain sugary children's authors or movie-makers. A lack of affection, if not cruelty, from parents, or just its opposite, excessive mothering and smothering or unwanted sexual attentions, can all have long-term effects. So too can illness or early death in the family, and prejudice, bullying and strict religious or political doctrine at home or in school. Once innocence is lost and childhood comes to an end, there is still the turmoil of adolescence to navigate. No longer a child but not yet considered an adult, what is a teenager's place in the world? Becoming a grown-up like our parents can seem like a surrender, so the responses to parental expectations and social conformity can often be alienation, anger, and rebellion. It seems that each misunderstood generation has had to make its own mistakes in order to find its own identity.

When did the experiences and emotions of children and teenagers start to be addressed honestly in comics? From the start, there was little scope for this within the mass-market, so long as publishers demanded only ephemeral laughs and neatly resolved, escapist adventures. Among the first-born children of the comics were Germany's prototypical, mischievous brats *Max and Moritz* by Wilhelm Busch, while in New York Richard Outcault's Irish urchin *The Yellow Kid* trod the backstreets barefoot and bald in nothing but a yellow shirt and a wide smile. Less earthy, more respectable tykes soon arrived in Outcault's upper-class rascal *Buster Brown* and Winsor McCay's dreaming *Little Nemo*. Their tales derived in large part from the conventions of 19th-century children's literature and its moralizing lessons that misbehavior must always be punished and there's no place like home. Children might be granted the vicarious thrill of reading about

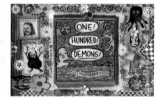

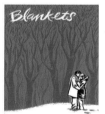

Right: A 1925 edition of *Max and Moritz* by Wilhelm Busch, first published in 1865

Opposite page: Phoebe Gloeckner's persona Minnie from *A Child's Life*

The Undiscovered Country

naughtiness, as long as the conclusion demonstrated its inevitably disastrous consequences. On the other hand, they could imagine themselves as model youngsters, plucky, stout-hearted, resourceful, wise beyond their years. These were allowed to go off on adventures in wonderlands, slumberlands, perhaps to the big city or foreign parts, certain that any perils or injustice would be overcome, and they would be rewarded by arriving back safe where they belonged, none the worse for wear.

For decades, most child stars in comics spent their days frozen in a never-neverland, eternally young. That explains part of their charm. We accept that Little Orphan Annie and Little Lulu will never lose their girlish will-power or shop for their first bra. We accept that Dennis the Menace will never behave himself and that no peach fuzz will ever sprout on Tintin's chin. America's "typical teenager" Archie will never get more than a peck out of either Betty or Veronica. This halted passage of time has been one of the reassuring pleasures of comics. While our lives fly by in constant flux, we can return to these familiar friends performing the same routines. Every gag or escapade plays yet another seemingly endless variation on a theme. This stasis can enable writers and artists to explore their theme at length, and sometimes in depth. It also guarantees a fixed brand, a merchandizable property, that can be sold forever.

The exceptions were rare. In *Terry and the Pirates*, Milton Caniff resolved to let Terry grow from boy to man, and fight and fall in love through the Second World War. When Frank King was instructed to add baby Skeezix, found in a basket on bachelor Walt Wallet's doorstep, to his *Gasoline Alley* daily, he felt it was essential that the baby and all his characters would age. "You have a one-week-old baby, but he can't stay one-week-old forever; he had to grow up." King made *Gasoline Alley* into a sweet, evolving family saga and had Skeezix grow to be a husband and father himself. If other cartoonists eventually made some change to their young characters' status quo, it was not long before they would settle into another status quo.

The safe conservatism of the medium was rocked in the fearful years following the Second World War by such new, grittier genres as crime and romance in American comic books. Anthologies specialized in short,

complete stories that charted the fate of a different protagonist each time. With no stable, recurring characters, anything could happen to them: a streetkid gets sucked into a vortex of crime; a teenage girl loses her heart to the wrong man. Tales of broken laws and broken hearts didn't always have a happy ending. Just as comic book creators began to engage with more of the real issues of life, an epidemic of moral panics spread across North America, Europe and elsewhere about what was perceived as comics' corrupting influence on impressionable youngsters. These scares led to some of the tightest controls on any medium. Governments in Britain, France and Canada enacted severe new laws, while the American industry only avoided legislation by financing an independent Comics Code Authority from 1955 to censor anything that failed to comply with its infantalizing code.

There was a price to be paid for making the newsstands safe again for kids. Art Spiegelman, author of *Maus*, explained: "Cartoonists were actually expected to keep a lid on their psyches and personal histories, or at least disguise and sublimate them into diverting entertainments." Occasionally cracks in the mask showed through. In 1950, Charles Schulz introduced feelings of inadequacy, disappointment and melancholy into the comic-strip world of children. In *Peanuts*, Schulz never pretended that childhood was the happiest of times. He always remembered the rejection of his love by a red-headed girlfriend and put himself into all of his cast of characters, most clearly in Charlie Brown, his namesake. Readers like the young Chris Ware and Seth warmed to Schulz's gang, who were grappling with the same insecurities as them.

It was finally only during America's underground movement centered in San Francisco's hippy subculture of the late 1960s and early 1970s that the more uncomfortable complexities of growing up could fully surface. This breakthrough required an entirely new format, publishers and distribution: comic books for adults only, with modest print runs, black and white interiors, higher cover prices, and sold via drug paraphernalia shops, sidestepping the Comics Code Authority. Initially, when the medium broke free of its enforced, arrested development, the underground comix with an "x" seemed to stand for "X-rated," as Robert Crumb, S. Clay Wilson and others tried to out do each other in breaking all taboos. But Justin Green invented a new genre in 1972, when he became the first neurotic visionary to unburden his uncensored psychological troubles onto the pages of *Binky Brown meets The Holy Virgin Mary*, an astonishing self-flagellation of Catholic guilt and obsessive-compulsive

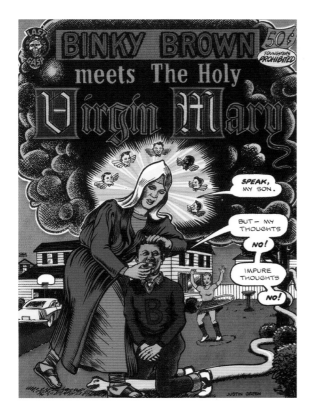

disorder. Within months, Green's searingly candid confessional immediately galvanized Spiegelman and Crumb into their first attempts at autobiography. As Spiegelman put it, "What the Brontë sisters did for Gothic romance, what Tolkien did for sword-and-sorcery, Justin Green did for confessional, autobiographical comix."

Without *Binky Brown*, *Maus* would not exist, and both in turn have inspired more cartoonists to deal with their early experiences and their after-effects. Some like David B., Al Davison or Chester Brown apparently put all of themselves center stage inside their panels; others like Chris Ware, Paul Hornschmeier or Max Cabanes adopt an alter ego and use memories, diaries, fragments from the past as a template for a more or less fictionalized life. Any similarities between author and alter ego may be just that: similarities, not necessarily the unvarnished truth.

Chris Ware, for example, had spent his entire life avoiding contact with his father, so he knew full well how a son might feel when out of the blue he receives a phone call from a man claiming to be his father. In strange synchronicity, when this happened to him, Ware was immersed on *Jimmy Corrigan*, attempting to cope with that issue while serializing his graphic novel. Ware pinpoints exactly the father's emotional disconnection, his empty, one-sided conversation, his overly cheerful self-confidence that one hug will brush away the years of absence. Like Jimmy, Ware also learnt offhand from his father that he had a sibling. In other ways, however, he kept life and fiction distinct. He dedicated the book to his mother partly to clarify that she "bears no resemblance whatsoever to the miserable wretch who dominates poor Jimmy."

For some their graphic novels can become a sort of art therapy, or an attempt to understand the past, if not always a cathartic release from it. For Phoebe Gloeckner, her comics based on her teenage traumas raise questions that she may never totally resolve, but drawing them becomes a survival mechanism. One concern is how honest a first-person memoir should be, as it may well offend or contradict others. During his account of growing up with an epileptic older brother, David B. portrayed his mother objecting to certain sequences. Despite this, he felt compelled to pursue his view of the truth, with the result that she refused to speak to him for three years. Craig Thompson's parents may never understand why he recorded his repressive Christian upbringing and sexual revolt—"They think I've bought my ticket to Hell"—but thousands of young Americans have found in his memoir *Blankets* a piece of their own existence.

You don't always have to write or draw what you know. There are many graphic novels about growing up that are not derived from the author's life but become authentic and affecting through a mix of observation, research and storytelling skills. Daniel Clowes and Nabiel Kanan somehow innately understand the limbo that their teen heroines are going through. To make a convincing tale of one runaway girl struggling with the effects of her father's molestation, Bryan Talbot read transcripts that let abuse survivors speak for themselves and found a perfect metaphor in the life and picture books of Beatrix Potter. Neil Gaiman may narrate *Violent Cases* in person and in the first person, but he deliberately casts doubt about the veracity of the yarn he spins. by playing on the unreliability of memory and the ways we construct our stories.

Lynda Barry wonders, "Is it autobiography if parts of it are not true? Is it fiction if parts of it are?" She prefers to call her fusion of the two "autobifictionalography," the fictional being incorporated within the autobiographical. Whether or not these stories about growing up are true, in the sense that everything really happened to the person who created them, or total fabrication becomes unimportant. What matters is that they ring emotionally true, and let us feel that we too can step inside the circle.

More Childhood Stories

The Ride Together
JULY & PAUL KARASIK
Memoir of a brother's autism

Hey, Wait...
JASON
The burden of a boy's mistake

Patty Cake
SCOTT ROBERTS
Wild, precocious, and seven

Daddy's Girl
DEBBIE DRECHSLER
Surviving incest and more

X-Day
SETONA MUZUSHIRO
Kids plot to blow up the school

Zero Girl
SAM KEITH
Infatuation with a teacher

Kampung Boy
LAT
Life in a Malaysian village

Astronauts in Trouble
TRONDHEIM & LARCENET
Kids uncover alien conspiracy

Big Baby
CHARLES BURNS
The horrors next door

I Never Liked You
CHESTER BROWN
A mother's schizophrenia

Jimmy Corrigan in focus

"In terms of attention to detail, graceful use of color, and overall design, Ware has no peer. And while each panel is relentlessly polished–never an errant line or lazily rendered image– his drawings–somehow, remain delicate and achingly lyrical ."

DAVE EGGERS

Parental bonds

One focus of Chris Ware's book is the difficulty of sincere, human communication of any kind, especially between distant parents and their children. For the first time, Jimmy Corrigan visits his father in Chicago, who vanished when he was small. Their one-sided conversations are dominated by his father's banalities. Jimmy hardly speaks, but his mind is always churning.

Associations

The slightest word, sound or image can trigger associations with unresolved issues from Jimmy's past. Here his father's pointing finger sends him back to a day when he took a photo of him and his mother, recorded in one larger panel.

After this, Ware has his father poke his other finger in his ear and study, wipe and eat the wax, an ugly habit and maybe a symbol of his inability to listen.

Like father, like son?

When they first meet at the airport, there's an uneasy silence as they recognize how much they look alike.

Memory tricks

These pivotal pages come from a 30-page encounter in a medical clinic, where Jimmy is being treated for a sprain and a nosebleed after an accidental fall.

While a phone rings in the next room, his father gives the "thumbs up" to Thanksgiving turkey dinners. These spark Jimmy's subconscious, shown in a memory grid of twelve small squares. In three repeated images of a phone, he remembers more of a recent call from his mother pressuring him to come home for Thanksgiving. The other nine squares insert Jimmy as a child, eating turkey with his mother, and later in bed hearing her crying at night.

"Hi Dad"

The "beep" of the answering machine sets off another chain of Jimmy's thoughts related to a message starting "Hi Dad," that he heard being left on his father's machine.

Plucking up courage to ask, Jimmy is stunned to learn here that his father has a daughter. He has to repeat the word, which appears as small as his whisper, before his father's wounding reply.

Jimmy Corrigan

Chris Ware
2001, 1 volume, 380 pages

Generations

Tragedy and a lack of parental affection have plagued the Corrigans for generations. As sad as Jimmy's fatherless life has been, his grandfather's childhood was no better a century earlier. Ware transports us from present-day Chicago back to the run-up to the city's 1893 World Exposition.

Little James grows up frightened of his father, who has never forgiven him for causing his wife's death in childbirth. When he loses a tooth one night, James expects to be punished. He reaches for comfort, but his sleeping father turns away.

Letter forms have meaning: red for danger; large, bold capitals to add gravitas; and elegant script for the period narrative voice.

Mother

All through the book, Ware goes to great lengths to avoid showing other people's faces. We never see Jimmy's mother's face clearly at all. This device seems to keeps our focus on Jimmy and isolate him all the more.

Jimmy is off on another guilt trip when his father is seriously injured in a car accident. Reality dissolves as the hospital lobby becomes a railway station and his mother arrives. She plays on his guilt for visiting his father and not telling her. We know it is a dream when Jimmy reverts to a child and his father shows up on a trolley. As his mother leaves, Jimmy is left talking on the red phone, his lifeline to her.

Following on from Jimmy Corrigan

Binky Brown meets the Holy Virgin Mary

Nothing this disturbingly honest had been shown in comics until Justin Green's 1972 attempt "to purge myself of the compulsive neurosis which I have served since I officially left Catholicism on Halloween, 1968." Through his alter ego Binky, Green shows how his Obsessive Compulsive Disorder and religious upbringing created such psycho-sexual guilt about his "impure thoughts," that he imagined them as rays of lust, emanating from anywhere, even his phallus-shaped fingers, which only complex rituals can prevent from striking anything holy. Green calls this book "a sin of youth," but its pathos endures, because it grew "out of internal necessity."

One Hundred Demons

In her contemplative vignettes, Lynda Barry picks out a few of her childhood "demons," from breaking up with her best girlfriend and her worst boyfriend to the strange world of dogs, head lice, or household odors. Barry counterpoints the wistful, slightly disappointed tone of her adult commentary with the brashness and dead-on delivery of the dialog. Hers is a text-heavy balance, the captions sometimes filling more than half the panel space, but her vibrant cartoons add so much to the humor and authenticity. Notice how she puts extra funny verbal asides into her drawings and indicates them with arrows.

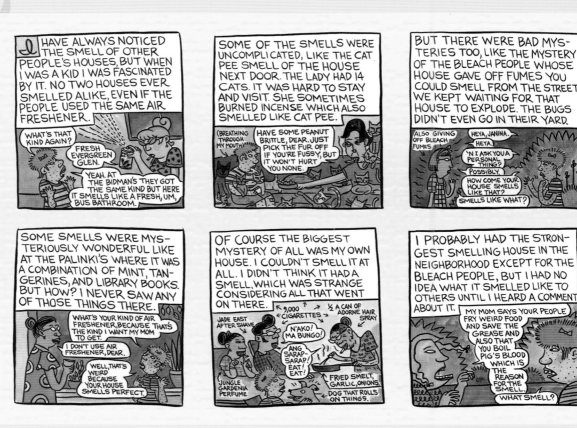

Heart Throbs

Max Cabanes loved his mother dearly and was only nine when she died in 1956. These memories led him to embark in 1989 on the first of his autobiographical stories about growing up without her and his hesitant encounters with the opposite sex. The vibrant colors of a sultry summer in the South of France match the desires that the more mature Marianne arouses in her three boyish admirers. She warms to Max, the quiet one, the last and shortest in the gang, and a poet. While Marianne recites Verlaine, Max's gaze and thoughts seem fixed on her jeans. Cabanes catches his sweet shyness, hands in pockets or arms folded, and his naive notions of love, which he knows only from romantic movies.

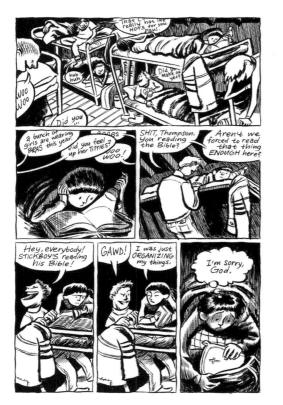

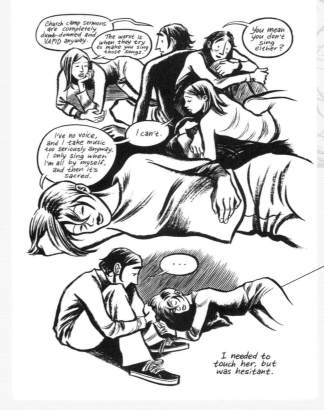

Blankets

How does a boy raised to obey the Bible reconcile his deep faith and the stirrings of sexual attraction? Craig Thompson pieces together his answer, first by going back to the small cruelties inflicted on him by his parents, and to his guilt over failing to protect his younger brother. He blends these scenes with the slow unfolding of his falling in love with Raina, a girl he meets at church camp. Nothing is rushed, as here Thompson shows the first nearness of their bodies and frees them from confining panel borders. "Blankets" refers not only to the Wisconsin snow, but also to the bed that he and his brother once shared, and to the quilt that Raina makes for him.

Epileptic in focus

"A work of deep, deep darkness and luminosity. *Epileptic* illustrates both
the horrible density of reality and the vast possibilities of the human imagination."

IAN SANSOM

The Monster

David B. imagined his elder brother Jean-Christophe's epilepsy as a monster, a sinister dragon slithering through their lives and stalking him as well. This becomes the potent symbol for the disease in his graphic novel.

At first, David shows the monster as an external menace, holding Jean-Christophe in its coils or sharp teeth, whenever he has a seizure. But as the illness worsens, he realizes that his brother is giving in to it. Here he shows this point of surrender by drawing monster and brother merging into one, never to be separate again.

The Cures

Rejecting surgery, the family attempt every kind of alternative no matter how bizarre, from macrobiotics to esoteric spiritualism. David shows Master N the way he remembers him, as a big cat. The book doubles as a catalog of these gurus' ideas, procedures and mostly empty promises.

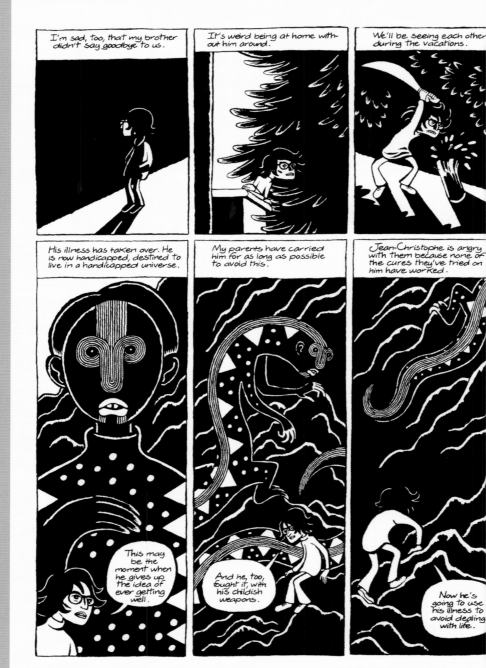

The Battle

"My armor is the night." To protect himself and his brother from the disease, David sees himself as a warrior engaged in a terrible battle. This becomes a way to let out his rage, shown here as he whacks away at a tree stump with his great-grandfather's saber.

The escalating struggle with the illness is also shown as a mountain, which Jean-Christophe climbs as his condition deteriorates. The book's original French title, *L'ASCENSION DU HAUT-MAL*, means the "rising" or "ascent" of the "high" or "great evil," a medieval term for epilepsy.

The Drawing

The ritual of drawing holds a special power through his life and this book. David B's bold artwork is at once simple and mythic, like woodcuts or designs on urns and vases. He was inspired by the primitive art that is common to most cultures and close to children's art. To him, "those kinds of simple designs are immediately understandable."

Epileptic
David B.
2005, 1 volume, 368 pages

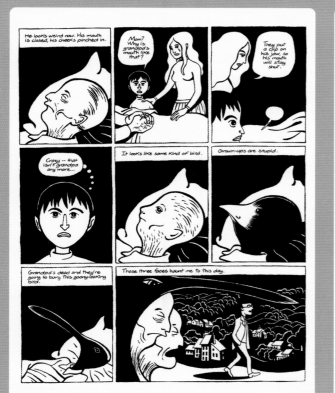

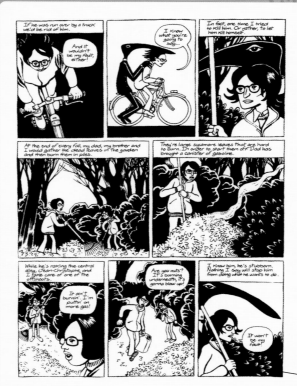

Grandfather Bird

David B felt close to his grandfather Gabriel: "We were able to understand each other without speaking." When he dies, David finds he can't say a last goodbye (his mouth stays shut, shown by a small, empty balloon). He sees his face morph into a bird and in this form the grandfather returns as his spiritual confidant.

David B admits that at times he wanted to kill his brother. Here David is tempted to let him pour too much gas onto the bonfire, causing an explosion. His life is in his hands, but David warns his Dad in time. Shortly after, he asks his silent grandfather, "Did I win or lose? I'm not sure..."

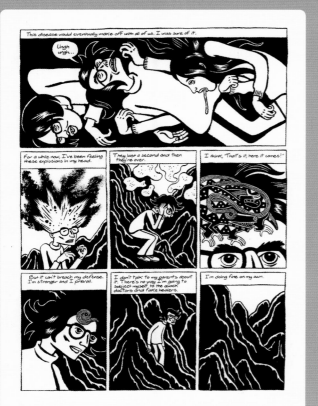

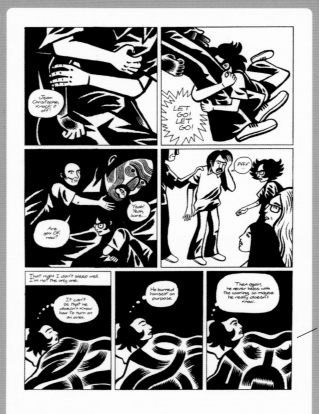

The Family

The repercussions of his brother's epilepsy affect the whole family. David and his younger sister Florence are afraid that the illness would also claim them. David admits here that he had some alarming symptoms, shown as the small monster circling his brow, but he kept them secret from his parents.

David distorts Jean-Christophe's physical size and appearance to show how his fits grow more violent, injuring his father and needing everyone to subdue him. Here, as a sleepless David tries to understand, the quilt on his bed takes on his brother's demonized face.

Following on from Epileptic

The Spiral Cage

People called him "scarecrow legs." Born with severe spina bifida, a condition that paralyzes him from the waist down and can cause brain damage, Al Davison was considered a hopeless case by doctors, condemned to the "spiral cage" of his DNA. But they reckoned without the fighting spirit of Al and his parents.

In his stylistically inventive record of their inspiring triumph over "disability," Al recalls from a child's perspective his mother taking him to a doctor's appointment, where he vows that will walk. He achieves this and much more, but at age eleven the insults he gets at his first "mainstream" school can still sting.

Mother, Come Home

After his mother dies, young Thomas tries to maintain normality as the "groundskeeper" inside the lion mask she gave him. Fantasy does not help his grieving father to cope. They share his bed for the last night before he is taken away and admitted into psychiatric care.

Later, Thomas "rescues" his father from the clinic and reunited, they face the truth about their loss. For his narrator's voice author Paul Hornschemeier uses the adult Thomas. Here his recollections of them sheltering from the rain add a symbolic lyricism to his father's admission.

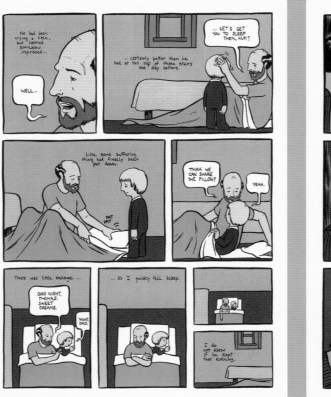

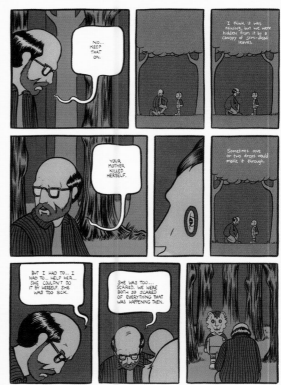

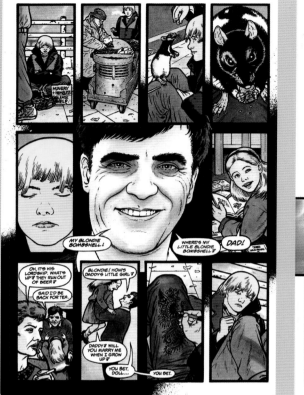

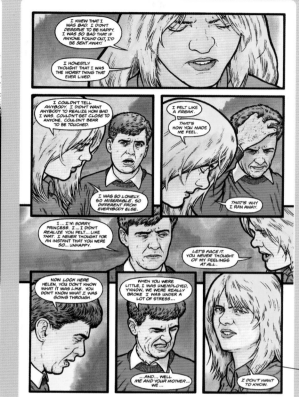

The Tale of One Bad Rat

Helen Potter still loves the little animal fables she read as a child by her namesake, Beatrix Potter. Molested by her father, Helen finally runs away from home with a rescued lab rat.

Homeless in London, she can't forget the desire on her Dad's smiling face, bursting into her reverie, its black stain spreading off the page. She doodles him as a demon onto her jeans. Helen follows Beatrix Potter's footsteps to the Lake District, where she finally tells her father how she feels about his abuse. Author Bryan Talbot offers no pat answers, but adds a story-within-a-story and a hopeful allegory in his facsimile of the "missing" Potter tale of the title.

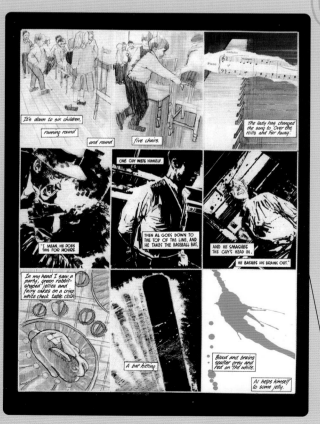

Violent Cases

He was four when somehow his father hurt his arm. Our casual storyteller Neil Gaiman pieces together his unlikely encounters with an old osteopath, who tells him how he used to treat Al Capone and how gangsters carried machine guns in "violent cases." A child's unsettling injuries in 1960s English suburbia are echoed in flashbacks to the brutal Prohibition-era underworld.

Dave McKean's noir graphics evoke the collage and blurring focus of memories, first in the boy's cigarette burn at a "grown-up party," and later intercutting a children's game of musical chairs with a bloody gangland beating. Notice how the sixth panel is foreshadowed earlier as the osteopath thinks back.

Ghost World in focus

> "Clowes spells out the realities of teen angst as powerfully and authentically as Salinger did in *Catcher and the Rye* for an earlier generation."
>
> VILLAGE VOICE

Suburbia

Meet Enid Coleslaw and her best friend Rebecca Doppelmeyer. Their story began when Clowes was wandering around Chicago and was struck by a piece of graffiti that shouted "ghost world." It encapsulated his feelings about the modern urban wasteland, where lives are only half lived and nothing seems permanent.

"The America we live in is disappearing, bulldozed under our feet and constantly rehabbed and remodelled. It also refers more personally to the characters and to the friendships that they've lost."

An eerie glow

To add to the mood, Clowes bathes people and buildings in an eerie, greenish glow, stifling all other colors, unnatural like artificial light or a flickering television. He also hides no flaws on his characters' faces, that resemble unflattering, slightly larger-than-life caricatures.

Comic and film

The comic and film of GHOST WORLD are significantly different. In the original graphic novel, Enid has no unlikely romance with the older Seymour, who is reduced to an unnamed "lonely heart" in a silent part, over in three pages.

Instead, Clowes delves deeper into Enid and Rebecca's emotions that are putting their friendship under strain, notably their confused attraction and confusing signals to their mutual boyfriend Josh.

Glasses

One night, after a row with Rebecca, Enid goes for a walk and winds up at Josh's apartment. Putting aside her cynicism and self-loathing for a moment, she tries to disclose her feelings for him, as best she can. At this point of disclosure, Enid removes her sunglasses, the only time we ever see her do this in public.

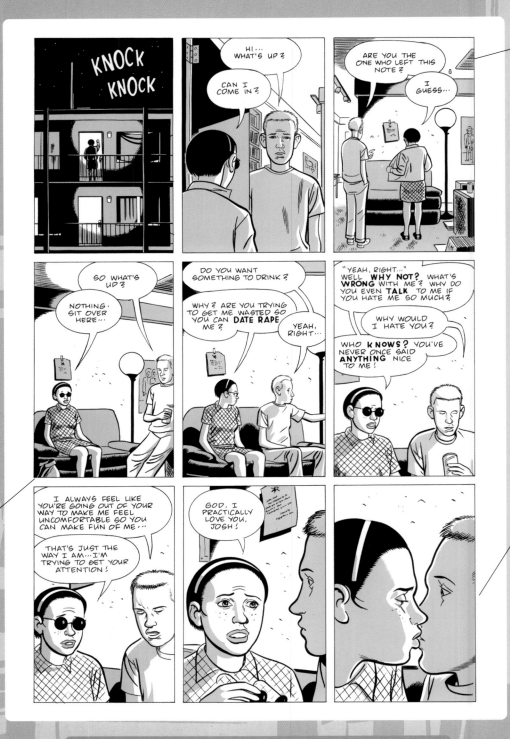

Daniel Clowes makes a cameo appearance at a sad book signing. Enid Coleslaw is an anagram of his name.

Ghost World

Daniel Clowes
1998, 1 volume, 80 pages

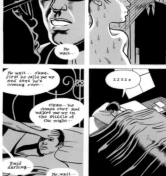

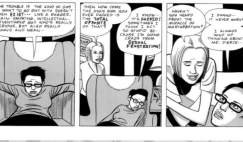

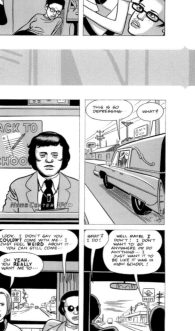

Self-loathing

Enid and Rebecca have a close, complex relationship. Their conversations can lurch from bitterness to self-mockery, from cynicism to surprising sincerity. Here, their practical jokes on the local losers, their scathing critiques of most men, and their teasing about lesbians and masturbation underline their teenage fears and frustrations about sex.

In bed, Enid tries to dream up an erotic fantasy involving her former high-school teacher, but none of them work and she falls asleep. Clowes indicates the shift into dreams by losing the panel borders and altering his lettering style.

Art college

The academic year starts again soon and Enid hopes to get into art college. As they cruise around the characterless streets in the funeral hearse that Enid has bought to go away in, their conversation reveals how differently these two high-school friends now see themselves and the future. It is like a funeral for a friendship.

With touching economy, Clowes relates how Enid gets the news that she has failed to get into college after all. The large, melancholic panel of the last falling leaves tells us that winter is coming and Enid has still not found her way out.

Following on from Ghost World

A Child's Life

Phoebe Gloeckner began drawing her candid reminiscences of her troubled childhood and adolescence in secret aged sixteen. Their contents are deeply personal and uncompromising, drawn with the detached accuracy of medical illustration, from which she makes most of her living. She brings a sympathy and ironic humor to her depictions of her alter ego Minnie's survival of life's cruelties, abuse, drugs and prostitution.

Here, Minnie, aged eight, has hardly been introduced to the mysteries of menstruation by her friend Cheryl, before she has to hide under the bed from Cheryl's father, about to whip her with a dog leash.

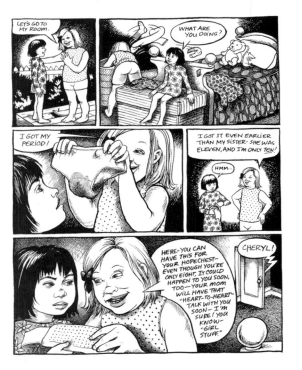

Lost Girl

Beth feels too old to be trapped on vacation with her boring family on a caravan site at an English seaside resort. Then she spots another slightly older girl, alone and free to do whatever she pleases, sleeping with strangers, stealing cars, breaking the law. The elusive thrill-seeking blonde comes to represent the reckless rebellion that Beth wants.

Nabiel Kanan stages their first tentative encounter. He shows Beth's innocence in her frisson of pleasure, filling two silent panels, at being mistaken for the owner of a friend's stash of drugs. The mystery girl remains distrustful and elusive. Kanan paints Beth's last, hazy, lazy summer of childhood.

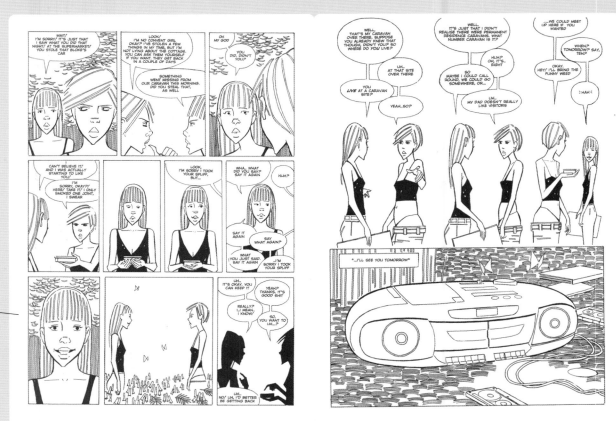

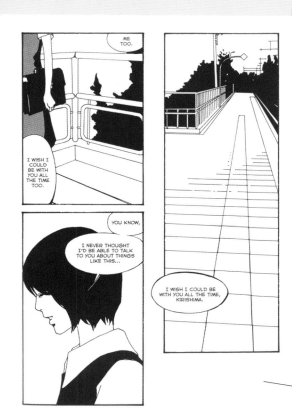

Blue

School is almost over and the future beckons. Kayako's fascination with outsider classmate Masami deepens into adulation and more, after she learns about her unwanted pregancy and abortion. Kayako's kindnesses to Masami—a candy to her lips, a sleepover while her parents are away, cutting her hair, holding hands, stolen kisses—build her hopes up, but Masami has more secrets.

In her poignant tale of one-sided first love, Japan's Kiriko Nananan takes the lightest of touches, avoiding melodrama or prurience. She contrasts sharp, clear interiors of the school, subway or seashore with the girls' fragile contours and the shapes of their black hair. These pages read from right to left, so start with this page first from top right.

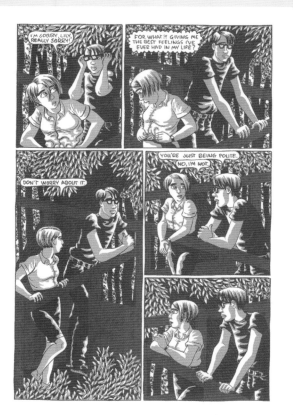

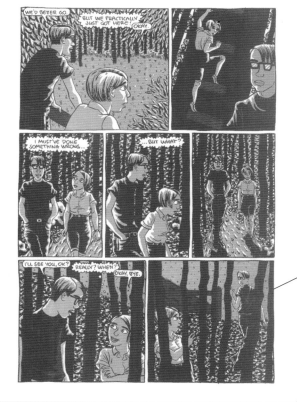

Summer of Love

Debbie Drechsler evokes life's mixture of magic and terror that seems especially vivid when we are young. For Lily and her elder sister Pearl, moving house to a boring neighborhood and making friends at a new school isn't easy. Both must negotiate the complex games of teenage desire: the girls' rivalries, gossip, and unspoken romantic longings; the boys' posing, fickleness, and insensitivity.

Here, Steve Farley takes Lily to a treehouse in a wood, where he saw her dancing, but after one hesitant kiss, he backs off. Drechsler shows how Lily's glib replies hide her confused thoughts, while the nature around them seems alive in a two-tone palette of pale green and earthy umber.

The Other Side of the Tracks

Perhaps it's because many cartoonists use their own faces as their models, that, as they age, they often come to look uncannily like their invented characters. By 1973, Will Eisner was in his fifties, a veteran of over thirty years in the comics industry, a successful self-made man, a balding Jewish New Yorker in jacket and tie, moustache and pipe. He would not have needed much make-up to play Commissioner Dolan, the harassed, hard-nosed police officer whom he had created in 1940 as a foil and father figure to his masked mystery man, *The Spirit*.

By 1952 Eisner stopped producing his innovative weekly short stories of *The Spirit* for newspapers and went into business as the grand-sounding American Visuals Corporation, providing informational and promotional comics for the defense and education departments and corporate clients. Art and commerce had always mixed in his blood. His father, a scenery painter for a Yiddish theater parents, had encouraged him to pursue his creative interests, while his mother, equally supportive, would remind him to look out for their money-making potential. So he was pleasantly surprised when his *Spirit* tales, whose copyright he cannily kept hold of, started enjoying a revival in 1972 through the unlikely channel of adults-only comix. That year, when underground cartoonist and publisher Denis Kitchen commissioned a new cover from Eisner for the third issue of *Snarf*, Eisner played with the incongruities of transplanting The Spirit and Dolan into the seventies comix counterculture by having his upholders of the law raid the publisher's offices. Dolan blares, "I'm gonna arrest 'em, Spirit," who answers, "For what, Dolan?"

Eisner conducted his own raid in April 1973, when he hit the first ever underground comic convention in Berkeley, California to promote *Snarf* and Kitchen's new *Spirit* reprint. Looking old enough to be their father, he probably stood out a little there among the young, happening crowd thronging to meet the comix creators, who were only a few years their senior. In fact, the admiration was deep and mutual between Eisner and the

fresh, radical generation of rebels, and their work was a wake-up call to him. "Writers and artists were defying the establishment with a powerful and accessible literary weapon: comics were employed for political protest, personal statements, social defiance and sexual expression. They were doing with this medium what I always believed I could do. They were doing literature —protest literature, but literature." These encounters renewed his passion and curiosity about what comics might become next. Shortly after, rather than coasting into his twilight years, he used his financial security to give himself several months off work to concentrate on a private project. With no advance, client or deal in mind, no assistants, no interference, he was flying solo, creating for himself. On his *Snarf* cover he had lampooned one struggling artist moaning, "After Crumb, what is there left to say?" Eisner now challenged himself to find out.

How might American comics be revolutionized still further, perhaps evolved into a sort of literature? The so-called comic book had long been a misnomer; it was certainly no book, but a flimsy periodical. True, among its incarnations from the turn of the 20th century and before, there had been proper books that compiled immensely popular newspaper strips onto good paper inside cardboard covers bound with cloth spines. The larger Sunday page strips were reprinted in landscape size and full color up until 1921, while Cupples & Leon published daily favorites in ten-inch square collections for 25 cents from 1919 and in smaller, 100-page paperbacks and 60-cent hardcovers with dustjackets from 1926.

The Depression changed all that. People could no longer afford such fancy tomes, and besides, the funnies came free with the papers. It was struggling New York print salesmen Harry Wildenburg and Max Gaines who arrived at a cost-saving product that might prevent Eastern Color's 24-hour presses from standing idle and losing money. By folding a 16-page colour comics section from a broadsheet newspaper in half and then half again, they could print a 64-page package, approximately seven

Above: Boarding house comedy with Frank Willard's dapper rogue *Moon Mullins* from 1932

Opposite page: Punkettes Maggie and Hopey are the crazy *Locas* by Jaime Hernandez

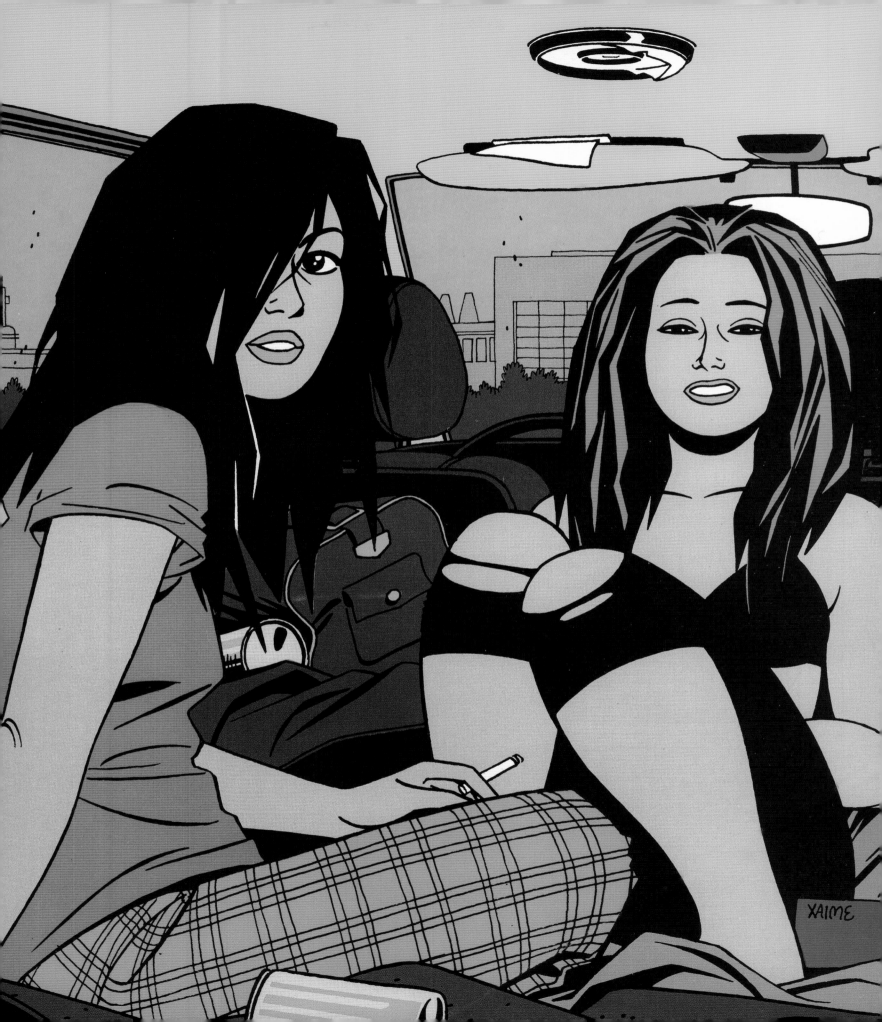

The Other Side of the Tracks

Right: Box seats for the theater of the everyday in Will Eisner's *A Contract with God* from 1978

inches by ten, that could be wrapped in a glossy paper cover. Desperate to keep those presses rolling, Gaines convinced Procter and Gamble to pay for a 32-page trial magazine in spring 1933, *Funnies on Parade*. The soap company knew that times were tight, so rather than sell this novelty, they gave it away free as a promotion. Thousands of kids sent in coupons clipped from their products and the whole print run was sent out in a matter of weeks. In little over a year, such premiums of 32, 64, even 100 pages had proved so successful, that they began to be sold, at first in department stories, and then from newsstands, "all in color for a dime." Out of sheer commercial survival and savvy marketing via children was born the modern comic book.

Aside from higher prices and production values, its appearance has stayed remarkably frozen since at least the 1950s, when 32 interior pages became the norm. Most of the underground comix creators stuck with the same format, perhaps partly to subvert its innocent associations, except that the interiors were usually in black and white. By the early 1970s, Eisner and several others had made sporadic and sometimes significant experiments to prove that their original material, as well as reprints, did not always have to be consigned to flimsy, ephemeral pamphlets, but could work and sell as books. The market, however, proved resistant to change. Inspiration came from abroad from the mid-sixties, when American writers and artists began to be invited over to European comic art festivals. There they got to meet their peers and witness first-hand how the medium was maturing, with its increasingly adult content and handsome, high-quality albums, so different from back home. No doubt this contrast would have struck Eisner yet again when he was honored in January 1975 at the second Angoulême comics festival in France.

Back at his drawing table, Eisner saw the blank page before him as a wide-open canvas, and his project as "a new path in the forest." As he explained, without the limits of a pre-set number of pages, "each story was written without regard to space and each was allowed to develop its format from itself; that is, to evolve from its

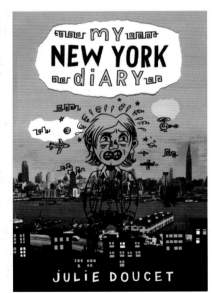

Above: Julie Doucet tells all in *My New York Diary*

Opposite page: Lost urban treasures discovered by Ben Katchor's *Julius Knipl* ('knipl' is Yiddish for a nest-egg)

narration." At last, the stories, the content, of comics could dictate their form. Their subjects and treatment, their composition and style, were all his to choose. Instead of relying on standardized, hard, black outlines and tightly-ruled panel borders, he introduced drawings in washes and tones, letting them bloom unconfined and floating on the pages. His stories developed out of the memories he had kept during his childhood in a Bronx tenement through the Depression. No longer having to kowtow to the censors or the Comics Code, Eisner could finally plant and cultivate "the seedlings which I have carried around with me all these years."

The result was *A Contract with God*, a quartet of sad, moving and disarmingly unglamorous vignettes of Jewish life set in New York in the "dirty thirties", curiously around the same time as the birth of the comic book. Eisner was intent on finding a mainstream, non-comics book publisher to put it out, but none would take the risk. Most were probably baffled by this oddity, an unfunny cartoon book about the past, to be printed in sepia. It was not until 1978, in his sixtieth year, that Eisner found a modest outfit, Baronet Books, willing to give it a try. They published it in hardback, without a dust jacket, and at the same time in a larger print run at $4.95 in paperback. How were they going to describe this puzzling illustrated book to the public? Eisner suggested putting on the paperback's cover: "a graphic novel."

Many would later hail Eisner as the "inventor" of the graphic novel, the term and the concept, though neither distinction is accurate. American comics fan and critic Richard Kyle coined the term as long ago as November 1964 in an article in a low circulation, internal newsletter solely for members of the Amateur Press Association, amateur in the best sense of the word. To encourage readers and professionals to consider the adult possibilities of the medium, Kyle wanted to circumvent the humorous and childish connotations that tarnished "comics" and proposed instead "graphic story" and by extension "graphic novel." Despite Kyle's later publications *Graphic Story Magazine* and *World* and his Graphic Story Bookshop mail-order service, his terms were slow to catch on. This may explain why Eisner later commented, "I had not known at the time that someone had used that term

before." It seems Eisner arrived at the graphic novel in 1978 quite independently.

As for his inventing the concept, he was well aware that it dated back much earlier, for example to Lynd Ward's wordless woodcut narratives of the 1920s, which had influenced Eisner in his youth. "I can't claim to have invented the wheel," he once remarked, "but I felt I was in a position to change the direction of comics." And that is what he did. Eisner committed himself to reinvigorating the ambitions of comics, building on the adult themes pioneered in underground comix, and aspiring to emotional depth and literary seriousness. The stand he made with A Contract with God would continue for the rest of his life and motivate his fellow professionals and successive generations to follow his example.

Since the late 1970s, successive generations of graphic novelists have been exploring the human condition in comics with perceptive insights and intriguing symbolism. Looking back for inspiration from the past, Los Bros Hernandez, Chris Ware, Seth, Eddie Campbell, and several others were drawn to America's robust legacy of "the funnies," especially the urban, socially real serials from the 1920s and 1930s. The daily struggle became a perfect subject for the daily strip. Those that tinged their laughter with pathos, realism and cliffhangers were great loyalty builders, hooking readers into coming back day after day to find out what happened next. As author Michael Chabon observed, their high quality and mass readership combined in "the creation of immense, shared hallucinations." Their working girls and flappers, conmen, gamblers, and newlyweds, Gumps, Nebbs, Bungles, and other eccentric households suggested that all of us could be the heroes of our lives.

For all the serials' pacey appeal and lively topicality, the public expected a certain optimism and decorum. The syndicates, eager to sell their features no matter what, regularly conceded to any complaints. Cartoonists had to bow to the unwritten, in-house censorship, which prohibited anything that might cause offense, from adultery, death, or disease (even a mention of diabetes had to be replaced by an imaginary ailment, "haliobetis"), to swearing, divorce or drunken behavior (unless the inebriate was a villain, of course). As comics historian Brian Walker commented, "A curious double standard developed. Newspaper readers were more sensitive about perceived transgressions in their favorite comics than they were about the same references in movies, plays, and books." Today, the comics section of an American paper remains a hypersensitive zone, where an outspoken episode of Doonesbury or The Boondocks, for example, can be summarily dropped if it oversteps the mark.

Neither the eternally respectable newspaper strip, nor for that matter the genre-ridden mainstream comic book cowed by the Comics Code Authority, was the place for the frank issues of rape, impotence, crises of faith, child sexuality, and alcoholism, that Eisner examined in A Contract with God in 1978. For comic artists of the time to attempt the kind of uncompromised, in-depth, adult realism possible in film and literature, they had to find a different arena. Not everyone had the financial security or clarity of purpose to take a sabbatical like Eisner and concentrate on a lengthy dream project. Instead, the early 1980s saw Jaime and Gilbert Hernandez, Dave McKean, Chester Brown, Eddie Campbell and other promising talents debut in modest, black and white comics, often self-publishing them at first, before being picked up by new alternative publishers. They might not all have intended from the outset to craft a substantial graphic novel, but gradually they would shape one, developing it organically as they put out further instalments. There was an air of excitement and discovery. So much of people's lives, dreams and feelings, all the extraordinary theater of the everyday, had been excluded from the medium and was ripe for expression, from gritty realism to magical surrealism.

It was bound to take time, because these sorts of graphic novels can require years, even decades, to come to fruition. Slowly, all of life is finding a place in these new comics, where it has always belonged. Towards the end of his prolific later life, Eisner could see that his vision of comics was being realized. He summed up his hopes: "I put up a tollbooth out in a field and I've been waiting for a highway to come through. And now I can hear the trucks."

A Contract with God in focus

Tenement tales

Something about the rundown Bronx tenement at 55 Dropsie Avenue brought Will Eisner back to it again and again during his final, nearly 30-year career in graphic novels. For him, the building in a New York Jewish ghetto was a place of memories, that became sharper as he got older.

"Within its walls great dramas were played out. There was no real privacy—no anonymity. One was either a participant or a member of the front-row audience." Notice in this page from "A Life Force" how Eisner signals his narrative through broad, expressive caricatures and clear, theatrical gestures.

Young Willie

It seems likely that the 15-year-old Willie, who loses his virginity in the "Cookalein" story is a thinly disguised teenage Eisner. As he said, "They are true stories. Only the telling of them and the portrayals have converted them to fiction."

It's a bug's life

In "A Life Force" Eisner asks what will keep Jacob Shtarkah going after a lifetime of sacrifice, now that he is 60, unemployed, unhappily married, and both his children are marrying out of the Jewish faith.

Here, collapsed in an alley, Jacob sees his own struggle mirrored in a fallen cockroach's determination to stay alive and risks getting attached in order to save it from being squashed.

Notice how Eisner increases the menace by shrouding the fifth panel in shadow and closing in so that it barely contains the man grabbing Jacob.

Dropsie Avenue

The 2005 edition, THE CONTRACT WITH GOD TRILOGY, adds the later stories "A Life Force" and "Dropsie Avenue," which reveals a century's history of the street's social and physical upheaval through its tenants' changing fortunes.

Dropsie is a fitting name that may refer not only to the illness dropsy but to its slang meanings of a bribe or tip.

A Contract with God

Will Eisner
1978, 1 volume, 150 pages

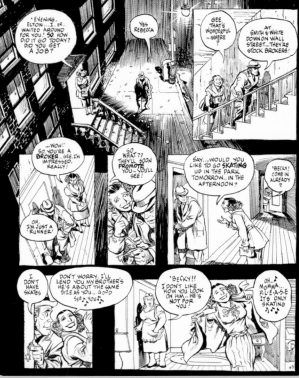

Living for the city

Everyone fears the "super" or building superintendent, Mr Scuggs, a lonely porn addict, except one devious Lolita who catches his eye. Here he pays her for showing him her panties, but she runs off with his savings. What is worse, the candy she gives his dog poisons his only companion. As sad as Scuggs' tragic fate is the callous greed in one so young.

Escaping the city for a country vacation, an assortment of tenants clumsily chase after love, sex and class status. Looking for a wealthy husband, office girl Goldie snubs a humble sax player, but her head is turned by Benny's fancy (hired) car. Notice how the shadows reinforce Herbie's disappointment.

Impoverished Elton Shaftesbury is about to throw himself from the fire escape when his Jewish neighbors offer to pay him for switching on their stove and lights on the Sabbath. Their 50 cents a week brings him back from the abyss and gives him hope.

The next night, as Elton climbs the stairs, he tells Rebecca about his new brokers' job, the first rung up the ladder of advancement.

Rebecca's radiant smile and sing-song voice tell us that her interest in him is not "only skating," despite her momma's disapproval of the "goy" next door.

Following on from A Contract with God

Julius Knipl

Describing himself as "a middle-man in the memory business," Ben Katchor can make you nostalgic about a past that you never knew and that never existed. Between assignments, Knipl, real-estate photographer, wanders in a lost American metropolis. Never named, it may stand for Katchor's native New York, or perhaps an "everycity" of desperate, small-time capitalism and utopian fantasies.

Here, Knipl, in the hat, learns about THE EVENING COMBINATOR, a nightly tabloid, whose weird reports are not inventions, but its readers' half-forgotten dreamlives. The lettering and balloons are crooked and quirky, like the stories; the panels are bathed in shadowy washes.

Stuck Rubber Baby

Young, white, and gay, Toland Polk struggles with the conflicts of his sexual identity, as his social conscience is awakened by the injustices of racism in America's South during the civil rights movement of the 1960s. Parallels are clearly drawn between real events of the time and Howard Cruse's complex, 210-page saga of one man's coming of age and coming out.

In this first scene, Granny Mabel deals in her unique way with a police raid on her gay bar. In the second, a peaceful black protest is disrupted by a racist thug and a cop is slow to stop him. Cruse's meticulous dots or "stippling" enriches the realism of his visuals.

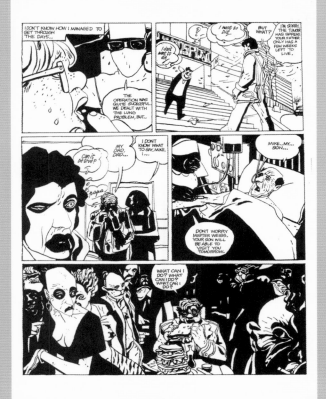

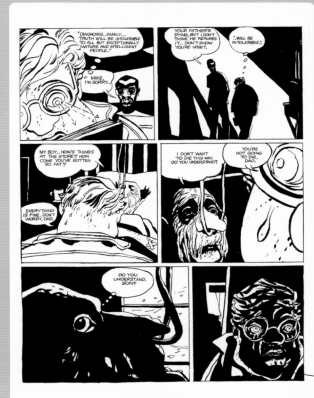

Joe's Bar

In ten years, Argentina's close writer-artist duopoly of Carlos Sampayo and José Muñoz never visited the Big Apple, but that did not stop their portraits of the city's transitory chaos from being utterly believable. Joe's Bar is the watering hole and magnet for the misfits, whose big city blues are played out in their comics.

Overeating at Joe's is little comfort to Mike Weiss after he learns that his father is dying of cancer. While he is being told, notice how we eavesdrop on other people's thoughts, showing that his tragedy is only one of many. His shadowed face in the last panel hints that Mike knows what he must do. Muñoz is a master here of Grosz-like distortions and stark black and white.

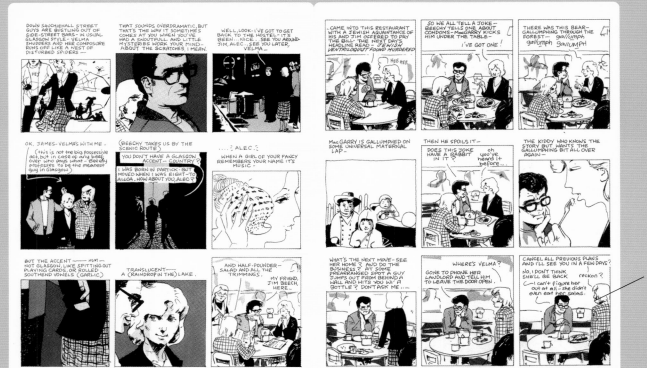

Alec

Eddie Campbell records those fleeting impressions and conversational gems that can otherwise slip by in the flurry of life. Through his alter ego Alec MacGarry, he lets us into his romances and friendships on the road and down the pub. His wry, unhurried yarn-spinning with its detours and asides mirrors his train of thought, easily sidetracked by a girl remembering his name or transporting him back to when he was young.

This sequence highlights his laconic wit and playful, poetic joy in language, coupled with his eye for revealing body language and his fresh, unadorned artwork, a sort of Zipatone impressionism.

Locas in focus

> "Hopey and Maggie are lesbian, Spanish-American, and punk.
> In a sexist, racist nation, only political and social underdogs
> can be the real heroes and heroines."
>
> KATHY ACKER

Love & Rockets

Mexican American Jaime Hernandez grew up with five siblings in Oxnard, California, north of Los Angeles. Teenagers in the late 1970s, Jaime and his older brother Gilbert credit punk rock's anarchic spirit with broadening their horizons and energizing them into making comics their own way.

In 1981, with oldest brother Mario, they put out their first issue of LOVE & ROCKETS, which Fantagraphics then offered to publish for them. Fifty issues later, LOCAS compiles the main Maggie and Hopey tales from 1982 to 1996.

Maggie & Hopey

Margarita Luisa Chascarillo and Esperanza Leticia Glass are "locas": mad, maddening, and madly in love, mostly with each other. Here they are reunited, after Hopey feared that Maggie had been killed working abroad. In her confusion, Hopey starts causing trouble again, like she used to do when she and Maggie first met.

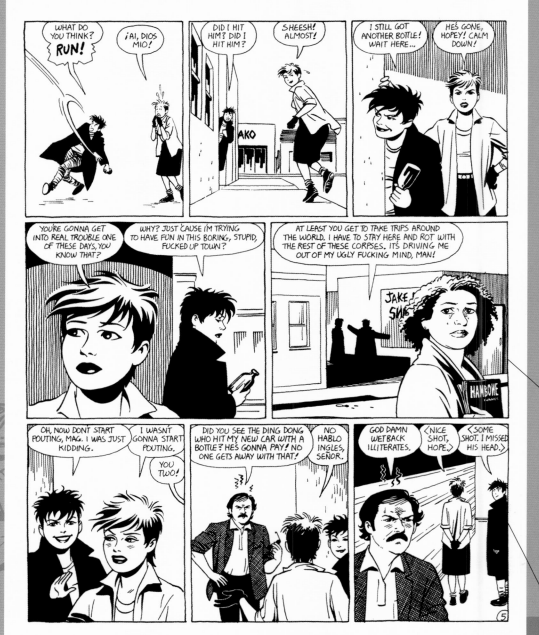

Writing women

Pressed for a reason why, as heterosexual men, he and his brother Gilbert are so adept at portraying women as three-dimensional personalities, Jaime Hernandez thinks back to their childhood.

"Maybe it's observing, maybe because our dad died when I was seven, and we were raised by our mom, by herself. She never remarried. So maybe we saw the world through her eyes."

Their mother would also tell them about the comics she collected and lost in the 1940s. No wonder she was fine about her kids reading them and having them about the house. Could this tearful woman clutching her copies of HAMBONE FUNNIES be a quiet tribute to her?

Cartoon realism

Jaime happily mixes quite realistic drawings with classic cartooning symbols, such as Maggie's anxious sweat drops and Sergeant Sado's angry squiggles.

The special brackets point out that they are speaking Spanish.

Locas

Jaime Hernandez
2004, 1 volume, 708 pages

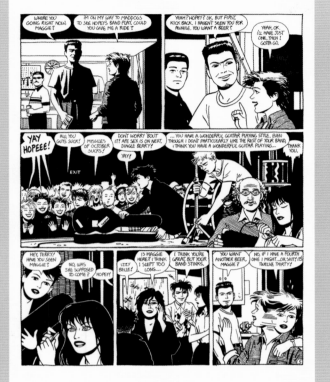

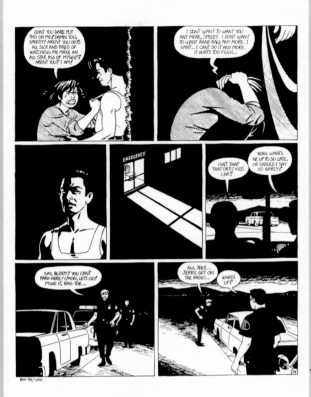

Speedy Ortiz

Maggie and Hopey are part of Jaime's larger ensemble, who spin off into the worlds of mechanics (Maggie's speciality), rock bands, gang wars, art galleries, and women's wrestling.

Maggie's attention can get distracted, as here by handsome charmer Speedy, who goes on to break her heart with his womanizing and recklessness. Speedy also gets caught up in violent gang rivalry that ends in his death.

Jaime deftly underplays the tragedy by showing us one last image of Speedy, insensitive to Maggie's anguish, and the window of the emergency ward casting a shadow like a cross, central to the page, before the police discover his body.

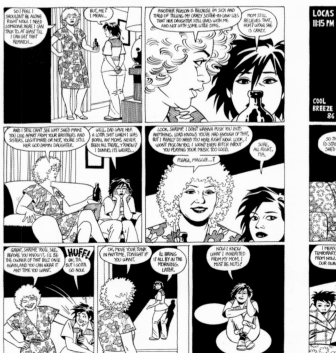

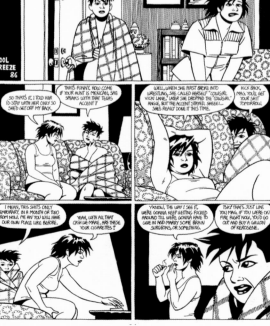

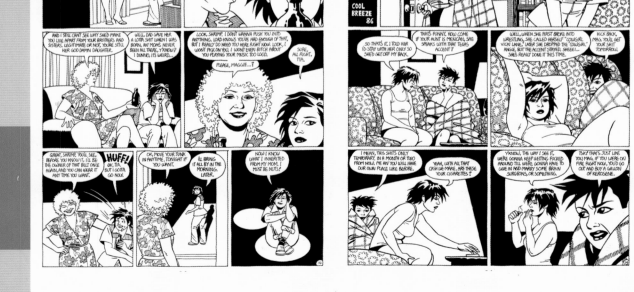

Secret histories

Jaime deepens the believability of his fictional characters by discreetly disclosing their secrets and fleshing out their histories.

In this sequence, Maggie's wrestling aunt Tia talks her into moving in with her until she gets a championship rematch. Their conversation reveals more detail about Maggie's past, her family troubles, and her eagerness to please.

Lastly, she breaks the news to Hopey, naked in a blanket. Notice how time smoothly jumps ahead with the second panel, simply by Maggie saying "So that's it" and having got undressed. Their faces and bodies say as much as their dialog about Maggie's distraction and Hopey's coy attention.

Following on from Locas

Food Boy

How far can loyalty take you? Gareth has known Ross since they were boys, and tries to understand him when he abandons normal village life for the wilds of Wales. Gareth becomes his "foodboy," bringing him meat, but realizes that Ross is turning increasingly feral. He finds Ross, fixated on a draining reservoir. A plaque reveals that it took the lives of a nearby village. Ross insists on digging up the bones of the drowned, which Gareth tries covering up. This tragedy shall not be buried again.

Carol Swain's charcoal textures and ever-changing viewpoints, circling around her characters, add to the atmosphere. Keeping Ross unheard and mostly unseen intensifies his presence.

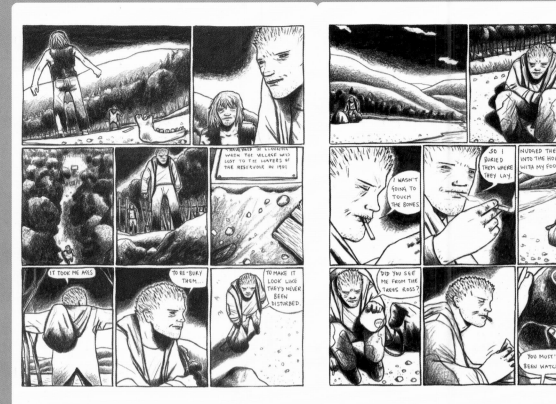

Paul has a summer job

Angrily quitting school for the real world in 1970s Montreal, Paul despairs at his dead-end factory job, so he jumps at the chance to work as a summer camp counselor. The challenges of looking after troubled kids puts his problems into perspective, and so does his gradual first falling in love with Annie, his vibrant co-worker.

Here, Paul meets the team and mistakenly counts on waitress service. In the second scene, twenty years later Paul finds their old campsite in the woods. In the opening panel, author Michel Rabagliati shows Paul's semi-transparent memory of his younger self.

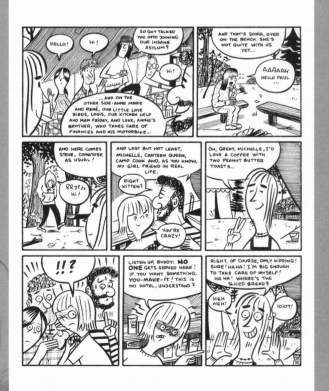

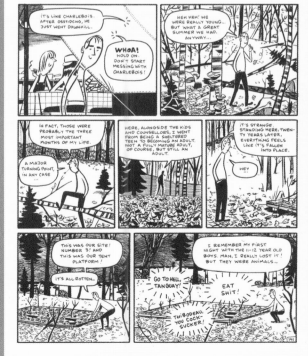

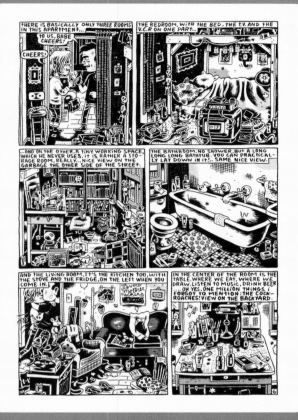

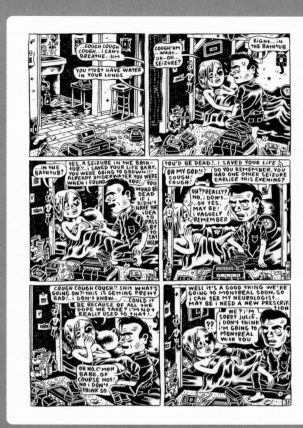

My New York Diary

For young French Canadian cartoonist Julie Doucet, New York is "a big, scary and merciless place to live... a pretty monstrous apple." She reveals everything that happens in her turbulent relationship with a selfish, possessive artist boyfriend: their love, drugs, sex, work, and fears that lead to rows and break-ups.

Here, she shows us round their cramped, three-room apartment in all its unvarnished detail. Later, she nearly dies in the bathtub when she has an epileptic fit. Her boyfriend saves her, but he is soon back to his self-centered ways. Throughout, Doucet displays her miniaturist's eye for tawdry beauty.

Maison Ikkoku

A beautiful widow, Kyoko Otonashi, manages Maison Ikkoku, a boarding house in the middle of Tokyo, and its eccentric tenants. Rumiko Takahashi's 14-volume urban romance follows Kyoko's slow-burning romance with the younger would-be teacher Yusaku Godai, as she learns at last to love again.

In this scene near the end, Kyoko has been taken to meet Yusaku's family. His grandma presents her with a special ring, as a sign of her relief that Kyoko is taking on her "dense, undependable" grandson. Characters in manga often have cartoon features and big eyes, but decors and objects are drawn with realistic precision.

Palomar in focus

> "Gilbert Hernandez is using the comic strip to tell us important stories about love and death and poverty and grinning-and-bearing-it, and the past we all carry with us wherever we go."
>
> ANGELA CARTER

Two matriarchs

Gilbert Hernandez never forgot the fantastical stories that his grandmother, aunts, and uncles used to tell about living in Mexico. They inspired him to create the close, closed community of Palomar, a mythical Central American village, as a way to explore his Latin American heritage.

Local life is run by two matriarchs, the formidable sheriff Chelo and the bath-house keeper Luba. Here Chelo confides in Luba about her self-doubts, after failing to stop a deranged serial killer from murdering the innocent and spreading terror and suspicion among the citizens. You'd never know that these women started as bitter rivals.

Here, Luba is at Chelo's place, recovering from a head wound, self-inflicted out of her fear and tension from the murders. She snaps in one panel and Chelo has to stop her ranting out of the window.

In the close-up of a tearful Luba that follows, Gilbert can seamlessly shift between panels from wacky cartooning to moving realism.

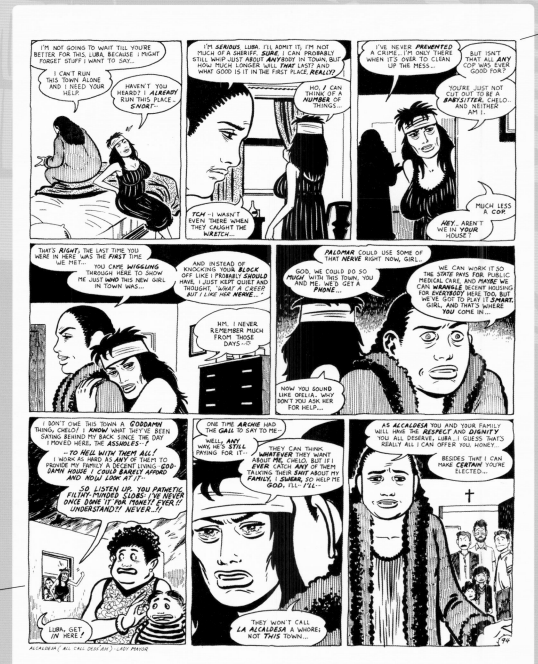

Gossip

Much of the drama in Palomar originates from gossip, the kind that spreads around any small town where everybody knows each other, or think they do. Ever since "outsider" and single mother Luba pitched up with her four daughters from different fathers and her touring bathhouse, prudish rumors have abounded concerning her "extra services."

Gilbert explained how Luba evolved. "She almost wrote herself. At the time I was very sensitive to what feminists were saying about how women were portrayed in popular culture. So I had to try real hard to make her a good character. And there are still people who won't read it because Luba's tits are too big."

Magic realism

Gilbert Hernandez has been hailed as the comics equivalent of the magic realism of Gabriel Marquez. He gets in a sly dig at this praise, when bookworm Heraclio has to stop his semi-literate wife Carmen from throwing Marquez's "junk" into the sea.

Palomar

Gilbert Hernandez
2003, 1 volume, 530 pages

Palomar scene by scene

Luba and Archie

A fan of Fellini, Bunuel, and many classic directors, Gilbert Hernandez used Sophia Loren as one model for Luba. The unashamed, soft-core sensuality in PALOMAR comes from his love of women and his love of drawing them.

Here Luba is in the big city and hooks up again with her ex-boyfriend Archie, after they rowed. His gloomy mood is indicated by a black thought balloon with a skull and bones, apt given his job.

What Luba doesn't yet know, but Gilbert has foreshadowed to the reader, is that Archie works as a mortician. Still, they get a happy ending, at least for one night.

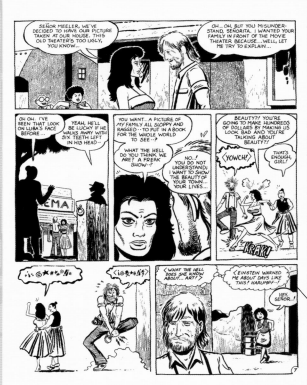

Village life

Luba comes to affect so much of Palomar life. Here, as she walks by with Archie, she's the topic of Carmen and Tonantzin's bitchy back-biting. This riles Carmen's husband Heraclio into an angry outburst, that raises Carmen's suspicions. Behind all this lurks Heraclio's secret boyhood seduction by Luba, and Carmen's jealousy over not being able to have kids.

Gringo photographer Howard Miller is "An American in Palomar," who wants to record their way of life for the world to see. In a clash of cultures, Luba puts her foot down. To remind us that everyone is speaking Spanish, Gilbert places brackets around Miller's English words, even his censored swearing.

Following on from Palomar

The Magician's Wife

Edmund, an ambitious illusionist, manipulates his stage assistant's daughter Rita into taking over her mother's role and becoming his bride. But his mind games unleash a rage within her and she tries to lose herself in New York. Here, Rita regresses to a girl as Edmund brings her home. Edmund is under the spell of the house's sinister new owner, but Rita's kiss rekindles the magic that they can make together.

In shimmering watercolors, France's François Boucq conjured up this unsettling love story, written by American novelist Jerome Charyn. "People aren't really like the image they try to project... they ignore their own mystery."

Cages

A writer and his wife, a painter, a jazz musician, and other residents of a London apartment block wrestle with their dreams and creative lives. This scene comes from a long, Beckett-like monologue by a house-proud, house-bound woman, in denial that her husband has walked out on her. Her parrot squawks back the awful truth in loud, distorted balloons.

Dave McKean rediscovers the power of comics to record the transient micro-expressions and moments that can take us inside the minds of his characters. His very act of making marks on paper forms a personal creation myth, and one that might also free his cast from their cages.

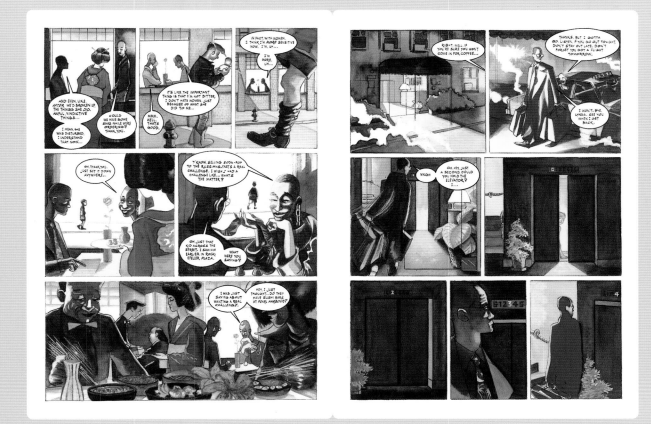

A Small Killing

High-flying advertising whizkid Timothy Hole (pronounced "holly") has come a long way from his left-wing, working-class roots in the English Midlands. Now in New York, he catches sight of a little boy following him, who looks familiar and seems intent on killing him.

Alan Moore and Oscar Zarate's collaboration is a stinging critique of yuppie greed and the everyday "small killings" that ease a bad conscience during the climb to the top. Here they nail Timothy's egoism, as he lays all the blame for his marriage break-up on his wife. Notice how Lynda, looking for a new challenge, flirts with Timothy's tie.

Why I Hate Saturn

Originally pitched as a car-chase murder mystery, Kyle Baker developed this thriller into a witty, character-driven comedy about two very different sisters: Anne, a hard-drinking New York lush, and Laura, convinced that she's Queen of the Leather Astro Girls of Saturn (hence the title).

Here Anne reads Frank's frank diary about meeting Laura on a blind date. By placing all text beneath the panels storyboard style, Baker has space to be free and flexible with his dialogue and narration. The climax to his 200-page romp is not unlike the movie THELMA AND LOUISE, which came out a year later.

It's a Good Life... in focus

> "Rich, evocative...characterized by small moments revealing the author's sharp eye for detail ."
>
> THE GLOBE & MAIL

Sentiment

Canadian cartoonist Seth feels distress that so much is trampled over by the rapid changes in modern life. He seems to have found some comfort in his mother Violet's much-repeated mantra: "It's a good life if you don't weaken." It becomes the title and underlying sentiment of his tale.

Gently positive if not profound, it's a saying that encourages perseverance without promising the moon. As Seth explains, "It's only when you weaken to all the negative forces around you, that your life is basically destroyed. You've got to make of it the best you can."

Seth sets out on a quest to find out about a cartoonist named Kalo, whom he discovers was forgotten by posterity, one of yesterday's men, who tried to live "a good life" and, all in all, did not weaken.

Picture-Novella

Seth came up with this slightly old-fashioned term to describe his story. He combines critical autobiography, failed romance, low-key mystery, and an appreciation of how comics and memories associated with them can affect us deeply. He also provides a glossary of cartoonists and characters that he mentions.

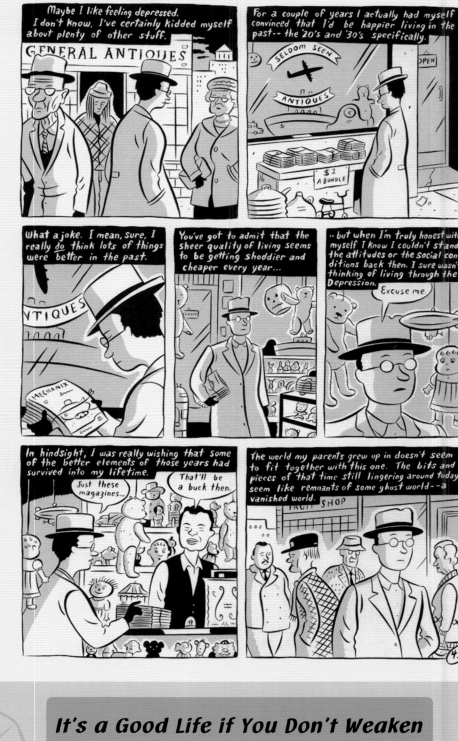

It's a Good Life if You Don't Weaken

Seth
1996, 1 volume, 192 pages

Nostalgia

In white-on-black captions, Seth lets us eavesdrop on his thoughts about living in the past, as he scours the antiques stores festooned with toys.

In his hat and smart coat, Seth dresses like the elderly man in the first panel, in contrast to the outfit of the long-haired youth in the background.

His glasses are blank throughout, his eyes unseen, suggesting introspection, self-reflection, perhaps a desire not to see the present day.

The real Kalo

Despite the cleverly faked evidence of his printed cartoons, Seth later disclosed that Kalo was an invention. This knowledge brings questions, not answers.

Like Kalo, Seth is a pen-name of a Canadian, raised in Strathroy. It's as if Seth imagines how he might have lived as a cartoonist who made it only so far and gave it up, not out of weakness, but to support his family.

This also relates to Seth's idolization of THE NEW YORKER magazine and his ambition to be published there. His fictional Kalo sold only one cartoon to the prestigious weekly; Seth has gone on to illustrate for them, including covers.

Finding Kalo

Trying to trace Kalo, Seth travels to Strathroy, Canada, by coincidence the town where Seth spent some of his childhood. Seth inserts plaintive drawings, frequently without people, here of a rundown building, perhaps vandalized, and a faded playground in the snow, as he thinks about childhood comics. He fills several pages with these seemingly unrelated images, some without words, to convey quietness, transition, contemplation.

Here, as he reviews the facts, he again takes us around the old buildings at night beneath a starry sky, a recurring motif in the book. Notice how the moon, like the Kalo puzzle, is "barely a quarter" and how space, like facts, is empty.

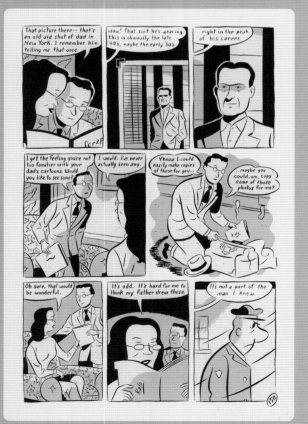

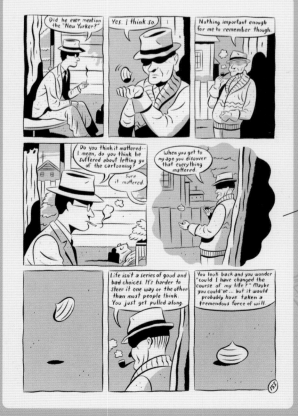

Perseverance pays off. On this left-hand page, Seth locates Kalo's daughter and they share their pieces of the puzzle. Notice how Seth creates resonance between the photo and the cartoon by placing them in same sized panels, on the right in a row of three.

Seth gets referred to an old friend, who gives him an insight into how Kalo felt about giving up cartooning. The man has been planting bulbs and, as he reflects, lets one drop to the ground, an allusion to growth and the cycle of nature.

As well as his retro drawing style, Seth's choices of the book's cream paper, subtle second colour, and refined design add to its charm.

Following on from It's a Good Life...

Hicksville

Naive journalist Lester Batts uncovers the sacrilege behind cartoonist Dick Burger's superstar status by visiting his New Zealand hometown, Hicksville. Far from being "hicks," everyone here loves comics deeply, as Batts learns from bookseller Mrs Hicks, of the town's founding family.

Later, Batts is let into a unique archive of unseen, unknown comics masterpieces, by Picasso, Lorca and many more. Appropriately, it is kept safe inside a lighthouse, a savior from disaster and a beacon of hope. New Zealander fabulist Dylan Horrocks builds a local Shangri-la legend for his beloved medium.

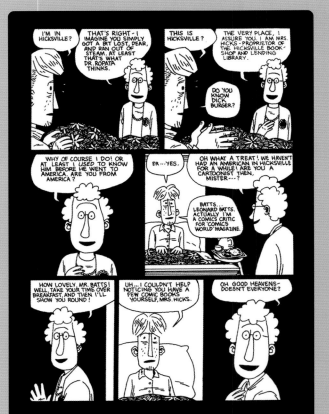

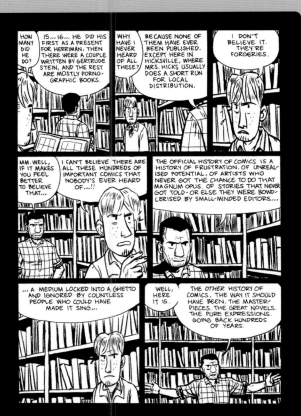

The Walking Man

In Tokyo, a quiet, observant man wanders off the beaten track. When he relaxes on the fallen cherry blossoms, he is joined by a woman, who tells him that she has come back to see a favorite tree from her childhood. He listens and then leaves her in peace.

Jiro Taniguchi's delicately illustrated interludes prove that, even in a crowded city, you can find the calming beauty of nature, if you take the time to look. Notice his careful use of silent panels to convey mood and time.

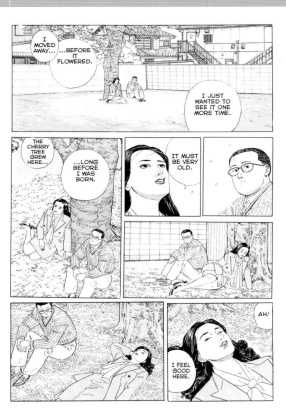

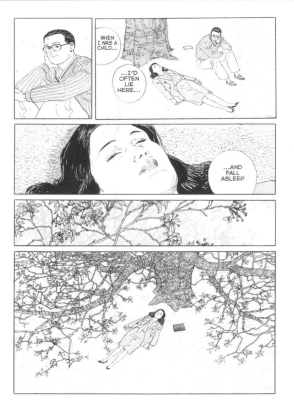

Following on from It's a Good Life...

Monsieur Jean

In the unusual Parisian partnership of Philippe Dupuy and Charles Berberian, both of them write and draw together and reflect their lives and anxieties in their composite alter ego. So far, Jean has stayed free and single, but here, over a sushi meal, he worries about losing Cathy to Pierre-Yves, a smooth rival.

Jean imagines Cathy as a mermaid in the restaurant's painting of a Japanese legend, which turns into an erotic print. When he comes to her rescue, reverie and reality blur and she ends up as his sliced tuna. Notice all Jean's fantasies lack panel borders, while his memory of an awful dinner party is indicated by tinted speech balloons.

La Perdida

Clashes of culture, class and politics spill over in Mexico City, when unwelcome American visitor Carla is kicked out by an ex-boyfriend, who is later kidnapped. Her relationship with Oscar, her new Mexican boyfriend, becomes strained after he disappears for days with Memo, a Marxist revolutionary. Here, on their return, Carla's relief turns to suspicion at their evasive answers. In LA PERDIDA or "loss," author Jessica Abel subtly stokes up the tension and conflicted conscience of a young woman, alien and alienated, and getting increasingly out of her depth.

The Long Shadow

Right: Hitler, before and after, on the covers of *The Beast Is Dead* from 1944 and 1945

Opposite: The mutinous naval lieutenant from Lorenzo Mattotti's *Fires*

Through the walls of his darkened bedroom, a young American boy's slumber is shattered as he is woken night after night by the cries of his sleeping parents. They had survived the German concentration camps, but their nightmares would never leave them. Born after the war, their only son grew up amid its lingering traumas and little daily reminders. A child of survivors needs to find a way to survive himself. Reading and drawing comics offer him some escape, and later he briefly tries psychedelic drugs. At the age of twenty, however, his LSD experiments trigger a deep neurosis and he is committed for several months to a mental hospital. Then, three months after he is allowed out, his mother takes her life. The war casts a long shadow, over parents and son.

Art Spiegelman started using his short story comics in early 1970s underground anthologies to deal more explicitly with his feelings about his parents Vladek and Anja. Justin Green proved a great inspiration by his example of the autobiographical *Binky Brown* in 1972 and also by personally insisting

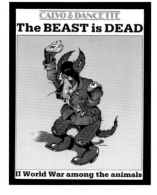

that Spiegelman contribute something to a comic called *Funny Aminals* [sic]. Green "even taped two tabs of amphetamine to the letter to get me over the hump. I never used the speed... but I did produce a three page strip called 'Maus,' which later triggered my long *Maus* project." Another huge encouragement was Will Eisner's first graphic novel in 1978, the year Spiegelman and his Françoise Mouly established their imprint, Raw Books and Graphics. Spiegelman adopted a similar format to that of *A Contract with God* and 1979 he outlined his project for "maybe a 200-page or more comic book novel, for want of a better word, that will be the story of my father's life in Nazi Europe. It will also be the story of my relationship with my father. I'm finding it very, very difficult, because it's just so painful. And yet I feel it is important for me to grapple with those demons, and also, insofar as there are

stories still left that people should know, this is certainly among them."

From the second issue of *Raw*, Spiegelman and Mouly's irregular, self-published "graphix" magazine, in 1980, he began serializing his story one chapter at a time. Instead of waiting until he had completed it, he took six chapters to Pantheon Books, who published a first volume in 1986. Any reservations about a comic tackling such tragic history were swept away by the intelligence and intensity with which Spiegelman engages the reader. *Maus* climbed the bestseller lists, at first in the fiction category, until Spiegelman pointed out that the Holocaust and his telling of it were in no way fictional. With help from a Guggenheim fellowship, he was able to complete the second, concluding volume in 1991. A year later it won him a Pulitzer prize, although they had to come up with a special category to accommodate the book's anomalous status. Once readers got over the fact that it was in a funny animal comic form, they discovered how readily they could identify with the stylized, almost abstract characters, as blank-eyed as Little Orphan Annie, and how *Maus* presented a fresh, involving way for them to try to grasp the Holocaust and its toll on survivors and their children.

Spiegelman knew that he was working in a long cartoon tradition of animals as symbols and stereotypes. Back in the mid-1930s, Walt Disney's Mickey Mouse had been attacked in an anti-Semitic editorial in a German newspaper, which Spiegelman cited, as "the most miserable ideal ever created... the dirty and filth-covered vermin, the greatest bacteria carrier in the animal kingdom, cannot be the ideal type of animal.... Away with Jewish brutalization of the people! Down with Mickey Mouse! Wear the Swastika Cross!" In fact, Hitler and the Germans went on to be caricatured as versions of Disney's Big Bad Wolf in *The Beast Is Dead*, a triumphalist re-casting of the Second World War into the animal world. This large

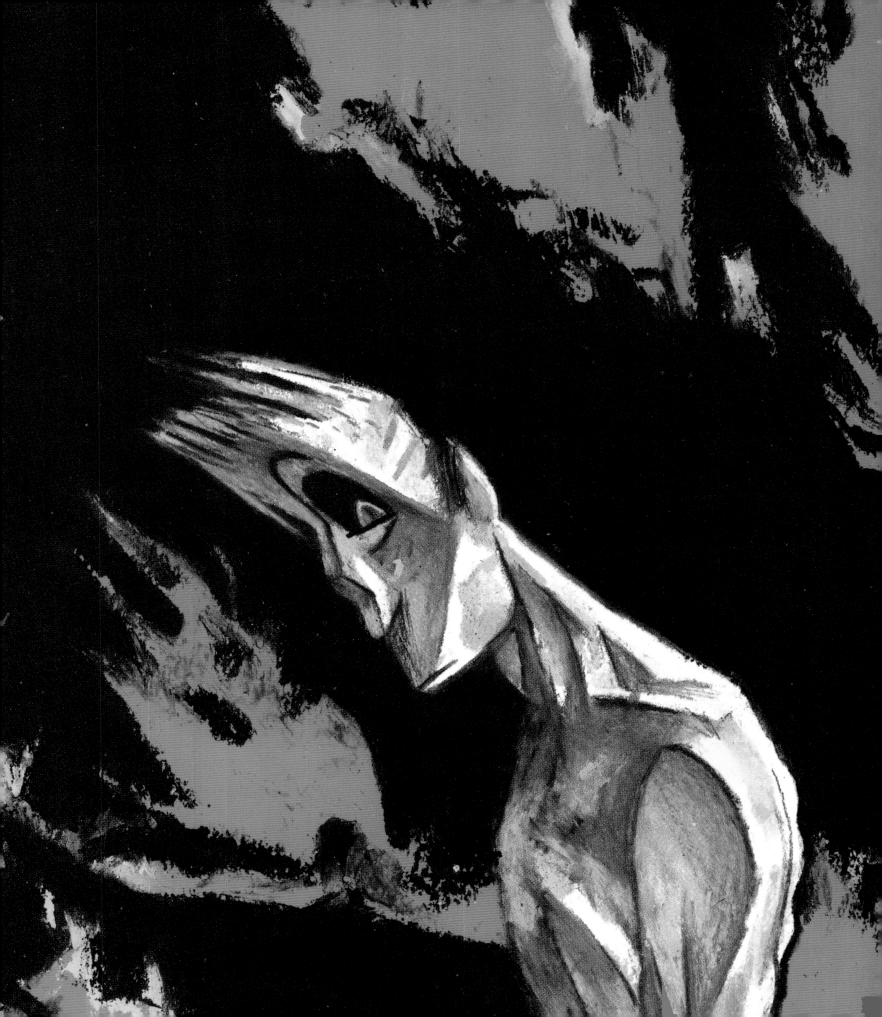

The Long Shadow

format, fully painted graphic novel was published in two parts in 1944 and 1945, during the early, heady period of France's liberation. The writer-artist team of Victor Dancette and Edmond-François Calvo have no time for shades of grey in their nationalistic menagerie; they brand whole countries as either all good, such as French rabbits and squirrels, British bulldogs, and American buffaloes, or all bad, as in Italian hyenas and Japanese yellow monkeys. In their oversimplified, jubilatory fantasy, they give the persecution of the Jews very short treatment, portraying them as rabbits on only one page.

The primary visual sources for what life and death were like in the concentration camps were the drawings made by the inmates themselves, which Spiegelman found vital in illustrating his father's history. Among the surviving pictorial record are three narrative cartoon booklets by Horst Rosenthal, born in Silesia, that depict his daily life as a prisoner in Gurs, the largest camp in France's Occupied Zone. In one of them, Rosenthal criticizes the Vichy regime's betrayal by depicting the cruel irony of Mickey Mouse being interned in Gurs. Arrested for having no papers, Mickey is asked if he is Jewish and writes, "I hung my head and admitted everything." Unpublished, Rosenthal's ironic satires existed as one-off, hand-drawn originals, passed between fellow captives.

There used to be few opportunities within comics for the victims and critics of wars, in the services or among civilians, to get their stories into print, unless they could be used by the other side as propaganda. For example, Taro Yashima, an exile from Japan, found a publisher in New York in 1943, mainly because *The New Sun*, his graphic account of his punishment for anti-militarist protests, served the purpose of supporting America's involvement in the war. Comics made ideal morale boosters and recruitment tools. They waved the flag, saluted the troops, and accepted the official line. Many popular characters in the Second World War set an example and signed up or fought on the home front. In the battle of the imagination, Americans were fired up by mighty superheroes, many uniformed in stars and stripes, while the Japanese took courage in

An inmate of the concentration camps from Joe Kubert's *Yossel, April 19, 1943*

a brave soldier dog and a giant, spike-booted robot.

It was after the Allies' victory in 1945 that war comics about the ordinary soldier proliferated in America and Britain, especially from 1950, when the Korean war began to be fought on the battlefields and on the comic book pages at the same time. At worst, these comics could be crude and jingoistic, dehumanizing the enemy. Even at their best, such as the stories supposedly based on real accounts in Harvey Kurtzman's EC series or Joe Simon and Jack Kirby's *Foxhole*, the common soldier might come across as unheroic, cowardly, fatalistic, but he was usually resigned to getting the job done. He would seldom question, let alone protest against, the war he was fighting. Read by servicemen, ex-servicemen, and would-be servicemen, these comics frequently tell of a private overcoming his fear and performing some act of heroism. In Britain, endless variations on this theme have filled over 4,000 editions of *Commando*, small-format, 64-page graphic novels, still issued eight times a month. Aimed partly at young potential army recruits, these "pocket libraries" omit the true horrors of war, because they would be too disturbing for these gung-ho adverts for bloodless combat and macho bonding.

America's Vietnam war also generated its share of mostly patriotic comic heroes at the time. Any hint of anti-war dissidence was not tolerated. When Archie Goodwin wrote a humanist story for Blazing Combat in 1966 that empathized with innocent Vietnamese peasants killed in

crossfire, the magazine was banned by the U.S. Army from being sold on their bases and folded after the next issue. It's surprising that in the rebellious underground comix that followed, there was little specific criticism of the war. One exception was the topical, brooding Legion of Charlies by Tom Veitch and Greg Irons, who interweave the Charlie company responsible for the My Lai massacre and the Charlie Manson murders. Only in the eighties, once the war was far enough removed, could more attempts be made to interpret it, ranging from Marvel's Code-approved *The 'Nam* to more faithful records by Will Eisner, Don Lomax, Cosey, and Harvey Pekar.

Through autobiography in graphic novel form, others answered the need to bear witness, for a loved one who had died, or for themselves. In Japan, when Keiji Nakazawa's mother died and was cremated in 1966, her bones disintegrated from the radiation stored in her body from the Hiroshima bombing. This shock drove Nakazawa to tell the story of their survival as *Barefoot Gen*. Amazingly, considering its horrific imagery and political sensitivity, this was serialized from 1972 in a mass-market weekly for boys, *Shonen Jump*, without any complaints being received. In Tehran, the young Marjane Satrapi, daughter of Marxist parents and great-granddaughter of Iran's last emperor, grew up under the Islamic revolution. On the eve of the Iran-Iraq war, her uncle Anoosh was arrested as a Russian spy. He asked for Marjane as his last visitor, before he was executed. He gave her a little swan that he had sculpted out of bread to remember him by and entrusted her with the family's history. "I will never forget," she promised. Years later, exiled in Paris and inspired by Maus, she resolved to tell her story in comics. In *Persepolis*, Satrapi is keeping her childhood promise.

After decades of telling make-believe adventures, American veterans Eisner, Joe Kubert, and Sam Glanzman used the graphic novel to look back afresh at their own experiences of the Second World War. In Kubert's alternative life story, he speculated on how different his fate might have been, if he had been unable to leave his native Poland for America and had fought and died as a boy in the 1943 Warsaw ghetto uprising. In another Kubert project, he adapted a stream of fax messages, a friend's only lifeline trapped in Sarajevo, into a graphic novel about the Bosnian war of 1992–95. Meanwhile in Serbia, young cartoonist Aleksandar Zograf responded to NATO attacks on his hometown Pancevo by drawing a weekly strip, fusing hard truths with dreams and dream-

imagery. Distributed abroad electronically, his *Regards from Serbia* bypassed frontiers and was published via papers and websites in the lands of the "enemy," as the bombs were still being dropped.

More or less fictional stories of war can naturally also carry a powerful charge, when backed by thorough research or perceptive imagination. Who would have thought that Pat Mills could present the harsh facts of the First World War in *Battle,* a British boys' weekly? "Censorship was never a problem. The incidents happened, therefore they couldn't be gratuitous." More recent conflicts of resistance, for example in Prague, Algiers, and Belfast, had hardly been touched upon in comics before, but are now the subjects of graphic novels. Such fantastical allegories as Lorenzo Mattotti's *Fires* convince the reader with their psychological insight. Even the purely hypothetical—Hitler's Jewish bloodline or Japan's future war for oil—can be compellingly plausible.

In the real world, cartoonists are becoming war correspondents, to witness for themselves the flashpoints and frontlines. Joe Sacco's visits to Palestine and Bosnia have resulted in documentaries of history as it is happening, intimate and sometimes devastating, that fix decimated streets and ravaged faces in maniacal detail. In the wake of September 11, there is a curiosity and urgency in many people to understand more about the so-called "outside world." Sacco has been commissioned to produce new graphic reportage by *Time* magazine and *The Guardian* newspaper. Other cartoonists are finding the complexities hidden behind the simplistic headlines, from Ted Rall in besieged Afghanistan to Mark Stamaty's tale of one woman's courage in war-torn Iraq. As Satrapi has commented, "The news hides the complexity of a society. They talk about politics but never about people who are suffering its consequences and who are fighting for more freedom. Nor about the poor, who don't have the possibility of leaving." The comics medium seems ideally suited to shedding light on the shadow of war and exposing the humanity, that is all but ignored or trivialized by much of the mass media.

The true story of an Iraqi librarian who rescues books, in Mark Stamaty's *Alia's Mission*

Maus in focus

> "*Maus* is a masterpiece, and if the notion of a canon means anything,
> *Maus* is there at the heart of it. Like all great stories, it tells us more about ourselves
> than we could ever suspect."
> PHILIP PULLMAN

Animal types

Art Spiegelman's animalistc metaphors of Jews as mice and Nazis as cats become even more pertinent, because Hitler compared Jews to vermin and used rat-poison Zyklon B in the death camps. Art regularly plays with these stereotypes to expose their absurdities and lies. Here Vladek tries to disguise himself and his wife as Poles, portrayed as pigs, by wearing quite obvious masks.

To keep past and present clear, Art captures the distinct Jewish sentence order of Vladek's narrative comments, but keeps the way he and others speak in the past normal.

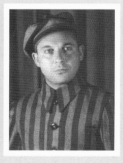

The Real Vladek

After the Holocaust, Vladek Spiegelman had this somewhat idealized "souvenir photo" taken of him wearing a clean camp uniform, one of the only photos which Art shows in the book.

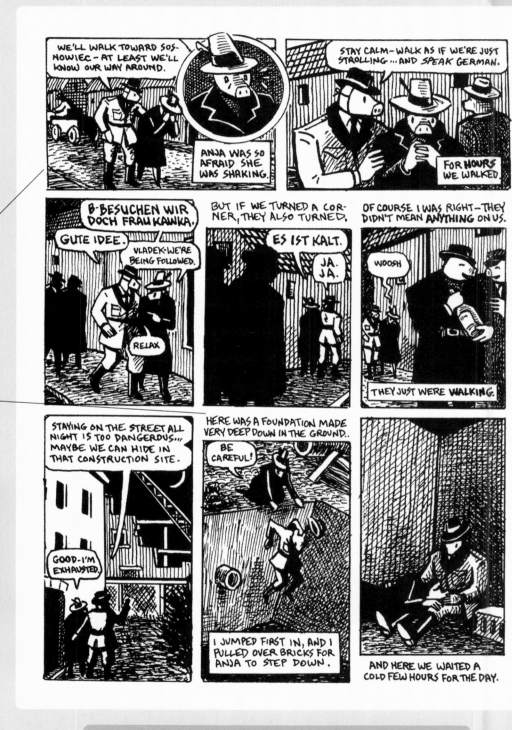

Drawing choices

Spiegelman first dealt with the effects of the Holocaust on his childhood in a three-page "Maus" strip in 1973 introducing the cat-and-mouse metaphor. For the longer version, he started drawing in a rendered, expressionist style, but rejected it, as it told the reader too much how to feel. He chose a modest directness, almost diagrammatic, drawn same size or smaller. You almost feel as if you are reading the one surviving original.

Mother

After his mother Anja's suicide in 1968, Art tries to comfort his grieving father in this panel from "Prisoner on the Hell Planet." This 4-page strip from 1973 about Art's own mental anguish portrays human characters in a fevered scratch-board technique. It is printed again in MAUS, when his father finally reads it years later.

Maus: A Survivor's Tale

Art Spiegelman
Volume 1 1986, Volume 2 1991, Complete 1999, 295 pages

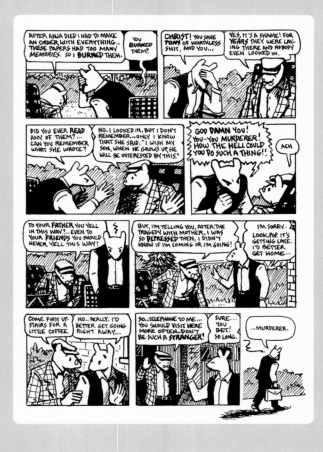

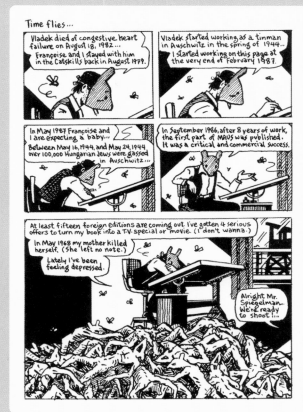

Anger and guilt

The final page of the first volume, far left, brings the strained relationship between Vladek and his son to a head. Recovering this oral history enabled Art to rebuild his relationship with his father, but it also exposes painful truths. His fury fills a jagged speech balloon and becomes black lightning over his head. His accusal "Murderer" stands out in a larger balloon as if spoken under his breath.

Art's anxiety and guilt over his success with the first part of MAUS becomes a key element in the second part. Art draws himself wearing a mouse mask, his desk atop a pile of emaciated, mouse-headed bodies, the death camp visible through his window. To underline his complicity, a big, barely visible black swastika holds the page together.

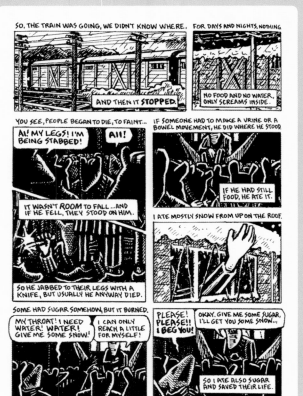

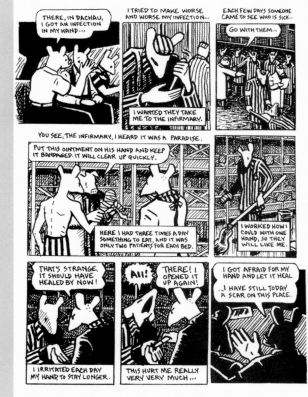

Survivors' tales

These pages show how Vladek negotiates his survival in the camp by helping others but also helping himself. Art does not make his father out to be a hero or saint, but records the sacrifices he was forced to make, going so far as to injure his hand repeatedly and leaving him with scars, physical and emotional, which he carried for the rest of his life.

Another way Art subtly shows shifts between the present and past is by omitting the panel borders or expanding them beyond the usual grid of the page, as if time is evaporating, demonstrated left in the opening and closing panels of this page.

Following on from Maus

A Jew in Communist Prague

After his father is sent to a labor camp for anti-socialist activities, young Czech Jonas Fink and his mother become suspects and their opportunities narrow. Jonas lands a job in a bookstore, but is forced to spy for the police on his employer, who is involved in an underground literary movement.

Somehow love blossoms in this climate of suspicion and anti-semitism, but can it endure when Jonas's girlfriend reveals that her parents know all about his criminal father? Cold War 1950s Prague comes alive in the meticulous research by Italy's maestro of "clear line" art, Vittorio Giardino.

To the Heart of the Storm

Will Eisner's most explicitly autobiographical novel examines prejudice against Jews, and among Jews, during his youth and young adulthood, as the Second World War approaches. Willie joins the army, and while riding the troop train to basic training he thinks back on what has brought him to fight for his country.

Here, years after high school, Willie bumps into Buck, his best friend from childhood. Buck's memories of their good times together soon dissolve into a racist tirade. Eisner uses the mounting downpour to convey the gathering storm of ethnic tensions in pre-War America.

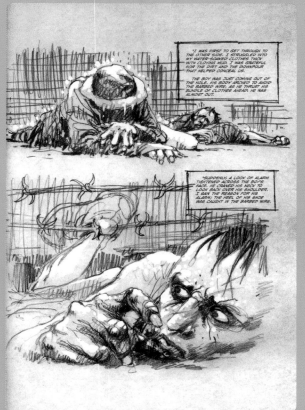

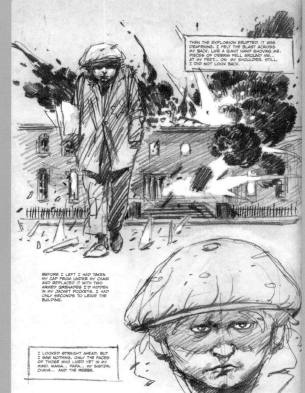

Yossel, April 19, 1943

In 1926, when Joe Kubert was two months old, he and his Jewish family left Poland for a new life in America. But Kubert was haunted by the thought of how life might have been, had they stayed and endured the Nazi invasion. At the age of 77, he wrote his speculative autobiography.

Yossel is a 15-year-old boy whose drawing talent wins favors from the Germans but can't save his family from being deported to the death camps. Rather than meet the same fate, he chooses to die fighting in the Warsaw ghetto uprising. Here, in raw, uninked pencil sketches, two prisoners try to escape, and Yossel sets a bomb in the Germans' base.

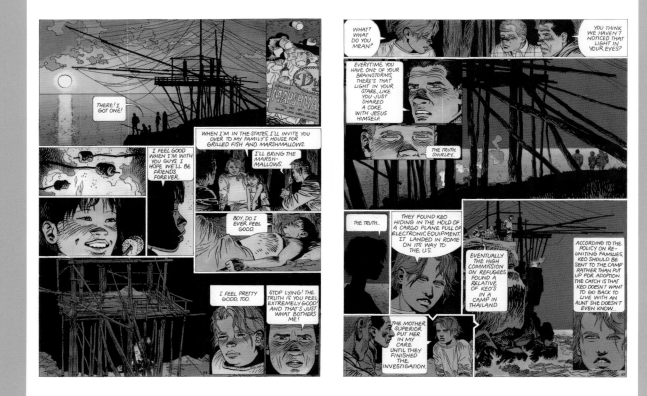

In Search of Shirley

Arthur and Ian grew up competing for the elusive Shirley, before they were drafted to fight in Vietnam. Now, as veterans struggling to adjust to civilian life, they hear from her again, living as a nun in Italy. Their reunion rekindles past conflicts between them, till Shirley introduces them to Keo, a young Vietnamese illegal refugee in her care. Here, the two guys discover Shirley's scheme: to get them to help Keo avoid being deported to a camp in Thailand, by taking her with them to America. In this scene, Swiss author Cosey's crisp art and elegant pacing convey all the interplay of emotions set around a fishing jetty as night falls.

Barefoot Gen in focus

Manga

The publication of BAREFOOT GEN in English in 1978 caused a culture shock to many Western readers. This was due not only to the searing honesty of Hiroshima survivor Keiji Nakazawa, but also to some of the alien characteristics of 1970s boys' manga, or Japanese comics.

These include faces with large eyes, gaping mouths, and overstated expressions; unfamiliar symbols or techniques; and a blend of casual violence with cuteness.

Once you adjust to these quirks, they in fact contribute to the compelling fascination of this account of one boy's survival of the atomic blast. The spare, shorthand cartooning allows readers to look at the bomb's horrifying physical effects and complete the picture in their imagination.

Alter ego

Nakazawa explains, "My alter ego's name Gen has several meanings in Japanese. It can mean the 'root' or 'origin' of something but also 'elemental' in the sense of an atomic element, as well as a 'source' of vitality and happiness."

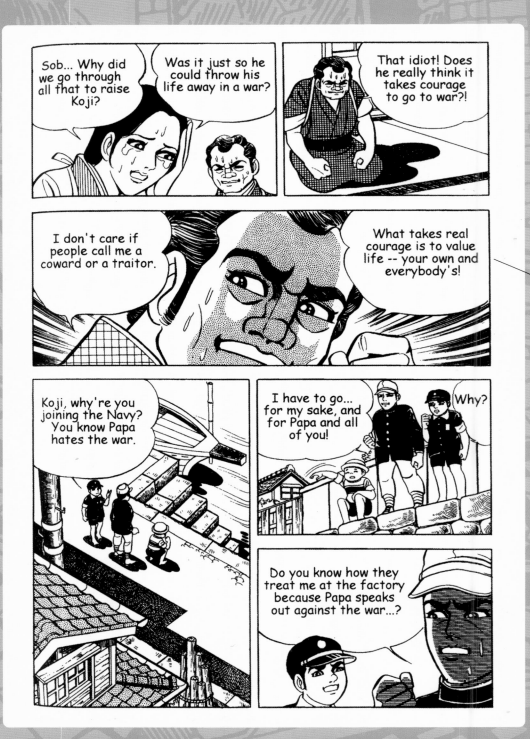

Militarism

Nakazawa shows the power of the military establishment pushing Japan to war and the imperial system behind it. The police persecute Gen's father for his pacifism. His children are also made to suffer at school and at work.

Here, the victimization drives his eldest son to enlist. Gen's father is angry at Koji's choice, his fury emphasized by the shadow over his face and swirling lines around his head like a psychic aura. A shadow also falls across Koji's face in the last panel.

Project Gen

Project Gen was formed by Masahiro Oshima and other young peace activists, Japanese and non-Japanese, in Tokyo in 1976. Several of them, while taking part in that year's walk for peace across America, had been urged to put GEN's strong anti-war message into English.

Reading right-to-left, manga are complex to convert and translate. A volunteer group reliant on donations, Project Gen managed to translate and publish the first two volumes in 1978 and 1979 and distribute them abroad on a non-profit basis. Over time came another two volumes. In 2004, new translations of all ten volumes began.

Barefoot Gen

Keiji Nakazawa
4 of 10 Volumes, 1978, 1979, 1989, and 1994, 1,096 pages

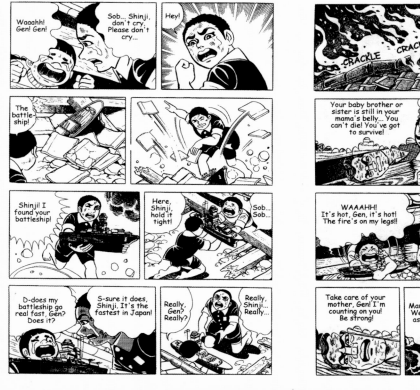

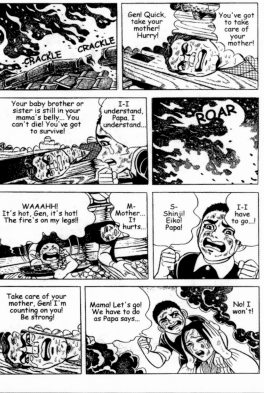

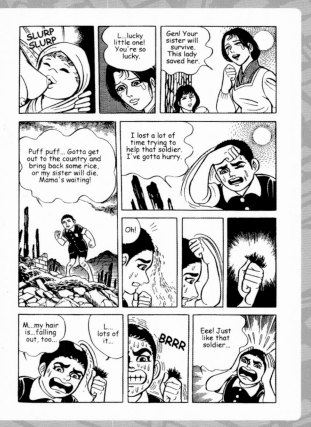

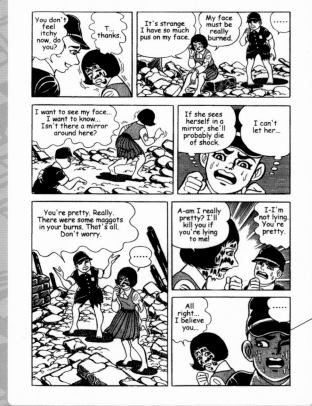

August 6, 1945

At 8.15 in the morning, the bomb was dropped and "created hell for the dying and hell for the living."

Here young Gen and his pregnant mother watch as Gen's father and younger brother perish, pinned under their burning home. For some time after, his mother goes into denial and refuses to accept that her loved ones are dead. Gen holds onto his father's last words, as he struggles to carry on.

Few, if any, comics have sustained such an emotional pitch. This tragedy is all the more powerful, because over the story's first 270 pages, Nakazawa has made this vulnerable family so vividly real to us.

New life is born out of the destruction. On the far left, Gen's mother gives birth to a daughter, Tomoko, but is unable to breast feed her. Another mother, whose baby son has died, forgets her sorrows for a while by giving her milk to Tomoko.

The scene cuts to Gen, who, despite his efforts, fails to save a soldier from dying from radiation poisoning. Here, Gen becomes terrified when he shows the same symptoms. The summer sun beats down on them all.

Underlining the massive scale of the physical horrors is the plight of individuals. Here, his face in shadow, Gen has to lie to a disfigured girl, to preserve her hope of dancing again.

Following on from Barefoot Gen

Charley's War

Reading letters by working-class soldiers writing home during the First World War gave writer Pat Mills the human angle he needed to put across the horror of the trenches. Mills plunged readers of the British boys' weekly comic BATTLE into the challenges faced by Charley Bourne, a Cockney lad aged 16, who starts as an eager, under-age private.

Here, during the battle of the Somme, Charley arrives with an urgent message to alert the artillery to save his mates, but callous snob Lieutenant Snell refuses to let this interrupt his tea. Charley learns a lesson in class-consciousness. Artist Joe Colquhoun is superbly adept at both savage caricature and the details of warfare and carnage.

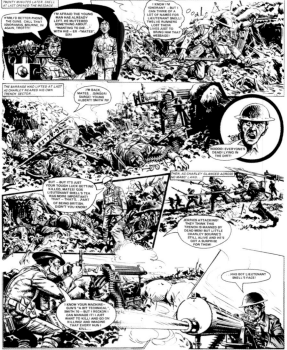

Troubled Souls

Dropping out of college to pursue comics in 1989, Belfast newcomers Garth Ennis and John McCrea took their story straight from the streets of Ulster. The Northern Ireland "Troubles" create a bond between two very different men: Damien McWilliams, on the left, explaining why he became a hardened IRA killer, and ordinary coward Tom Boyd.

Here Damien has ensnared Tom into planting a bomb in a trashcan to blow up a British Army Landrover. Notice how six extra top panels cut to the vehicle's approach. Tom's chief aim is to get himself and his girl out of danger, but his curiosity, shown inside parentheses, makes him want to look at what he is about to cause.

Fires

Italy's Lorenzo Mattotti relates one young naval officer's mutiny, following his return to nature on an island that the navy is sent to destroy. To save his paradise, he abandons his crew and ship, which sinks in an explosive inferno.

This sequence marks the point where he decides to desert. Mattotti's oil-pastel techniques harness the narrative power of fine art: the warmth and vibrancy of Post-Impressionism for the magical isle; the harsh mechanics of Futurism for the massive battleship; the distortions of Expressionism for the sailor's altered mental state. No clever homages, these shifts in style always serve the story as well as communicating atmosphere and feeling.

A Sailor's Story

Here is another young serviceman's record, this time the two-volume autobiography of 18-year-old American sailor Sam Glanzman, fighting the Japanese in the Pacific after Pearl Harbor. Although he omits his most horrifying experiences, Sam brings home the combat pressures and cramped conditions that he and the "tin can soldiers" faced serving on board the destroyer U.S.S. Stevens.

Here, even at quiet times, a small slip could leave a fellow seaman injured. In the other incident, Sam shows how eight long years in the navy push one man over the edge. As Sam discovers, life in the navy is "nothing like the comics or the movies."

Palestine in focus

Reporter

Among Joe Sacco's role models were such passionate seekers of truth as George Orwell, Hunter S. Thompson, and Vietnam war writer Michael Herr. Sacco's dreams of being a hard-hitting reporter turned sour, however, when he found himself stuck on a boring city magazine, hacking out advertorials. He quit and committed himself to another vehicle for his journalistic ambitions: comics.

Why comics? "The main benefit is that you can make your subject very accessible. You open the book and suddenly you're in the place." In this mixture of documentary and autobiography, we accompany Sacco into the unfamiliar territories of Israeli-occupied Palestine and make discoveries at the same speed as he does.

Here, Sacco takes us inside the prison and mind of a Palestinian detainee. When all speech and narration disappear, we are left with the awful silence of solitary confinement. In the next panel, sleep deprivation makes him hallucinate, conveyed by the unexplained body of his daughter lying at his feet. After all this, Ghassan is released without charge after 19 days.

Pressure

In "Moderate Pressure," Sacco sees for himself the fresh marks on the Palestinian Ghassan's back and wrists, after he was held without evidence on suspicion of belonging to an illegal organization. Sacco illustrates the innocent man's account of the physical and psychological techniques applied by Israeli security to extract a confession.

To convey Ghassan's claustrophobia, Sacco increases the number of panels on successive pages, making them smaller and smaller, going from four, six, nine, to twelve and here twenty.

The black background to this episode reminds us that blackness is all Ghassan can see when the urine-smelling sack is put over his head.

Interviewer

In spite of his exaggerated self-caricature and unappealing qualities, Sacco comes across as likeable, determined, and persuasive. All kinds of people open up to him, from Palestinian detainees and feminists to Israeli soldiers and American tourists. Self-aware without being self-righteous, Sacco manages to avoid being polemical or pompous.

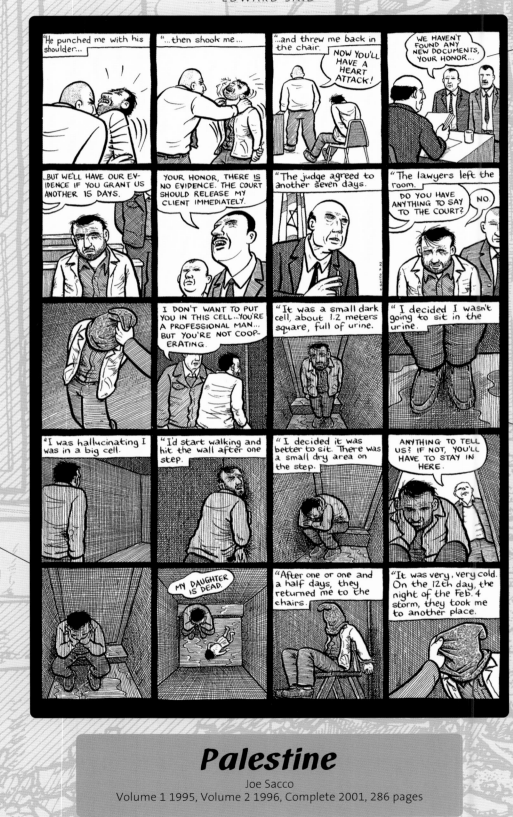

Palestine
Joe Sacco
Volume 1 1995, Volume 2 1996, Complete 2001, 286 pages

Palestine scene by scene

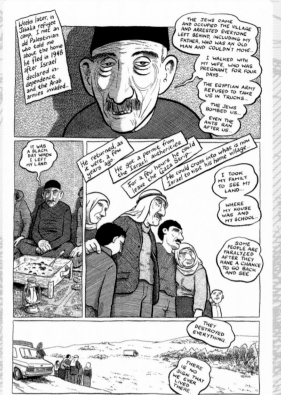

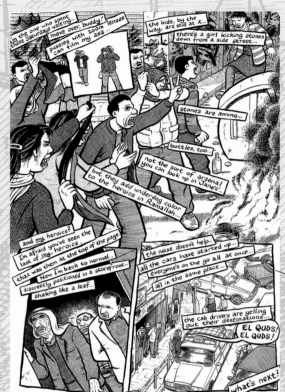

Injustice

Some of the most telling "straight-to-camera" accounts of injustice are the most simple, taking up just a single page. Here on the lefthand page, a family returns briefly to their home village, only to find it has been obliterated.

Always on the lookout for a strong story or photo—"It's good for the comic"—here Sacco ends up cowering in fear, when a street protest in Ramallah turns violent and Israeli troops move in.

Instead of keeping balloons and captions neat and horizontal, Sacco often lets them tumble across the page at all angles. This adds a feeling of urgency and disorientation, of being unstable, unmoored from normality, swept along in the rush of the moment.

Women's views

Here on the left, he tries to grasp what women think about wearing the "hijab," the veil that conceals their hair, and the outfits that cover all but their face and hands, as approved by the Koran. Their answers confound his expectations.

Sacco also brings in something of the Israeli perspective, for example here in a discussion with two women in Tel Aviv, who seem unwilling to give up the high ground, moral or otherwise.

Note that Sacco places his private thoughts in boxes in upper- and lower-case text, while dialogue is spoken in capital letters.

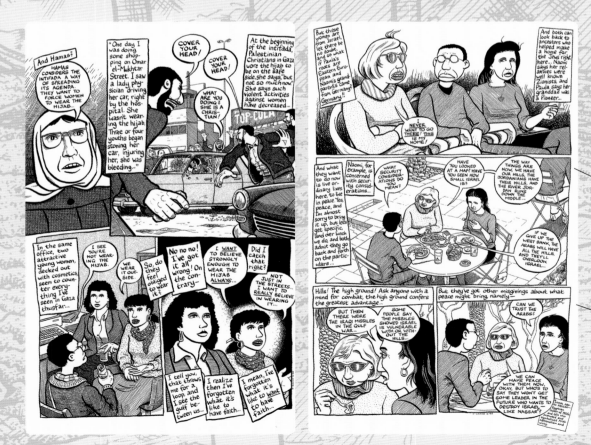

Following on from Palestine

Road to America

During Algeria's long and bloody struggle in the late 1950s to free herself from French rule, gifted boxer Saïd Boudiaf rises from his poor Algerian background to become champion of France aged 22. Saïd's win is not without controversy; here, when he arrives in Paris for the fight, he is subjected as an Arab to police brutality.

The French team of Baru and Jean-Marc Thevenet take a totally convincing documentary approach to this fictional sports icon, who finally cannot refuse to choose sides between the colonial oppressors and his countrymen's resistance movement. Baru fills his crisp, expressive lines with washes of subdued colors.

To Afghanistan and Back

During the attacks on the Taliban after 9/11, radical American cartoonist Ted Rall distrusts the mass media's propaganda and decides to spend two and a half weeks in Afghanistan, to witness for himself the effects of the bombing campaign on everyday existence. Rall finds great kindness, but is not prepared for the wholesale terror and resulting cynicism on both sides. Here, Rall realizes that he is part of a group of foreign journalists being hunted and killed for their money. The final straw comes when Northern Alliance thugs shoot a Swedish cameraman, and Rall knows how easily it could have been him.

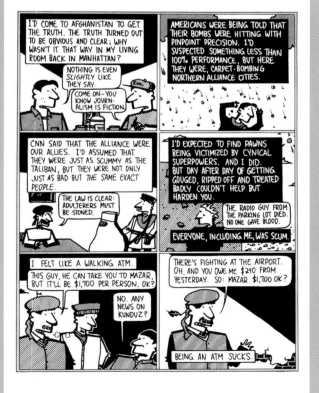

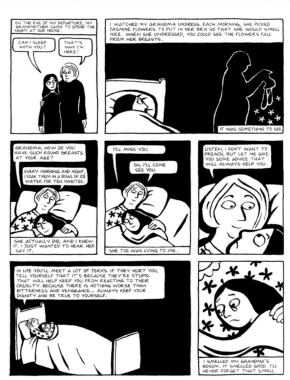

Persepolis

Politically aware from an early age, Marjane Satrapi grew up amid the Islamic Revolution and the outbreak of the Iran-Iraq war. She escaped Tehran to study in Europe, and later returned to Iran. In PERSEPOLIS, named after Iran's ancient capital, she tells her family's history and her personal growth, as she struggles in Europe and her native land to find some sense of belonging.

Here the young Marjane experiences the perils of demonstrating against fundamentalism in Iran, and spends her last night with her grandmother, before leaving the country. The bold simplicity of her woodcut-style drawings matches the directness and honesty of these memories.

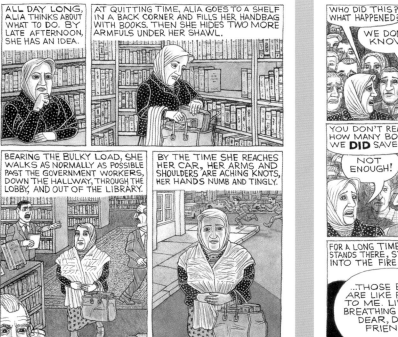

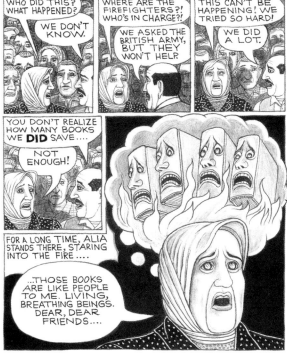

Alia's Mission

Alia, the devoted chief librarian of the central library in Basra, fears that irreplaceable books will be destroyed in the coming Iraq war. Her pleas for help from Saddam's government are ignored, so she starts to smuggle books out of the library under her coat, storing them in safe places. Soon her family, co-workers and friends are helping her.

When the library is hit and burns to the ground, Alia imagines the books as "living breathing beings." In fact, she and her cohorts have saved over 30,000 volumes. In his book based on a true story, New Yorker Mark Stamaty chronicles one woman's determination to save the printed culture of Iraq.

Little one.
We have always felt you close to us.
We will stay here and become forest.

Hayao Miyazaki, Nausicaä

The Superhuman Condition

Life behind the masks and disguises used to be a lot simpler for America's supermen and wonderwomen of the 1940s. Their "Golden Age" dawned in 1938, when Superman, the first of their kind, came down to Earth and walked among us as Clark Kent. Their costumes and adventures might come in many colors, but their moral spectrum was usually limited to black or white. They never had any doubt that they were the good guys, and gals, and that ultimately they would always triumph. They filled the role of a modern pantheon, that could answer an anxious public's longing for secular saviors to fight for them against crime and injustice on the streets and against the Nazis in a looming world war in Europe..

Not all Americans endorsed their country's entry into the Second World War. After their front cover showed Hitler being socked on the jaw by the flag-wearing Captain America in late 1940, his creators Joe Simon and Jack Kirby were flooded with hate mail and telephone threats from anti-war, pro-German agitators. Their attitudes were harder to shrug off when some of them started loitering menacingly outside their offices. Then a call came through from New York's Mayor LaGuardia himself. He praised Simon and Kirby for "doing a good job" and guaranteed their studio round-the-clock police protection. Patriotic champions like theirs were significant in convincing Americans to enter the war, months before the attack on Pearl Harbor in 1941. Part messiahs, part golems, it's no wonder that so many of these "superheroes" were fabricated by the city's predominantly Jewish comics industry.

Though quintessentially American, superheroes have roots that run deep, stretching through early 20th-century pulp fiction magazines like *The Shadow* and *Doc Savage* and 19th-century European fantasy fiction, back to some of the planet's great founding beliefs and legends, to individuals with exceptional gifts and cosmic responsibilities. Jacques Derrida has suggested, "We are by nature messianic. We cannot not be, because we exist in a state of expecting something to happen, awaiting the

arrival of someone whom we hadn't anticipated." These heroes also feed on our inadequacies and our aspirations to be superhuman, to exceed normal human ability or experience, to be something a little more than we are. Their reincarnation as colorful urban crime-fighters had real mythic potential, as became clear in their earliest forms as brief, brash entertainments and stirring propaganda. But what if they could be made to mean much more?

At first, for each issue to be instantly accessible to an absolute beginner, superheroes would usually operate in inconsequential short stories and isolated worlds, unaware of any others of their type, unaffected by any previous story's events, always restoring the status quo at the end of every case. It wasn't long before a few writers tried bringing their heroes together and telling serialized, multi-issue sagas. In 1943, Otto Binder was given a two-year, 25-part serial, "Captain Marvel and The Monster Society of Evil," modelled on the "Big Cheese's" Saturday morning cliffhanger movie serial. Binder's sinister secret villain Mr. Mind turned out to be a tiny green worm with spectacles and a voice amplifier. At 232 pages, it was the longest, continued and complete comic book story yet.

Gardner Fox, another workhorse from the science fiction pulps, imagined the ultimate exclusive club, The Justice Society of America, where some of the most popular heroes could finally meet each other. They would convene in book-length yarns as long as 58 pages, to pool resources in the opening chapter against that issue's mutual menace, then battle individually in separate chapters, before reuniting in the finale. Not all the JSA's menaces that Fox devised were super-villains; he also involved them in important social concerns, from juvenile delinquency to prejudice about race and disability. For example, "The Test of Time" in *All Star Comics* 22 sends the team on a time-travelling history of intolerance and the need for understanding. This story was written in response to a request from the Office of War Information and the Writers' War Board.

Right: The Justice Society of America from *All Star Comics* 22, Fall 1944, drawn by Frank Harry

Opposite: Superman ponders how much even he can do in *Peace on Earth*, art by Alex Ross

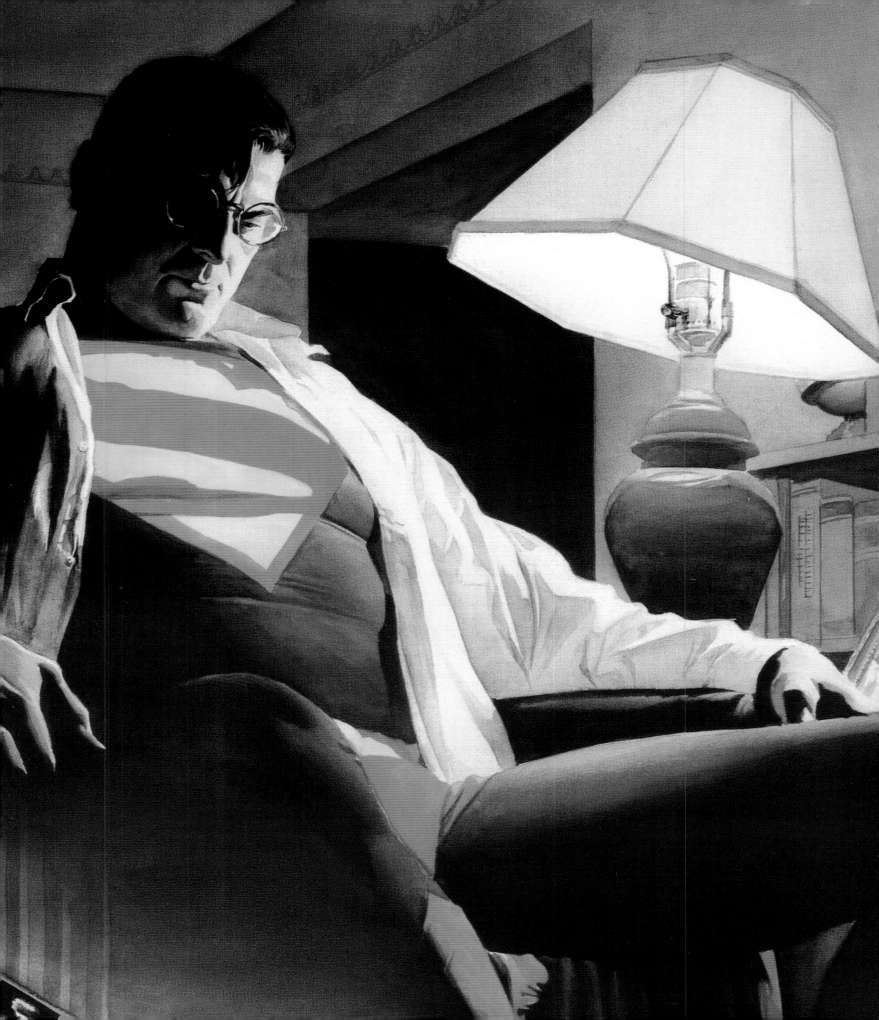

The Superhuman Condition

Right: *The Silver Surfer* soars to new heights in Fireside Book's first original graphic novel in 1978 by Jack Kirby & Stan Lee

Below: *Planetary*'s frosty Elijah Snow, mystery archeologist, art by John Cassaday

Opposite: *Promethea*, mystical embodiment of imagination, art by J.H. Williams III & Mick Gray

Superheroes dominated more or less half America's market during the war years, but rapidly lost their purpose and appeal in the post-war, Cold War climate. The public preferred to read about real men, not supermen, fighting the Korean War. Aside from perennials Superman, boosted by his television show from 1953 to 1957, Batman, Wonder Woman, and a handful of others, all the others hung up their capes and cowls. The genre accounted for no more than a meagre three to five per cent of the comic books for sale throughout the 1950s.

It was science and science fiction that engineered their revival by the early 1960s. Market leaders DC Comics tapped into the optimism of the space race and technological advances to invent entirely modernized versions of their lost properties The Flash, Green Lantern, Hawkman, and Atom, all clean-cut, well-adjusted adults. In contrast, the new, darker, misfit heroes at struggling competitor Marvel Comics resulted mainly from the bizarre side effects of radiation and mutation, drawing on their B-movie monster comics and the period's fears of an atomic war. While DC reintroduced their heroes' Golden Age counterparts, happy and well on a parallel Earth, Marvel's three most successful wartime stars returned to everyday New York: as the hot-headed teen The Human Torch in the *Fantastic Four*; as an amnesiac Bowery bum who remembers he is the vengeful ocean king The Sub-Mariner; and as a man out of his time, thawed out of an iceberg, Captain America.

The legends could now live on and their history could be added to that of a new generation of superheroes. Marvel's storytelling artists Jack Kirby, Steve Ditko and others with principal writer and overall editor Stan Lee began asking how unexpected, perhaps unwanted super powers might affect an individual's life. Wouldn't a young Spider-Man rather seek fame on television than take on the great responsibility of fighting crime? Wouldn't the orange, craggy Thing long to be his former human self again? Wouldn't a teenage mutant feel like a freak always having to hide his strange ability? Lee and his collaborators made the superhuman human. By situating all their heroes in

continuing soap opera melodramas set in the same interconnected "universe," they were building stories into histories, with the possibility of consequences and change. They turned every issue into part of a larger whole, of the expanding back-story or "continuity." Shrewdly, they were also attracting an older, hipper student audience and enticing readers into picking up every issue of every title.

Marvel's continuity meant that their stories mattered, but also resulted in stories never reaching an end, only a pause, in their ceaseless, momentum-driven spinning of yarns. By contrast, DC mostly preferred complete adventures, starting afresh each time, letting readers jump on with any issue. Notably, the 1960s *Superman* line specialized in "Imaginary Stories," whose attention-grabbing covers promised that the most unlikely or tragic plot twists would be inventively explored inside and taken to their logical conclusions. One of the finest was "The Death of Superman" in 1961. Jerry Siegel, appropriately the writer who first gave him life, relates his final, fatal adventure with such grace and depth of feeling, that readers can care and be touched by even an "Imaginary Story." Because, in a way, aren't they all?

Meanwhile, in the best soap traditions, Marvel superheroes fell in love, married and gave birth, lost and found loved ones and super powers, discovered unknown relatives and secrets from their past, all while saving the world. DC eventually adopted this approach too, and month after month, increasingly vast continuities were accumulating within their separate superheroic universes. But major characters are allowed to alter only by so much, because they are primarily commercial properties, recognizable brands, to be licensed and merchandized. This is why, in the 1970s, Stan Lee allegedly instructed his writers to convey only "the illusion of change" in all future stories. When Superman's death in 1993 sparked massive media coverage, six million copies of the comic book were sold, some bagged with a free armband. The public may have believed that this truly was the end, not another "Imaginary Story," but fans and collectors knew he would be back. Sure enough, some ten months later the original Man of Steel rocketed again from the grave, little changed apart from a cooler, longer hairstyle, which proved as temporary as his extinction.

A crucial element was missing from the stories of these immutable, immortal icons. English writer Alan Moore identified it as time. "All of our best and oldest legends recognize that time passes and that people grow old and die. In comic books, however, the characters remain in the perpetual limbo of their mid-to-late twenties, and the presence of death in their world is at best a temporary and reversible phenomenon." In two landmark graphic novels, *Batman: The Dark Knight Returns* in 1986 and *Watchmen* in 1987, DC Comics granted their acclaimed creators the rare opportunity to examine what superheroes might be like if change was not always an illusion and time caught up with them at last. In *Watchmen*, Moore and artist Dave Gibbons make the death of a superhero undeniably permanent from its front cover and opening page, where, fittingly, The Comedian has plummeted to the ground, blood splattering his yellow smiley button. In *Dark Knight*, "a good death" is a tempting prospect to an ageing Batman from the first page, where his alter ego Bruce Wayne decides that a blazing motor-racing accident is "not good enough." Both books are wound tight like watchsprings, set ahead in time, with time racing and an end ticking closer on every punctuated nine- or sixteen-panel grid. Even in these works, however, Miller's death of Batman is not terminal, while Moore and Gibbons had to invent replacements, when DC vetoed their plan to play with the pre-existing Charlton heroes.

Far from sounding the death-knell of the genre, the bestselling *Watchmen* and *Dark Knight* have sparked all kinds of responses ever since, for or against, imitative or innovative, in a so-called "Dark Age" of unprecedented questioning and experimentation. True, there were lazy creators who, rather than learning and advancing from the books' examples, pounced on only their grim, violent surface. Still, there were several who perceived the potential of exploring what might happen if, in the words of English writer Neil Gaiman, "all this dumb, wonderful, four-color stuff has real emotional weight and depth, and it means more than it literally means." In search of more Moores, the American publishers headhunted the British profession for talents like Gaiman. They set them to work, applying a bit of thought to their forgotten and forgettable properties, sometimes injecting them with unexpected nuances. Grant Morrison speculated on how fourth-rate hero Animal Man, unemployed and married with kids, might kickstart his career, become a vegetarian and animal liberationist, only to realize eventually that he is a character in a comic book. Over fifty years, various versions of Starman had never quite clicked, until James Robinson tied them together through a young, reluctant

successor who learns from his father. Perhaps there is no such thing as a "bad" character, just a badly handled one.

More avenues opened up by allowing creators to re-examine established characters' "origins," how they came to be, or formative adventures during their "Year One", and reveal unsuspected facets, hidden in the gaps between the panels, that do not contradict but enhance continuity. So, for example, Miller could introduce Stick, a mentor who trained the blind boy Matt Murdock to be Daredevil, or Matt's unseen mother, now a nun. Just when you think that there can't be anything new to say about these heroes, somebody finds another wrinkle. These days, because publishers want to offer a way in to the majority of the public, who discover their characters through television, games or movies, a superhero can appear in a plethora of series and spin-offs for different ages and tastes, as well as "Imaginary Stores," now called "Elseworlds." On top of this are the many other unofficial tangents, presenting barely-disguised facsimiles of the major hero franchises. As well as the sense of wonder in Kurt Busiek's *Astro City* or Alan Moore's *Supreme*, this strategy enables merciless satirists Pat Mills and Kevin O'Neill to skewer their famous targets in *Marshal Law*, while Warren Ellis and John Cassaday can send the archeological team *Planetary* to unearth suppressed truths. Can there be any other legends that have been embroidered by so many and for so long, up to sixty years or more, and continuing to this day?

More than ever, the superhero story is becoming "more than it literally means," such as compelling detective drama in *Powers* or personal allegory in *It's A Bird*. Having renounced the genre after Watchmen, Alan Moore has since returned to it in force in his own vast universe for the America's Best Comics line. Moore's epic intention was to create a vast, referential, reverential universe and guide it to its transcendent destruction at the hands of Promethea, his symbol of imagination, and beyond death into a cycle of renewal. Neil Gaiman in *1602* explains that superheroes are governed not by the laws of physics, but the laws of story. He has a past version of Mr. Fantastic observe, "We are in a universe which favors stories. A universe in which no story can ever truly end; in which there can only be continuances." Because the imagination, like the stories themselves, is endless.

The Dark Knight Returns in focus

"...probably the finest piece of comic art
ever to be published in a popular edition..."
STEPHEN KING

Vigilante

To Frank Miller, a 19-year-old country boy raised on comics, crime fiction and Catholicism in Vermont, moving to New York in 1976 was a rude awakening. He found that The Big Apple was no Gotham City. Muggings, robberies, murders were no longer on the printed page, but on his doorstep.

Miller recalls, "I had to adapt to survive and that involved some changes inside myself, changes which contributed to the macho fantasy of the street vigilante."

Miller found an ideal symbol for his fantasy in Batman, now aging, granite-faced, battle-scarred, his costume and stomach sagging. Here, Bruce Wayne resolves by the last panel to end his ten years of retirement. Nothing, not even the law, will stop him from taking his vendetta against criminals onto Gotham's mean streets.

Production

Impressed by the quality of French albums, Miller insisted on the best production values ever seen in American comic books: card covers, good paper and printing, and moody, fully painted colors by his wife Lynn Varley, which set new standards.

The Dark Knight Returns
Frank Miller with Klaus Janson & Lynn Varley
1986, 1 volume, 192 pages

Before his eyes

Nobody before Miller had made us feel so vividly the childhood tragedy that gave birth to Batman. Its every moment is branded onto Bruce Wayne's memory. Here, when the movie THE MARK OF ZORRO comes up on TV, it takes him back to the night, when, on leaving the cinema, he watched his parents get gunned down by a robber.

He stares, transfixed, not at the screen but at his memories, in slow motion, of the moment when the shot is fired and his mother's pearl necklace snaps. His switching stations doesn't help, with their reports of fresh crimes. Notice how the rapid "Klik"s of the remote suggest the sound of the scattering pearls.

Surprises

Miller uses a dense, four-by-four grid to instill claustrophobia and an adrenaline-pumping pulse. He interrupts this with full-page shots like the one above, nearly all over the page on the left-hand side, to maximize their surprise.

The Dark Knight Returns scene by scene

Supporting cast

Miller refreshes all of the supporting players and props too. On the far left, we see an injured Batman being driven home in his huge, tank-like Batmobile after a gruelling brawl.

Tending him is bright young Carrie Kelly, whose wish is to be the new Robin the Girl Wonder. The circular balloons carry the radio voice of Alfred, long-suffering Bat-butler, who has some of the funniest repartee in the book. Superman is also a major player, portrayed here as a government lackey.

Miller also satirizes the banality of television that intrudes into many scenes, here with a gang leader's rant and the President's address on imminent war.

The last laugh

Miller's Joker is a terrifying psychopath. On the far left, he has left a victim, Selina Kyle, bruised but alive. A former flame and villain Catwoman, she now runs an escort service—hence the kinky Wonder Woman outfit. Notice how Robin's mention of her friends at the county fair triggers Batman's momentary flashback, in one silent panel, to the young Bruce Wayne seeing his parents murdered.

With no Comics Code to rein him in, Miller has Batman almost kill The Joker, but finally pull back. Here, in an awful, last "twist," The Joker finishes the job himself, so that Batman will be condemned as a killer. In a manga technique, images like this suggest that time is bleeding off the page.

Following on from The Dark Knight Returns

Daredevil

Frank Miller rose to prominence on Marvel's lone blind man, who fights for justice as a lawyer and a vigilante. In THE MAN WITHOUT FEAR, drawn by John Romita Jr., Miller expands on the hero's growing years and inner turmoil before he put on the costume. Here Matt Murdock finds himself again in the ghetto where he grew up, and his heightened senses bring memories flooding back.

Most of all he remembers how he was bullied at school, and forbidden by his boxing father from retaliating. From this comes his nickname, "Daredevil," giving his eventual secret identity an extra relevance. Miller breaks the narration up by scattering caption boxes across the pages.

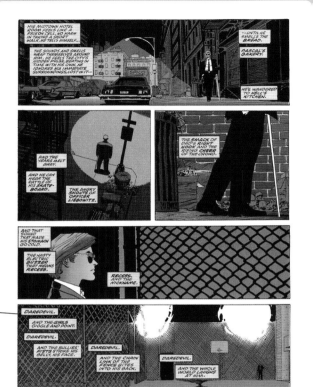

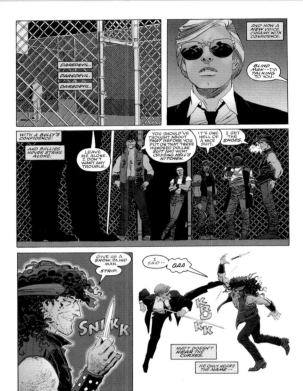

Weapon X

British-born Barry Windsor-Smith answers some of the questions about the man who became Wolverine, the wildest, hairiest, and most mysterious of the X-Men. In a visceral psychodrama, he shows how Logan's healing powers are perverted by heartless scientists to turn him into a killing machine under their control.

Here they monitor him, naked and feral, battling a snow leopard. Windsor-Smith uses his own painful recovery from a driving accident to convey Logan's ordeal at the hands of surgeons. Notice how he color-co-ordinates their voice-over commentary: green for the professor, yellow for Dr. Cornelius, pink for Miss Hines.

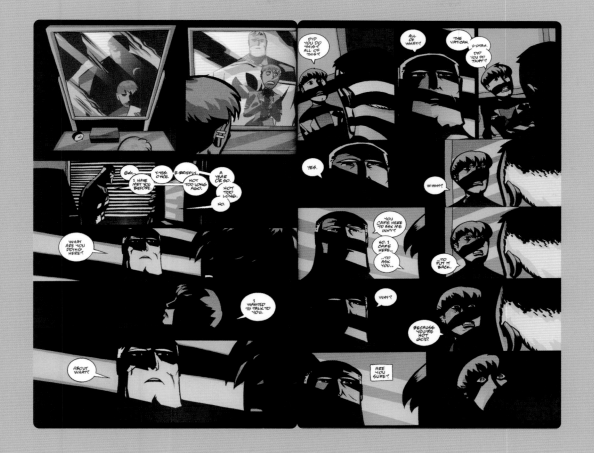

Powers

If you measure a hero's powers from one to ten, "level eight or higher, and we as a society are just praying they're good folks." Supershock, the sad Superman in "The Sellouts," goes off the scale, and off the rails, when a fellow team member's sex scandal pushes him to murder and revenge against the world.

Here Supershock suddenly appears to specialist homicide detective Deena Pilgrim, who hopes to reason with him. Writer Brian Michael Bendis has an ear for naturalist dialog and timing and with artist Michael Avon Oeming's bold cartooning infuses the genre's spectacle with a noir grittiness.

It's a Bird

Is there anything left to say about Superman? Scripting tales of invulnerability rings hollow to comic book writer Steve, when an incurable disease threatens to claim another generation of his family. Through his eponymous, blocked author, Steven T. Seagle challenges the clichés and paradoxes of the Superman myth with artist Teddy Kristiansen.

Here, Steve is infuriated by Kryptonite, the Man of Steel's weakness. It reminds him of how arbitrary their genetic disorder is and the day it took his grandma. He is a boy again, distracted from the unread balloon in his SUPERMAN comic, because he can overhear his father whispering the family's strange new vulnerability.

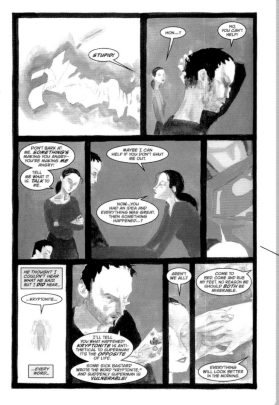

Watchmen in focus

> "Moore's writing is remarkable. He catches the rhythms of speech so naturally, presents his world so seamlessly, that the whole seems effortless."
>
> NEIL GAIMAN

Watch closely

Timing is a central theme and mechanism. The grid of nine uniform panels on each page allows you to follow the fine-tuned passage of multiple stories moment by moment. Panels tick by like a metronome or a timebomb, counting down to midnight. Several different stories interweave on the same page, setting up visual and verbal links and counterpoints.

The first panel here shows the climax and lurid treasure-map captions from a pirate comic, through the eyes of a black youngster reading it. His reverie is interrupted by the lonely newsvendor's complaint, which echoes the image of a reaching hand.

Who are they?

Moore and Gibbons dreamt up their own archetypal superheroes: the near-omnipotent superman, the perfectly evolved man, the wondrous woman, the ordinary man gifted in science, the vengeful vigilante, the patriotic soldier. Then they gave them a long history and psychological depth.

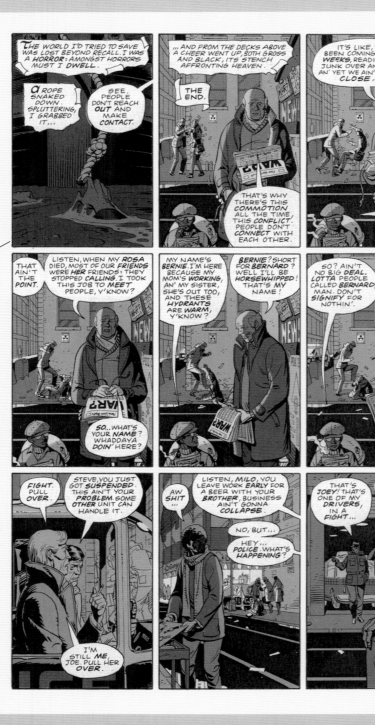

Watchmen

Alan Moore and Dave Gibbons
1987, 1 volume, 398 pages

Multiple levels

This scene is set at the newsstand and junction, which become the crossroads anchoring several narrative threads. In the foreground, the newsvendor and his comic-loving young customer struggle to connect over the next five panels shown from a fixed point of view. Meanwhile, a conflict between two lovers breaks out behind them, which then draws in other secondary characters. As the kid says, with comics this multi-layered, you "gotta read 'em over" to "make sense."

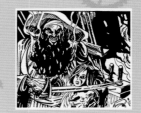

Why pirates?

The TALES OF THE BLACK FREIGHTER comic book is a nod to Bertolt Brecht and Kurt Weill's Pirate Jenny from THE THREEPENNY OPERA, as well as Bob Dylan's song. This approaching deathship parallels the catastrophe to come. It also rewrites comic-book history by showing lurid swashbucklers becoming the staple genre instead of superheroes. After all, if superheroes were real, why would you want to read about them in comics?

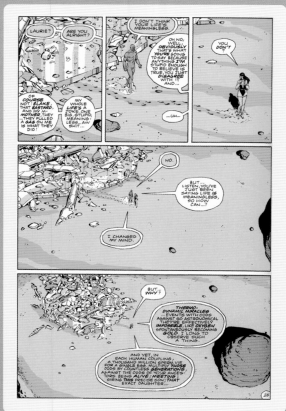

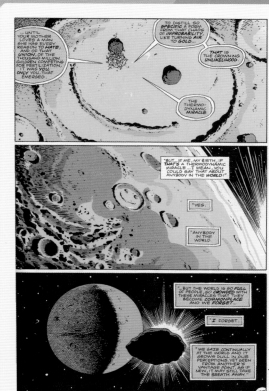

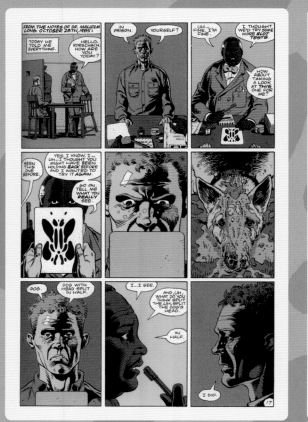

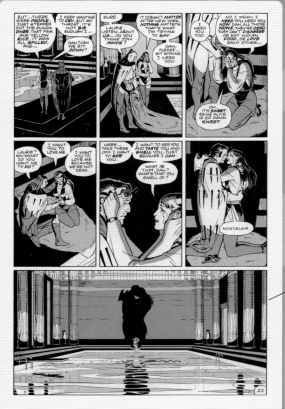

Potent symbols

WATCHMEN is full of recurring symbols and shifts of perspective. Here on lifeless Mars as we pull away, the nine panel grid dissolves into three wide-screen panels to reveal a crater shaped like The Comedian's "Smiley" badge which opens and closes the book.

This change of viewpoint reflects the crucial change of mind in this scene by the blue-skinned Dr. Manhattan. His extraordinary powers to read atoms and see across time and space have made him alien to his wife Laurie, but enable him to marvel at the "thermodynamic miracle" of Laurie's birth, and of "anybody in the world."

Notice how Dr. Manhattan's speech appears in blue with an extra outline to convey his very different voice and worldview.

On the left page, psychiatrist Dr. Malcolm Long finds out what pushed Walter Kovacs over the edge to become the vigilante Rorschach. Almost as dreadful as the child-murder Kovacs relates is the spiritual death he causes in Long, who is dragged down into Kovacs' nihilism, losing his wife and job.

The story climaxes with a devastating attack on New York (eerily prescient from a post-September 11 perspective). After seeing this horror, Laurie finds comfort and meaning making love to Dan. This moment of life-affirming grace fills a wide, wordless panel. The shadow they cast is another recurring symbol, invoking the Hiroshima shadows, silhouettes imprinted on surfaces by the force of atomic explosion.

Following on from Watchmen

Astro City

Welcome to another busy day in the life of Samaritan, the equivalent of Superman in this metropolis, where mortals and marvels live cheek by jowl. The goal of writer Kurt Busiek, with artist Brent Anderson, is to show us "not what it would BE like if superheroes existed in our world, but what it would FEEL like if we could wander through theirs."

Here, Samaritan juggles with the pressures of his human guise as a magazine editor and the incessant call of duty. Being Samaritan has its price: he has no time for friends, for love, and can hardly spare two seconds to reassure a little girl. How does a hero cope knowing that he can't save everybody?

Marshal Law

Not for the easily offended, this bleak satire by Britishers Pat Mills and Kevin O'Neill envisions an America overrun by false, decadent superheroes, whose corruption is finally punished by the aptly named Marshal Law, a "fascist cape-killer," who seems little better than the scum he hunts down.

Here the body of serial murderer Sleepman's latest victim falls past the windows of the block's oblivious residents, as they are regaled by TV hype for their beloved Public Spirit. How will the masses react if Marshal Law exposes this ruthless hybrid, part Superman, part Captain America, as a murderer?

Promethea

Schoolgirl Sophie Bangs is the latest in a long line of hosts of Promethea, the female embodiment of imagination, who promises to bring the end of the world. Before this takes place, however, her quest through the ten levels of the Kaballah exalts the magic of art to create something from nothing.

Here, Promethea tells a former boyfriend of the wonders she will perform, not in punishment, but by a timeless enlightenment. Alan Moore's visionary epic is illuminated in a variety of apt palettes and artistic homages by J.H. Williams III and Mick Gray. As here, the majority of pages are read as inventively structured, "wide-screen" spreads.

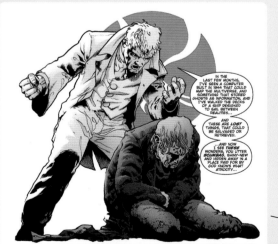

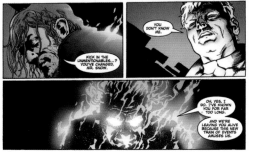

Planetary

Three mystery archeologists are determined to expose the secret history of the 20th century's scientific wonders, denied to mankind and thought to be merely the stuff of fantasy. In this conceptual conspiracy theory, the alien baby that would have become Superman is shown far left being incinerated upon landing.

Here Planetary's Elijah Snow corners the culprit, one of The Four (a nod to Marvel's Fantastic Four), scientist gods who since 1961 have been keeping our world mediocre. Warren Ellis and John Cassady rewire the popular culture of the past, from James Bond and Doc Savage to Japanese rubber-suited monsters.

Of Futures and Fables

The fantastic and the futuristic seem perfectly suited to comics, because the only limit on visualizing the impossible in pictures and words, and on outdoing Hollywood's biggest special effects budget, is the author's imagination. That is why you never know in comics where dreams, or dreams of science, can take you. Sleep sends Little Nemo, the great serial dreamer of the funnies created by Winsor McCay in 1905, to a tantalizing other life of adventure in Slumberland, where he can never stay longer than one night. Roused from his reveries, Nemo is a nobody again, a momma's boy, home in his safe, boring bedroom. Comforted by his secret, he waits for night to come and steal him back to Slumberland.

Not every fantasy character in comics has Nemo's luxury of finding himself restored to normality. When a peculiar gas puts First World War fighter pilot Buck Rogers to sleep, he wakes up unchanged five whole centuries later to find the world ravaged by another war fought with startlingly advanced technology. Nerdy David Ellis Norman, intent on tracing his missing uncle, follows his plans to build an electrical gateway. Stepping through it into Neverwhere, David is transformed and lives as never before as the naked, virile warrior Den. Pacifist Alcide Nikopol is preserved in suspended animation and incarcerated in space, only to be revived after three decades into a bizarre new existence, possessed by an alien on the run. In the same way that these ordinary humans are thrust into extraordinary circumstances, readers can also lose themselves by stepping into the panels of comics and lingering within their unknown worlds. Transported there temporarily, each of us can be a Little Nemo, knowing we can always get back to reality.

Comics are part of a long and fruitful synergy between science and fiction in all its forms, each inspiring the other. Writers speculate on the latest discoveries and theories and experiment with their repercussions in stories, wildly exaggerating or sticking within the broad bounds of plausibility. From the far-sighted 19th-century French novelist Jules Verne, who predicted such marvels as cars, submarines, and rockets to the moon, to some of today's graphic novelists monitoring cutting-edge research, they offer us glimpses into the best and worst of all possible worlds. As the new 20th century rushed forward and make-believe inventions became everyday newfangled wonders, America's science fiction and fantasy pulp fiction magazines of the 1920s and 1930s were well-springs of the newspaper strip and comic book industries, of many of their principal founders and contributors, and of their earliest fantasy archetypes like Tarzan, John Carter of Mars, Conan the Barbarian, and Buck Rogers. Buck, originally Anthony Rogers, rocketed to life in a short story written by Philip Nowlan in a 1928 issue of *Amazing Stories*, but it was through the

JEAN-CLAUDE FOREST / LE TERRAIN VAGUE 1964

newspaper strip written by Nowlan from 1929, and the radio and movie serials, that Buck reached millions. His name entered the dictionary as the byword for all things futuristic. To author Ray Bradbury as a boy, "*Buck Rogers*, now, was the coming reality, fantasy with a vengeance, dreams suddenly peeling off the bedroom wall into three dimensions that moved, re-created themselves, and became yet further dreams."

Tapping into this fever of anticipation, science fiction became a staple of the comics, some of it from the pens of the genre's celebrated authors. However wildly fanciful their galactic operas of ray-guns and bug-eyed monsters became, the writers of *Buck Rogers* and others would sometimes take advice from scientists on how their imaginary inventions might really work. The more space technology advanced, the more vividly accurate artists became, notably England's Frank Hampson on *Dan Dare, Pilot of the Future* and Hergé in Belgium on Tintin's moon trip, the two of them launched in 1950 at the dawn of the space age. Hampson and Hergé relied on scientific advisors (Arthur C. Clarke, author of *2001: A Space Odyssey*, assisted during *Dan Dare*'s early missions), and a staff of assistants to produce the most realistic renditions in comics so far of space exploration.

Of Futures and Fables

Above: Arzach and his winged companion survey their prey, in his 1975 debut by Moebius

Opposite above: Enki Bilal's Jill Bioskop, a reporter of the future with blood on her hands

Opposite below: Mike Mignola's Hellboy defends humanity against the monsters of legend

Renowned novelist Isaac Asimov was convinced that comics had played a key role in priming the public for the rapid advances in technology during the 20th century, by presenting "a dilute science fiction to all levels of the population. The concept of scientific advance became a dim part of the general consciousness, therefore, so that when the time came, for instance, to reach the moon, enough romance had been created around that theme to make the concept acceptable to the general population." The ability of comics to explore and expand on all kinds of theoretical concepts has also fed back into the minds of scientists, architects, and designers. For example, the fact that Japan is so advanced in robotics stems partly from their experts' childhood passion for robots in comics. It's no surprise that they hire comic artists to design how their robots look. It's as if the future is being invented and made tangible to fulfil these imaginary predictions.

One prediction, the science fiction graphic novel, was made in 1941 by American pulp and comics writer Otto Binder, who foresaw that comic books, "by a process of evolution another year from today, may see 60-page stories comparable to your favorite novelettes by science fiction authors, with pictures telling the story instead of [just] words." In the 1950s, authors like Binder and Bradbury had their short stories adapted into comics, but steps towards more sophisticated SF graphic novels aimed at adults properly began in France with the publication in 1964 of *Barbarella* by Jean-Claude Forest. His voluptuous blonde heroine recalled America's cheesecake beauties from the simplistic *Planet Comics* of the 1950s like Mysta of the Moon, Futura, or Gale Allen, except that Barbarella was no vamp or victim, but a strong, sensuous, independent woman in her own right, a Brigitte Bardot in space, a symbol of the decade's sexual revolution. Forest started serializing Barbarella's exploits in 1962 in *V*, a naughty quarterly magazine for Frenchmen, where he combined an eroticism (daring at

the time but quite innocent today) with witty dialog, conceptual flare, and literary allusions. This unique concoction became the first luxurious hardback collection of comics from Eric Losfeld, until then a publisher of surrealist writers. *Barbarella* became a *succès de scandale* in France, banned from being publicized or sold to minors, appreciated by adults for its poetic, pop art intelligence. In 1966, the book was translated by bold literary mavericks Grove Press in New York, and two years later adapted by Forest and Roger Vadim for the big screen.

Barbarella can be seen as a harbinger of what became, in the wake of May 1968, a French revolution in *bandes dessinées* or comic albums for adults. Losfeld went on to publish more, including *Lone Sloane* in 1966, in which the young debutant Philippe Druillet detonated orderly panel conventions in favor of warped layouts and vistas bursting across whole pages and spreads. Druillet contributed to *Pilote* magazine from 1972, where he joined Moebius, Jean-Claude Mézières, and Enki Bilal and found that they shared an enthusiasm for the new worlds of modern science-fiction literature and the artistic license of American underground comix. Eventually, Moebius, Druillet and others clashed with *Pilote*'s limited freedom and quit in 1974 to found their own magazine, *L'Echo des Savanes* ("The Echo of the Savannas"). A year later, Moebius and Druillet united with young writer Jean-Pierre Dionnet and one other to launch the slick, rebellious SF comics magazine *Métal Hurlant* ("Screaming Metal"). Moebius fully flowered here in the painted flights of the silent *Arzach* on his pterodactyl and the unravelling arcana of *The Airtight Garage*.

Métal Hurlant had an energizing effect on the medium, not just in France from 1975, but via 12 different translated editions, including an American version since 1977 retitled *Heavy Metal*. This network of glossy, color newsstand magazines and graphic novel collections propagated the French masters alongside an inspiring wave of multi-national talents, like America's Richard Corben and Britain's Angus McKie. The timing could not have been better. The release of *Star Wars* in 1977 brought science fiction back with a bang, while the rediscovery since the 1960s of *Lord of the Rings*, Robert E. Howard's *Conan* and others had established a market for fantasy and "sword and sorcery." American and British book publishers eyed the opportunities for novels in comics form, but it took time for the format and content to gel. Despite the lousy pay, American comic book artist Gil Kane jumped at the chance of an eight-book series of fantasy comics in paperbacks for Bantam Books in 1971. Kane completed two volumes of *Blackmark* and pencilled most of a third before the project was dropped after the first

book underperformed. Its cramped size, typeset text, lack of color, and uniqueness in the market didn't help.

Publishers and punters preferred the larger, "European" art book size, which displayed the illustrations better, as in the first book compilations of Hampson's *Dan Dare* (1979), George Metzger's *Beyond Time and Again* (1976), and Corben's *Neverwhere* (1978). Securing big-name authors, though, by adapting their classics or paying for brand-new stories, seldom clicked, especially when their prose was left uncut, deforming comics into overdone picture books. Premier *Star Wars* comics artist Howard Chaykin labored on his share, and also on more engaging original graphic novels written by Samuel R. Delany and Michael Moorcock, but it was when he was given total writer-artist control that he found his voice, in his barbed satire *American Flagg!* from 1983.

Darker, stranger, more complex strains of SF literature gradually began to be reflected in SF comics. Working for most of a decade from a wealth of influences, Bryan Talbot conceived the three-part *Luther Arkwright*, Britain's first epic graphic novel. Talbot was one of a generation of British talents from children's comics and the underground press who proved that the future was no longer what it used to be in the weekly *2000AD*. In what was a surprisingly ironic, grim-witted read for a supposed boys' comic, Judge Dredd stood out from his debut in 1977 as an arresting, coldly efficient futurecop. His violence avoided being dubbed gratuitous because it was inflicted by an officer of the law, in the name of the law. Gaining popularity during Margaret Thatcher's years as prime minister, Dredd seems to appeal to polarized readerships, who recognize him as either the nightmarish extreme of police state brutality, or the best way to combat crime.

It's an example of the power of much science fiction to comment on current concerns by extrapolating them into the future or to other worlds. Man's next step in evolution as *Akira* and the ecological heroine *Nausicaä* are

two Japanese cautionary masterpieces, both begun in 1982 and later animated by their creators. The soaring cityscapes of Belgians Schuiten & Peeters and the alien ethnic diversity of Carla Speed McNeill take us to tomorrows that are fragile, wondrous, and alive. Nearer to home, *Y: The Last Man* picks a single Wyndham-esque hypothetical, the end of all male life, and runs with it.

In recent years, comics creators in America have enjoyed greater freedom to tread fresh paths of fantasy, and this has resulted in some unusually rich, pleasurable storytelling. *The Sandman* was a failed DC Comics property in limbo, so there were no expectations when a novice comics writer from Britain turned him into a pale, shrouded Lord of Dreams. Neil Gaiman recalls, "There is a joy to being allowed to create something, while you don't know what you're doing. The joy of *Sandman* was the freedom to fail." Out of this, Gaiman and his artistic collaborators wove a seven-year tapestry of tales of gods and humans, spinning it carefully through to its end. Its ongoing success in book form helped foster the more experimental Vertigo imprint and an openness in the field to finite artistic statements. This supportive climate has nurtured remarkable works, like the warm, wise *Bone*, self-published by Jeff Smith over a dozen years, or Mike Mignola's *Hellboy*, a hornless demon in a trenchcoat.

Fantasy and SF graphic novels are often accused of copying movies, but the opposite is more commonly true. It's no secret that film-makers have been more or less officially exploiting the visions of comics creators for decades. Bilal was told by director Michael Mann that "all the albums of French BD artists like Druillet, Moebius, Mézières, and myself were lying around every American studio." Perhaps we can look to modern graphic novelists, free and idiosyncratic, to go on bringing us previously unimagined fantasies and reinvigorating populist folklore in pen, paper, and pixels.

The Airtight Garage in focus

> "I have been impressed and affected by Moebius's keen and unusual sense of design and the distinctive way in which he depicts the fantastic."
>
> GEORGE LUCAS

Another side

Can there be a more amazing transformation of an artist in comics than Jean Giraud? By 1973 he looked all set for a lifetime career drawing the classic French Western hero Lieutenant Blueberry. But there was another side to him, longing to break free from the shackles of literalism and all his personal history.

When he had started a decade earlier to create surreal, humorous tales he re-imagined himself, adopting a new pen name, Moebius. An apt choice, because it is also the name of a 19th-century German mathematician, who devised the intriguing "Moebius strip." This is a strip of paper, twisted and joined to form one continuous, one-sided surface. It seems as strange and unearthly as some of the strips that the new Moebius would now develop.

Moebius brought to science-fiction comics such a rich sense of alien places and cultures, all the way down to food, furniture, and clothes. Here, he gives the incidental "exo" Mikey a touch of individuality as a grouchy intellectual from this society's underclass.

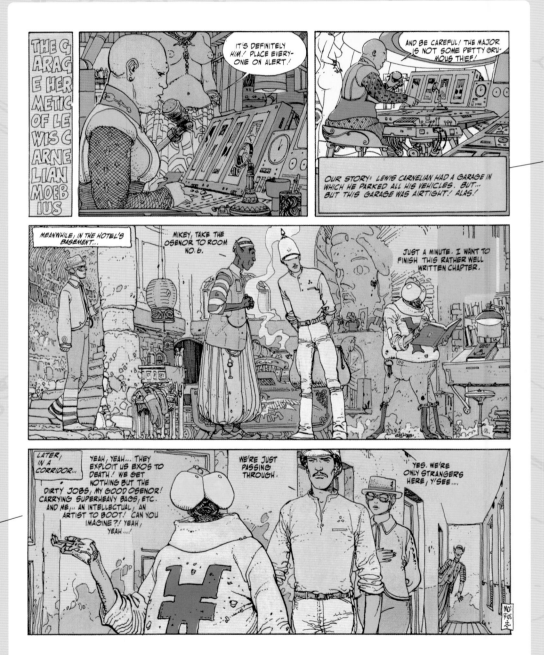

Our story so far

Why stick to the same old, overfamiliar plots? Moebius prefers "the creativity of surprise," like free jazz or ad libs, spinning off onto detours, dead-ends and deviations to keep the reader and himself constantly off-balance.

Originally serialized, first at two pages a time, many episodes open with a summary, which can be as puzzling as the events themselves.

Here we cut from the sinister president in fishnet and earrings on his trail to Major Grubert, dressed like an old colonial explorer, and Okania, as they are escorted to the mysterious Room Number Six.

Name games

When it ran in the French magazine METAL HURLANT starting in 1976, the serial was titled THE AIRTIGHT GARAGE OF JERRY CORNELIUS, an in-joke alluding to the character created by Michael Moorcock. In the 1987 color translation, Moebius changed the name to the similar-sounding LEWIS CARNELIAN (perhaps a nod to ALICE author Lewis Carroll, while carnelian is a red, translucent gemstone).

The French title has a playful double meaning, because "hermetique" means both airtight and impenetrable.

The Airtight Garage
Moebius (Jean Giraud)
1976–79, 1 volume, 120 pages

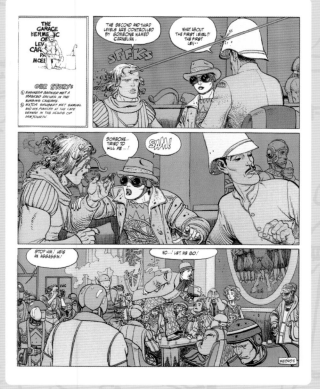

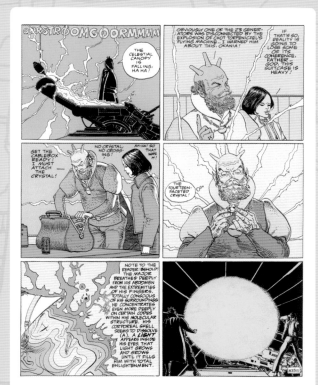

Levels

Unchaining the stuff of the unconscious mind, Moebius, like his helmeted hero Grubert, is operating here on a variety of levels. Far left, before he can report on the first level to the Major, Samuel L. Mohad is shot in the head. Notice that, as he is an android spy, his blood runs green. In fact, Sam does not "die" until several panels later.

Graad, left, three-horned, bearded keeper of Room Six, and Okania's father, helps Grubert gain access to the first level with a crystal. Moebius adds some bizarre touches to this scene, such as his long, crazy sound effect in the first panel, and the "(A)" footnote to pinpoint Grubert's dissolved body.

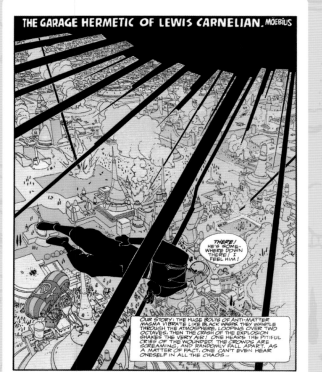

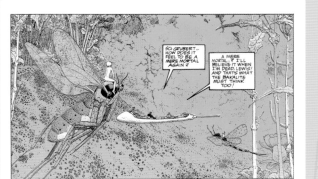

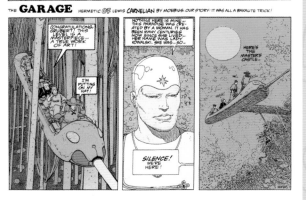

In a graphically arresting whole-page image, far left, we finally meet Lewis Carnelian floating on high, while black "sky cracks" ravage the city below. He can sense that the Major has arrived, in fact in a similar form to his own but in white. These aerial, costumed figures are part of Moebius's very personal homage to superheroes.

In the final episode, left, Lewis and Grubert are transported to a paradise of giant plants and insects. Moebius gathered together all the threads in the last 15 pages, created in one sitting. By leaving the story open-ended, as Grubert flees to our reality, he shapes a story as cyclical and unending as the paper loop of a Moebius strip.

Following on from The Airtight Garage

Luther Arkwright

Time is being distorted, allowing revolutionary Oliver Cromwell to keep control of England. Now, after three centuries of puritanical oppression, Nathaniel, the latest in the Cromwell dynasty, is sinking into debauchery. Disgusted zealots from his ranks plot to kill him. Notice the political hoardings and arrest in the background.

Psychic temporal agent Luther Arkwright has been sent to bring this reality into accord with the future. Here he aligns himself with Anne, heir to the throne, who bears his child. Bryan Talbot's dense, intense work of English historical science fiction proves as multi-levelled as reality itself.

Finder

One of author Carla Speed McNeill's concerns about the future is the dehumanizing impact of technology's quest for ever more stimulating escapism. In "Talisman," a vanished book read to her as a child makes Marcie long to learn to read it for herself. Reading is a dying art when people can hook up to her mother's wired imagination.

For the ultimate sensory experience, Ayo and thousands of workers like him are happy to be packed in "like a cocktail weiner," if they can go to Elsewhere, the mindscape of Magri White. In "Dream Sequence," McNeill weighs the price of passive consumerism and unused creativity.

Following on from The Airtight Garage

Nausicaä of the Valley of Wind

A great tidal wave or "daikaisho" has shrouded the pollution-wounded earth in gigantic mushrooms exhaling poisonous miasma. Their guardians are giant insects, or "ohmu," and here Nausicaä rides and communes with one. By staring into its deep blue eye, she comes to understand their healing role. Will Nausicaä, a chieftain's daughter wise beyond her years, embody the prophecy of an environmental messiah?

Deeply concerned about ecology, Hayao Miyazaki animated his manga saga in 1984. Nausicaä is named after a brave princess from Homer's ODYSSEY.

The Invisible Frontier

In an elegant blend of Jules Verne and Franz Kafka, the trained architect François Schuiten and author and historian Benoit Peeters, both from Belgium, imagine strange, allegorical cities.

Here, the ambitious new marshal of Sodrovno-Voldachia arrives on a vast dirigible at the country's neglected cartography center. His orders are for them to re-draw the official maps to extend the nation's frontier. But could his conquest by geography be undone by the secret map found on a young woman's body? Though alluding to the former Yugoslavia, Schuiten and Peeters keep their retro-future tale intriguingly enigmatic.

The Nikopol Trilogy in focus

"Before Enki Bilal, directors like Orson Welles or Wim Wenders impressed me with their remarkable aesthetics, playing with beauty and gentleness, and with a dirty, damaged, run-down world. They are true visionaries, and Enki Bilal is their equivalent in comics."

PIERRE CHRISTIN

Who is Nikopol?

Time is on his side. Alcide Nikopol is a man who fell to earth after orbiting in suspended animation imprisoned in space for desertion. His "miserable mortal life" alters radically when he is revived, injured but unchanged, 20 years later in a world where everyone else has aged.

His missing leg is replaced with a metal graft welded by Horus, a naked, falcon-headed alien renegade, who looks like his namesake, the Egyptian god. Nikopol can no longer call his life or his body his own because Horus needs him to act as his instrument of revenge against his fellow gods.

Here, Nikopol and Horus inside him communicate by thought. Note that Horus's mental comments appear in rectangular balloons.

Influences

The son of a Bosnian father and a Czech mother, Enki Bilal's baroque, overwhelming visions derive in part from his childhood in the Yugoslav capital Belgrade, living in the shadow of communism and the Second World War. Moving to Paris in 1961, he was inspired by film directors like Andrei Tarkowsky whose films include SOLARIS and STALKER.

Confusion

Gods, and men, are in chaos. Disoriented and on edge, the possessed Nikopol stumbles through the sickly streets of Paris, where he is suddenly spotted by a bearded stranger guarding a grave. It's a shock for him to learn that Clementine, the woman he loved, has died and given birth to their son, also named Nikopol, who is now about his age and virtually his twin, hence the confusion.

Bilal surrounds his hero with sordid goings-on in the backgrounds, teeming with mutated inhabitants, signs and graffiti. The giant broken shells are debris from the bizarre terrorist "egg war."

Trilogy to film

Bilal took 12 years to complete his trilogy while working on other projects, including directing his first film. The trilogy began with GODS IN CHAOS in 1980, his first solo graphic novel. He returned to it in 1986 with THE WOMAN TRAP, and completed it in 1992 in COLD EQUATOR.

In 2004 he directed his third film, condensing part of the trilogy, shot entirely using "blue screen" digital art for the sets and for the aliens. Its title, IMMORTEL (AD VITAM), translates as "immortal (for life)."

The Nikopol Trilogy

Enki Bilal
Vol. 1 1980, Vol. 2 1986, Vol. 3 1992, Complete 2002, 176 pages

Appearances

Global power politics have devolved into a bizarre circus. Here, on the far left, in a bid to seize power, Horus, inside the body of Nikopol, has infiltrated the chambers of the governor of Paris, Choublanc (French for loser), who is painted in his honorary make-up.

Horus's appearances are not always so deceiving. Here he has trouble manipulating another human, while dining on a train with Jill Bioskop (Serbian for cinema). She can't help noticing her partner's altered behavior, the presence of Horus indicated by the blue light. The blue-haired reporter Jill types her story in white-on-black captions. Overhead fly Nikopol and the cat Gogol, tracking them both.

Far left, Nikopol, Horus and Gogol look on as Jill's masked, murdered protector miraculously reappears to save her with memory-scouring pills. Here the narration is by Nikopol to Jill, who become lovers after they flee Berlin for Cairo. Notice how the cat under the shower reverts to his green and white stripes.

Later, in Africa's Equator City, Jill and Nikopol's identical son cross paths, while they watch a big-screen broadcast of the chess-boxing world championship. Nikopol senior achieves his dream of winning the title by being possessed by Horus. It's a payback for his services. Nikopol is also given a new, blank memory and a bittersweet sort of immortality.

Following on from The Nikopol Trilogy

Akira

Destructive psychokinetic forces are mutating the children of Neo-Tokyo after World War Three. The most terrifying of these is Akira, whose energies are being contained by The Project, a covert government operation, until the presence of a potentially even more powerful boy, Tetsuo, awakens Akira here with devastating results.

In this mammoth opus of over 2,200 pages, Japan's Katsuhiro Otomo harnesses his precision drawing and measured, relentless pacing to turn his manga into a widescreen, "sensurround" experience. In fact, before he had finished the manga, Otomo directed an animated version in 1988 which led to the graphic novel being translated worldwide.

America

Towering over the shattered Statue of Liberty, her torch broken, stands the Statue of Judgement, a symbol of judges like Judge Dredd, whose iron rule of law has erased the rights of all Mega-City One's citizens. But a few refuse to be intimidated, like young America. Puerto Rican and named after the American dream, she dares to protect her friend Benny and answer back. In adulthood, America becomes a hooker and a rebel political agitator, while Benny achieves celebrity as a singer. Their paths cross again tragically through her terrorist activities in this timely warning about the loss of civil liberties by writer John Wagner and artist Colin MacNeil.

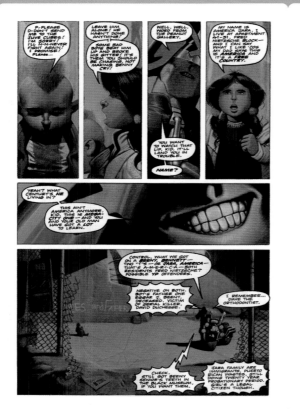

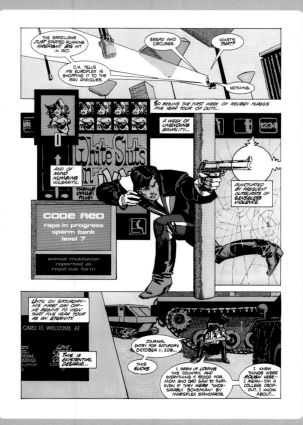

American Flagg!

What can one man do? A has-been video hunk and patriot raised on Mars, Reuben Flagg is in despair after only one week on Earth as the new deputy Ranger, policing the corporate-run madhouse of Chicago in 2031. Here, Flagg guards the mayor at a Jewish society wedding, with firearms as gifts and a tank made of chopped liver, till the event degenerates into a shootout.

Introduced in 1983, Howard Chaykin's satirical projections of a violent, TV-saturated, death-and-sex-obsessed, amoral wasteland seem rather prescient. The media's excesses buzz around Chaykin's fractured layouts in letterer Ken Bruzenak's swarms of logos and icons.

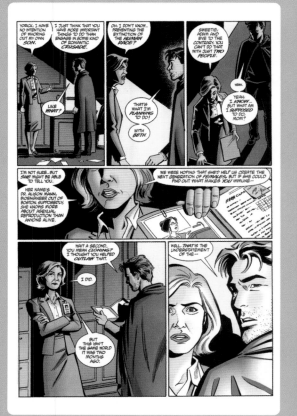

Y: The Last Man

Women rule, now that all men are dead from a "gendercidal" plague. All except Y, as in the "Y" chromosome and the question "Why?," real name Yorick Brown, young American, amateur escape artist, maybe the last man alive and the last hope for the future.

Here, instead of naively expecting to repopulate the planet with his girlfriend, Y gets directed by his mother to a bioengineer, who might explain his survival. Later, Y unwisely confronts a man-hating Amazon gang defacing Washington's monuments. Writer Brian K. Vaughan and artist Pia Guerra slyly undermine male sexism in their brave new matriarchal world.

The Sandman in focus

"These are great stories, and we're lucky to have them. To read now, and maybe again. Then, when we need what only a good story has the power to do: to take us away to worlds that never existed, in the company of people we wish we were or thank God we aren't."

STEPHEN KING

Family matters

Families are meant to look after their own, even The Endless, a disparate family of seven beings, who each embody a different phenomenal force in the universe, that all happen to start with the letter "D": Dream (also known as The Sandman and Morpheus), Desire, Despair, Destiny, Delirium, Destruction, and Death.

When Destruction goes missing, his siblings Dream and Delirium search for him. Here, they have found him and, seated around a lantern under a starlit sky, they discuss why he left and why he chooses not to return.

Notice how the style of balloons and lettering convey the different characters and voices. The Sandman's serious words appear in upper and lower case, in black, amorphous shapes. His sister Delirium talks in an eccentric script in unstable balloons of shifting colors.

Here, while she strokes Destruction's dog Barnabas, she fashions a plaything in the form of Cerebus, in a friendly nod to Dave Sim's much-admired aardvark warrior.

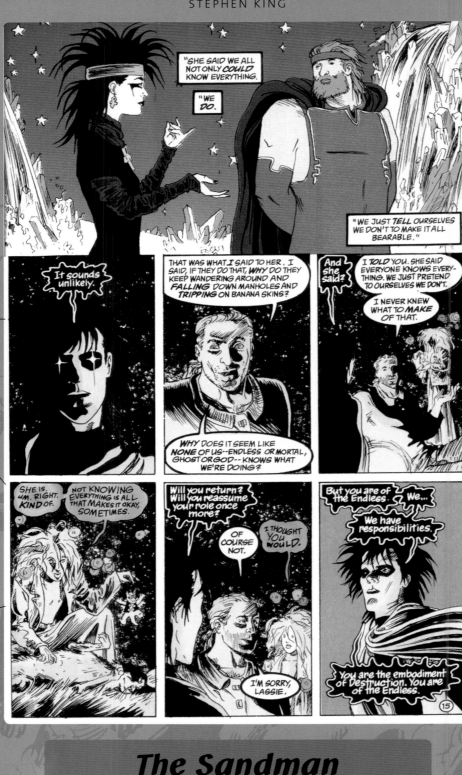

Mere immortals

Much more than blank, abstract concepts, Morpheus and his brothers and sisters come alive as complex, engaging characters in the hands of British writer Neil Gaiman and his artist collaborators, here Jill Thompson and Vince Locke.

The first panel from this page from BRIEF LIVES is a flashback of Destruction, shown in his former costume and beard, recalling a conversation with his sister Death. It might come as a surprise that even as powerful an entity as Destruction can feel insignificant and wish he knew more. Gaiman uses his cast to give unique perspectives on immortals and mortals.

The Endless

So what are The Endless? Destruction describes himself and his kin as "merely patterns, ideas, wave functions, repeating motifs." He goes on: "The Endless are echoes of darkness, and nothing more. We have no right to play with their lives, to order their dreams and their desires."

He also suggests that The Endless are not eternal. "Even OUR existences are brief and bounded. None of us will last longer than this version of the universe."

The Sandman

Neil Gaiman & various artists
1990–97, 10 volumes, 1,993 pages

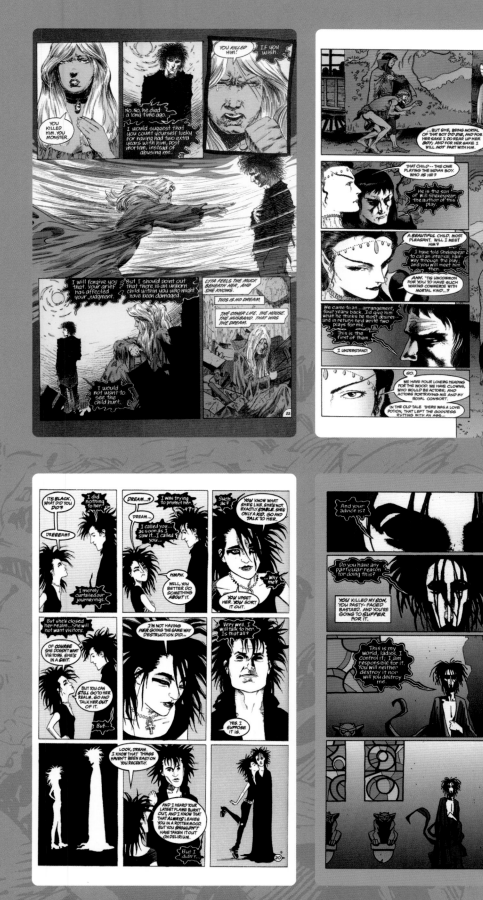

In dreams

Gaiman began his saga, serialized first as 75 monthly comic books, with a strong horror theme. He also drew on previous versions of The Sandman created since 1939.

In THE DOLL'S HOUSE, far left, drawn here by Chris Bachalo and Malcolm Jones, Morpheus has ended the unnatural afterlife of the ghost of Hector Hall, the 1974 superhero Sandman. Remote from all human feelings, Morpheus ignores his pregnant widow Lyta's fury and intends to claim her child. Mother and son have crucial roles to come.

Gaiman also inserts dream-related short stories. Here, Morpheus aids Shakespeare with his plays and brings the Faerie Queen herself to watch the first performance of A MIDSUMMER NIGHT'S DREAM, illustrated by Charles Vess. The bard returns in the saga's last tale, THE TEMPEST.

Nobody understands The Sandman quite as well as his little sister Death. Gaiman brings out both personalities in this sharp brother-sister dialogue, far left, staged by artists Thompson and Locke.

Past actions come back to haunt Morpheus. Here, his realm, drawn by Teddy Kristiansen, is assaulted by The Kindly Ones, agents of vengeance, incited by Lyta Hall, sure that he has murdered her missing son, Daniel. In red captions, The Kindly Ones seek another revenge, for Morpheus's mercy-killing of his son Orpheus, tragic poet of Greek myth. How do you end an Endless? Death and young Daniel hold the keys.

Following on from The Sandman

Bone

Something is disturbing the Dreaming. Dragons, hooded men, and locusts fill the nightmares of Thorn and her small friend Bone. Here, they follow Thorn's tough Gran'ma Rose out in a storm to press her for answers. Jeff Smith raises the tension with claps of thunder. Imagine Walt Kelly's POGO meeting LORD OF THE RINGS and you have an idea of the warmth, wit, and fantasy of this 1,300-page epic. Bone arrives with his two cousins, scheming Foney and good-natured Smiley, below.

Rose

For all Smith's slapstick and humor, behind BONE lies a gripping drama rooted in myth. Crucial background is revealed about the youth of Thorn's grandmother Rose and her sister, Princess Briar. In this encounter between Rose and her dragon guardian, she makes a promise to him, whose importance is accented by dropping the light in this key panel and illuminating her eyes.

Notice how cold is conveyed by showing the figures' breath—the dragon's being naturally larger. Written by Smith, this story is drawn by Charles Vess in delicate lines and rich colors, reminiscent of such masters of fantasy illustration as Arthur Rackham.

Hellboy

At first, Hellboy was in denial about his demonic origins. Raised on a U.S. army base and given honorary human status by the United Nations in 1952, Hellboy joined the Bureau for Paranormal Research and Defense to deliver us from evil. Here his creator, Mike Mignola, adds more dimension and sympathy by revealing that Hellboy has rejected his mission to wipe out mankind. He symbolizes that act by showing him breaking off his horns.

Mignola draws on all the old tales he loved as a child from world folklore. His use of color and black creates a stained-glass effect, the red of Hellboy grabbing the eyes like a car crash or autopsy, the only other red on the pages being blood.

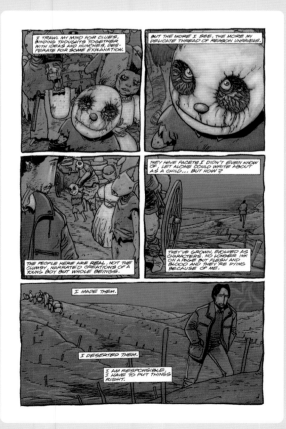

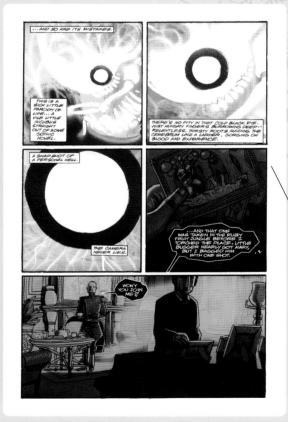

Kingdom of the Wicked

Move over J.K. Rowling. Chris Grahame's books have made him today's most successful children's author. His make-believe realm of Castrovalva sprung into his head after suffering as a boy from blackouts, which are now taking him back there.

Far left, Grahame wanders his mental playground, desecrated by a dictator, and resolves to save it. A later scene zooms in on an anomalous twin found in Grahame's brain, before cutting to its form in his mind, himself as a despot. Notice how British duo Ian Edgington and D'Israeli use the "camera" reference to slip between worlds, from X-ray to framed photo.

In the Mind's Eye

Right: Stoker's classic is adapted by writers Otto Binder and Craig Tennis with art by Al McWilliams

Opposite: Fear and loathing fill Charles Burns' Black Hole

Supposedly, it was all being done for the kids' own good—and maybe for the photographers too. Standing with his pals, hands in pockets, a young boy is caught on camera, looking on in sullen silence, as a man, maybe his father, cheerily throws another much-read, much-loved book onto the piles of pages going up in flames. This is not a book-burning in Nazi Germany. This is America in the paranoid early 1950s, an era of communist witch hunts, and the book being chucked onto the funeral pyre is Harvey Comics' *Chamber of Chills* 25, cover-dated October 1954. Little did those round the bonfire know that it would be one of the last of the era's infamous "horror comics."

Their end was nigh. The month of October 1954 marked a turning point in American comic books. It saw the majority of publishers start to pay to submit their pages for spring 1955 in advance to the newly formed Comics Code Authority or CCA, an independent regulatory commission financed by the industry and empowered to remove anything remotely objectionable. Without the CCA's big white postage stamp of approval printed up to one inch across at the top right corner of its cover, a comic book would not be handled by distributors and retailers and thus would not reach the public. Only Dell's wholesome fare and Gilberton's educational *Classics Illustrated* were exempt. For the rest, it was either clean up or close down.

No doubt the fire-starter stoking that blaze of four-color chills thought he was doing the right thing. Perhaps he had been persuaded by the media's barrage of accusations that this "marijuana of the nursery" was corrupting the minds of his young son and his friends and threatened to turn them into delinquents. After the Second World War, America's moral guardians became alarmed by the rise in juvenile crime. Rather than deal with issues within society or the family, they looked for an easier cause and found a perfect scapegoat in comic books. These were misrepresented as solely for children, whereas new post-war genres, including horror, were increasingly also consumed by adults. Horror comics by definition are meant to unsettle, but certain publishers,

greedy to sell more copies, resorted to cruelty and gore that many thought unsuitable for children. Among them was New York psychiatrist Dr. Fredric Wertham, who became convinced that violent comic books influenced his young patients' troubled behavior. In 1954, he stated his findings in the alarmist book *Seduction of the Innocent* and in televised Senate Committee hearings into the comics industry. Wertham has been demonized as a censor by fans and collectors, but he never proposed or endorsed the CCA, let alone book burnings. His solution, "that the most gory comic books should not be directly displayed to children 13 and under," sparked little interest, because

the public outrage that he helped to inflame was baying for much tougher curbs. The industry's exaggeratedly severe Comics Code was partly an overreaction to pressure, and partly a public relations exercise, but it was effectively also a sly business maneuver by the major conservative companies, led by *Archie* publisher John Goldwater, to drive annoying competitors into line or preferably out of business, stifling divergent points of view and making more rack space for their own product.

Horror had never been all that welcome in wartime comic books either, aside from a few superheroes' monstrous foes or brief versions of Edgar Allan Poe stories. Poe's tales later featured in *Classics Illustrated*, as did *Frankenstein* and *Dr. Jekyll and Mr. Hyde*. Gilberton never got around to adapting *Dracula*, perhaps because it was too bloody; Ballantine Books eventually put out a quite faithful 160-page strip version in paperback in 1966. As for an ongoing American horror comic book, after the false start in late 1946 of a single issue of *Eerie*, it arrived as *Adventures into the Unknown* in 1948 from the American Comics Group. From its debut, entirely written by prolific author Frank Belknap Long, editor Richard Hughes relied on the ghosts, werewolves, and vampires of the weird mystery pulps and their roots in 19th-century fiction.

Adventures into the Unknown weathered the moral panic and industry crackdown of the 1950s by banishing all monsters in favor of clever but tamer yarns, and would notch up 169 issues by its end in 1969. In contrast, William Gaines, publisher of Entertaining Comics, or EC,

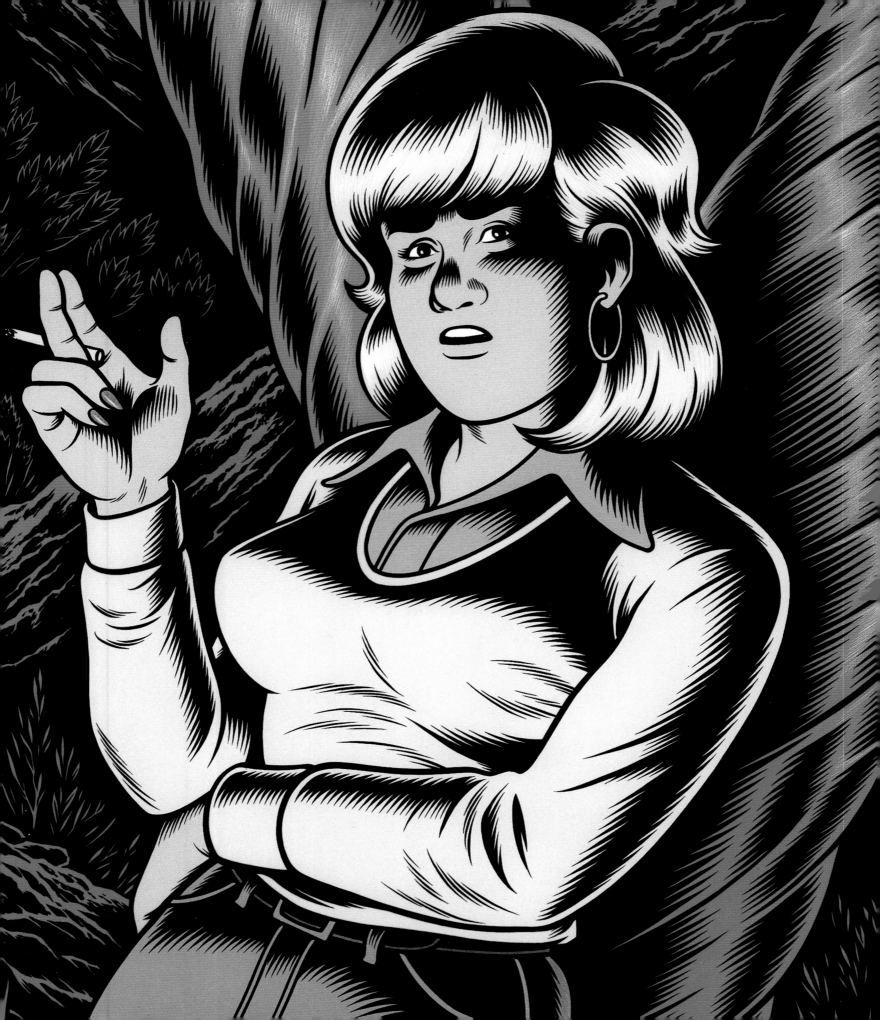

In the Mind's Eye

Above: In Kazuo Umezu's 1978 horror manga *Orochi: Blood*, why is this little girl fascinated by the color of her blood?

Below: Everyone rejects the pitiful, maggot-ridden monster *Hell Baby* by Hideshi Hino

Opposite above: Frank Frazetta paints EC's Crypt-Keeper on this 1964 reissue paperback

Opposite below: *Swamp Thing*, a plant that walks like a man, is back in his element, drawn by Steve Bissette

decided to close his *Tales from the Crypt* in 1955 after only 27 issues. Like the comic's cackling hosts, however, Gaines would have the last laugh. In a twist ending as twisted as any he published, *Crypt* later came back from the dead in movies and television series, and along with the rest of the EC titles it has been repeatedly reprinted in comic and book form. Ballantine's black-and-white paperbacks started this process from 1964, followed by a color Nostalgia Press tome in 1971, before the ultimate accolade, Russ Cochran's *Complete EC Library* from 1978, the first time that a single company's output was repackaged in deluxe, slipcased, annotated hardcovers. How their 1950s critics would have been stunned to see these comics live on and inspire global popular culture for over 50 years. While *Crypt* and its companions *Vault of Horror* and *Haunt of Fear* deserve acclaim, there has been a tendency to overlook the qualities of other companies' wild, eccentric horror output before the Comics Code, when over 50 went on sale each month at their peak from 1951 to 1954. EC tales were limited to 6, 7, or 8 pages in length and by the need for shocking, and at times gratuitous, finales. Their captions, written first and lettered onto the artboard, could be rich with description and tongue-in-cheek wit, though at times they repeated what the superb illustrations clearly already showed.

Yet how different the landscape of modern horror might now look, had young Stephen King, George Romero, and many other masters of the genre not been steeped in EC horror. Clive Barker never forgot how "those comics really grossed me out when I was a kid, and they also fired my imagination." Gaines and crew had little time for flimsy ghost stories; they relished *contes cruels*. They dared to suggest that everything might not be perfect in the 1950s American dream by regularly showing one wronged partner in a romance or marriage inflicting a fittingly grotesque punishment on the other. Revenge fantasies of this type might account for some readership surveys finding that women, notably married women, were a sizeable

percentage of horror comics fans. Stephen King also pointed out that, "when EC started to produce supernatural tales, they did it after the worst holocaust that people had ever known—World War II and the deaths of six million Jews and the bombing of Hiroshima and Nagasaki." Are their vengeful corpses warning us that we cannot bury and forget the wartime inhumanities that we committed?

In comics as in literature, horror seems well suited to short stories, lean and mean, with no need for recurring characters because they usually end up condemned, mad, dead, or living-dead. In America from the early 1960s, short-story anthologies of darker, more dangerous horror comics escaped the clutches of the Comics Code by abandoning the racks of color comic books next to the candy counter. They converted to black-and-white magazines shelved with *Time* and *Newsweek*, and to underground comix sold via counterculture outlets. Many contributors revered and rejuvenated the EC style; a few ventured into stranger areas. In *Bogeyman* in 1969, for example, Rory Hayes delivered primal, desperate terror, gushing straight from the id, unfiltered by aesthetic finesse, an example to Mark Beyer, Savage Pencil, and others to express whatever and however they needed. The second-string 1970s Skywald magazines *Psycho*, *Nightmare,* and *Scream*, of all places, spawned a distinctly perverse voice in writer-editor Alan Hewetson. Praised by Stephen King as "constantly moving ahead, breaking new ground, using innovative stories," Hewetson's "Horror-Mood" menu offered some serialized "original illustrated novels," always intended to be put into books. In his exploitive, fatalistic cliff-hanger *Saga of the Victims*, compiled in 2003, he showed that "human rules don't count," when an alien, beyond emotions or morals, tested two female humans' endurance, before casually destroying them and our inconvenient universe. By 1971, times were changing and comic book publishers persuaded the CCA to permit "vampires, ghouls, and werewolves... when handled in the classic tradition." Though mild compared to the 1950s, tragic monsters old and new, from Dracula, Werewolf, and Frankenstein to Swamp Thing, Man-Thing, and Ghost Rider, stalked the stands again, now in their own color series.

Lengthy, complete horror graphic novels, however, caught on elsewhere. Since the 1960s, Japan's Kazuo Umezu has become

renowned for his horror manga, lending his name to a major award and to a "haunted mansion" attraction in Tokyo. Hideshi Hino followed in this tradition when he began his *Shocking Theatre* series in 1971. "As a child, I had a very acute sense of horror, probably more so than most kids of my age. I'm able to exaggerate those feelings and exploit them as the basis for my comics." A crucial memory in his semi-autobiographical masterpiece from 1983, *Panorama of Hell*, is the *yakuza* tattoo on his father's back of a bat that seems alive. Hino's accursed generational history assaults the reader with its mutilations, no less visceral for being in black and white, and its narrator-confessor device "to remove the distance that allows a reader to be entertained without any sense of risk." The danger you feel is justified, because his mad painter finally flings his ax out of the page, straight at you. Italians acquired a taste for less menacing splatter from 1986 in *Dylan Dog*, 100-page monthly graphic novels of an occult London sleuth styled on Rupert Everett, with Groucho as his "Watson."

John Constantine, aka *Hellblazer*, is another Londoner, a much harder, more ruthless Cockney magician modelled on Sting, who emerged in 1985 in American comic books from British writer Alan Moore and artists Steve Bissette and John Totleben. Constantine was part of their overhaul of DC Comics' poor-selling *Swamp Thing*. They replaced the stock situation of the muck monster longing to be human again with the startling idea that the creature had never been a man transformed, but was a dying man's consciousness absorbed by the swamp, "a ghost dressed in weeds," reborn as a kind of vegetable god. Straining the limits of the Comics Code, the creators experimented relentlessly by connecting standard horror figures to horrors of the real world, from spectral incest and a toxic hobo poisoned by nuclear waste to female werewolves' menstrual pain. They also breathed new life into many of DC's dormant supernatural characters and broke away from the Code, building the audience for a DC imprint dedicated to "mature readers," called Vertigo. The Code was made slightly more lenient still in 1989, but now it polices only the minority of comics sold from the newsstands. Most publishers ignore it because they sell comic books only through specialist comics stores, before reprinting them as graphic novels. Marvel quit the Code in 2001, opting to put its own advisory labels on its books. Symbolic of the CCA's shrinking power, its cover stamp has been reduced to a quarter of an inch or less across.

In this climate, all tastes in horror can flourish, whether you want some gloomy, goth-friendly shivers or all-out, bloody *grand guignol*. The classic scenarios seem ever ready for revival and reinterpretation, in the pitch-black comedies of *The League of Extraordinary Gentlemen* or *Criminal Macabre*, and in the psychological dissections of *Strange Embrace* or *Frankenstein, Now and Forever*. Steve Bissette's aptly named anthology *Taboo* (1988–95) permitted some provocative projects to first see print, not only *From Hell* and *Lost Girls* written by Moore, but also Jeff Nicholson's *Habitrails*, an indictment of soul-destroying toil, and Charles Burns' "Teen Plague," an embryo that grew into his freakish hormonal love story *Black Hole*.

Unlike their fleeting effect on film or television, comics fix horrors on the page from which many would instinctively turn away. After the gleeful gruesomeness and sacrilege of *Preacher,* there can be few taboos left unbroken. So what draws so many to such terrifying stories? *Hellblazer* writer Jamie Delano asserts that they are "shining a light on the beast which crouches in the darkest corners of our minds, giving us a chance to both recognize and oppose it." The horrors in comics may no longer incite burnings, but complaints and prosecutions still erupt. One difference now is that pros and fans have donated to a Comic Book Legal Defense Fund to defend creators, publishers, and retailers. If necessary, the industry in America is prepared to fight for the freedom to show us, as Delano puts it, that "horror occupies half our hearts and we're the ones who let it out."

Strange Embrace in focus

> "In part psychological horror, in part an existentialist study of the classic 'Outsider,' it has the emotional, thematic, and historic sweep of a novel, but manages to retain the immediacy and cerebral impact of the best comic."
>
> PETER MILLIGAN

Feed the hunger

In his teenage years, Alex Steadman's telepathic abilities grow so strong that they unhinge his sanity and drive him to murder his uncaring parents. His powers turn him into a sadistic "psychic vampire" with a greedy appetite, not for other people's blood but for their thoughts, the more nightmarish the better.

Leaving the now empty family home, Alex is drawn to a huge lodging house, where he rents a room. The attraction here is the house's seriously disturbed owner, Anthony Corbeau, who must be Alex's next victim to satisfy his hunger. "It was all falling into place. I was a writer and Corbeau was my story."

Sukumar

The stories of Alex's past and his discovery of Corbeau's tragedy are framed by another present-day story that opens and closes the book. This introduces Sukumar, an Indian errand boy, above, who delivers Corbeau's shopping, and whom Alex lures into being his unfortunate audience.

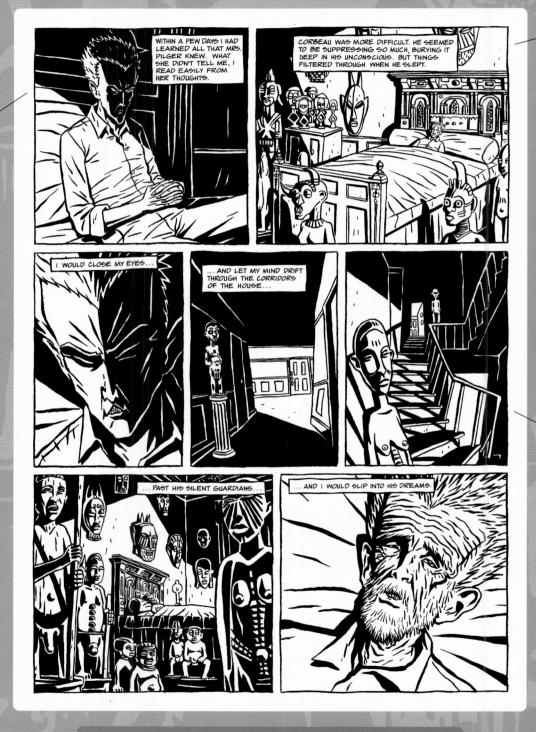

Into his dreams

Having spent all his life in this house, now Anthony Corbeau never leaves it. Corbeau (French for crow, symbolic of death) is a decrepit widower and broken recluse, bottling up terrible secrets.

Alex begins to probe his sleeping mind to find out about his past and why his wife killed herself. He learns that Corbeau was a listless, withdrawn youth whose wealthy father forced him to enter the family business, dealing in antiques. He showed no interest until he discovered African art. This fired an obsession with amassing a vast private collection of tribal carvings.

Now these figures loom on the stairs, in the hallway, and surround him in bed. Notice in these interiors how author David Hine uses a distorted, angular perspective to create an unsettling mood. This technique is reminiscent of German expressionist movies such as THE CABINET OF DR. CALIGARI from 1919.

Often scarified and pierced, the African statues and masks strike a stark contrast with the genteel formality of the story's turn-of-the-century setting. They also glorify ritual physical punishment and refer to another object of worship, the crucifix.

Strange Embrace

David Hine
2003, 1 volume, 204 pages

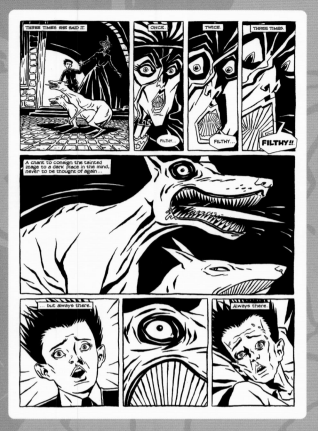

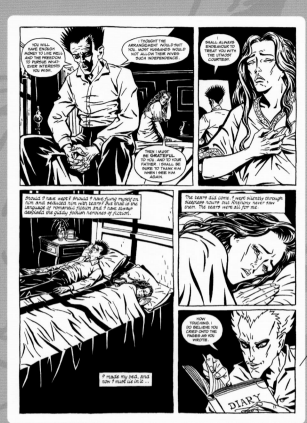

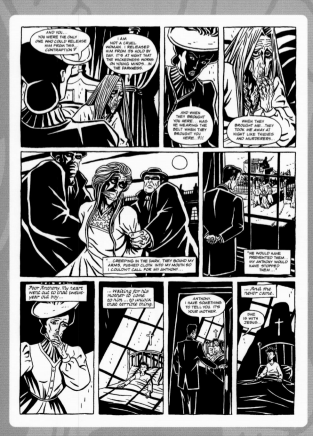

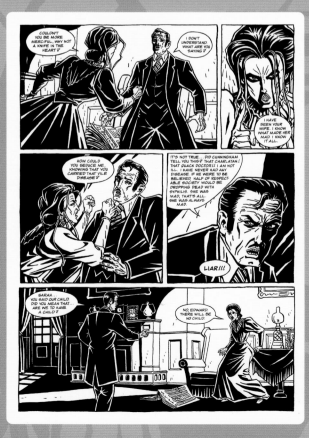

Sins of the past

Corbeau's father has told him that his mother is dead, but he cannot forget her excessive moral tyranny. Here, far left, little Anthony recalls her repulsion on seeing two dogs copulating in the street. Notice how Hine exaggerates both her teeth and the dogs' teeth.

Only on their wedding night does Corbeau's bride Sarah realize her mistake. She had admired his unorthodox views, seriousness, and reserve, but discovers that he married her merely to please his father and get the antiques shop and an allowance. Here, Alex reads from Sarah's diaries with the knowledge that she will take her own life. Notice the diary's handwritten script and the two crosses formed by shadows across their loveless marriage bed.

Sarah finds out that Agnes Corbeau, Anthony's mother, is alive but insane, and visits her in an asylum. Here, far left, Agnes insists that she is "not a cruel woman," but Sarah sees how, in her zeal to keep her son pure, she has permanently scarred his body and mind. Agnes relates the night she was taken away. Notice how she believes "my Anthony would have stopped them," when in fact his father lied to him that she had died.

Beneath the veneer of the Corbeaus' respectability, Sarah uncovers the scandal of syphilis, carried by the father and spreading madness to his wife and son, and now to Sarah and their illegitimate child. No one will be spared in this spiral of tragedy.

Following on from Strange Embrace

Preacher

The *DA VINCI CODE* was never like this. Here, Starr, a mad member of The Grail, spoils their plan to rule the world through the supposed direct blood descendant of Jesus Christ, and plots instead to use the miraculously empowered Texas minister Jesse Custer as his puppet messiah. When this goes painfully wrong, the mutilated Starr co-opts the Grail for revenge on Custer: "This is about my genitals."

Custer's vendetta is with God, and resurrecting his girlfriend Tulip, right, won't deter him. Custer learns more when he saves his vampire mate Cassidy from The Grail, far right. Blood and blasphemy aside, at heart Garth Ennis and Steve Dillon's fable prizes human love over debased dogma.

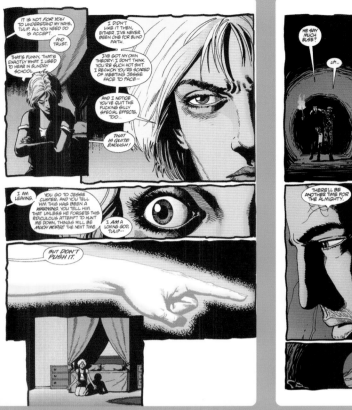

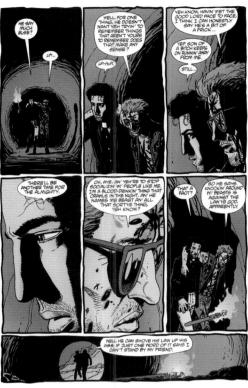

Hellblazer

Cynical, self-interested Londoner John Constantine, latest in a long line of magicians, has few friends. All his old friends are ghosts, because his mistakes cost them their lives. What's worse, they stick around to remind him of this. Any new friends come to him for protection, but don't always get it.

Here, Constantine has to use a doomed addict as bait to hold and consume a hunger demon. Hearing the addict's agonies drives Constantine to smoke and drink himself into oblivion. British writer Jamie Delano and artist John Ridgeway undercut the grotesque with the humor of Constantine's wry patter and the silent ghost giving him the finger.

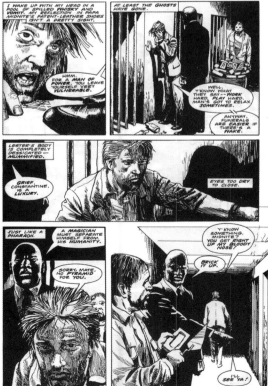

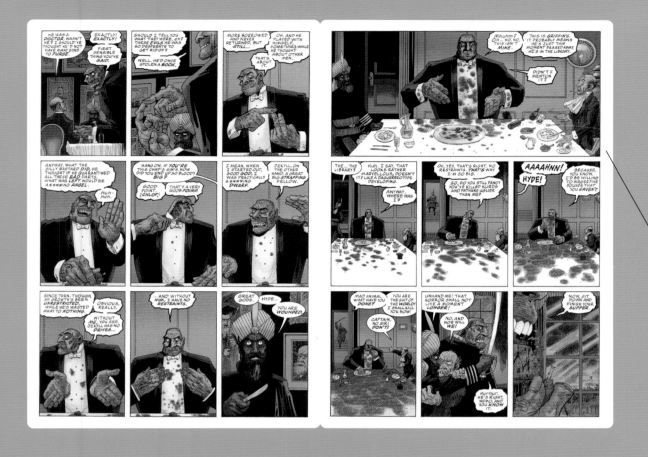

The League of Extraordinary Gentlemen

Alan Moore and Kevin O'Neill alter forever some of the 19th century's greatest fictional figures. Here, over supper, Mr. Hyde tells Captain Nemo and coach-driver Samson how his bestial nature has wiped out his repressed, weaker half, Dr. Jekyll. As if in proof, blood mysteriously appears on his shirt, hands, and the tablecloth. It is the blood of Griffin, The Invisible Man, invisible no longer now that he has finally died from Hyde's unseen but unspeakable punishment for being a traitor and rapist. Notice Hyde's huge, expressive hands and his speech balloons, as rough as his voice and table manners.

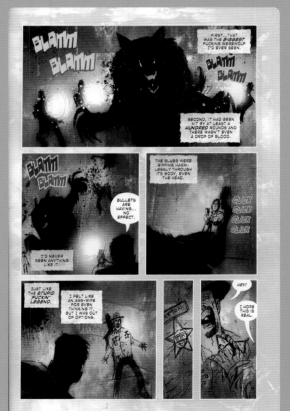

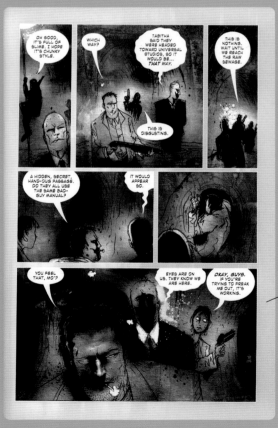

Criminal Macabre

Ex-junkie and hard-living investigator Cal McDonald has seen his share of weirdness, but nothing like this conspiracy of creatures who want to spread an ancient plague and turn all humans into monsters. On the far left, Cal runs up against a huge werewolf. When bullets fail, he realizes that all the old methods, like a silver star, still work to dispose of these monsters of legend.

On their trail, Cal drags his green-skinned dead pal Mo'lock and sceptical detective Brueger down into L.A.'s sewers, left. In their splatter-noir comedy, Steve Niles scripts snappy dialog and Ben Templesmith fills the panels with suitably creepy atmosphere.

> "The work of Charles Burns is a vision that's both horrifying and hilariously funny, and which he executes with cold, ruthless clarity... It's almost as if the artist... as if he weren't quite... human!"
>
> R. CRUMB

Teen plague

Charles Burns explains that his horror-romance "is directly based on my life growing up in the 1970s in Seattle, Washington. The characters and events all reflect that period of my life. No, my friends didn't have strange growths coming out of their necks, but I really did feel like I was some kind of diseased teen."

In BLACK HOLE, high-school students become infected after having sex and experience alarming physical side-effects, different in every case. Parallels with AIDS are obvious, but this is no simplistic cautionary tale.

Burns is not interested in explaining this plague's origins or meanings, nor the search for its cure. He prefers to explore how it changes these young people's bodies and their relationships with each other and with the "normal" world.

Rather than schlocky, B-movie ciphers, these are vulnerable, sympathetic teenagers at the mercy of their sex drives and peer pressure. Drugs and drink offer only a temporary escape. All they really long for is to get away from the sterility of home and school and to connect emotionally with others.

Physical love

"It was dark, I remember kissing his neck..." Chris Rhodes thinks back in the caption commentary here to when she was making love to Rob Facincani, and she discovered something unexpected on his neck, just below his T-shirt.

Rob's freakish second mouth is one of several vaginal symbols for the pleasure and pain of burgeoning sexuality.

Dissecting a frog in science class, removing a shard of glass from Chris's foot, splitting her skin along her spine when she starts to shed—these are a few of the dark, bodily openings, the "black holes," that pervade this drama. Another black hole in reverse is the rising full moon across water, an image of release that beckons Chris to the end.

In the last two panels, their split faces are shown as one, as the shock sinks in that Chris has unknowingly been infected by Rob.

Like the watery dissolve of a flashback in vintage films, the rippled edges of these panels indicate memories. The same technique is used for nightmares, drug-induced trips, or future hopes, acknowledging the blurring between memory and fantasy.

Black Hole

Charles Burns
2004, 1 volume, 368 pages

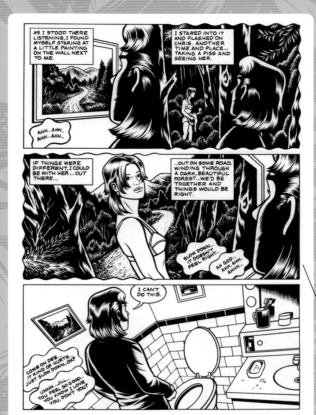

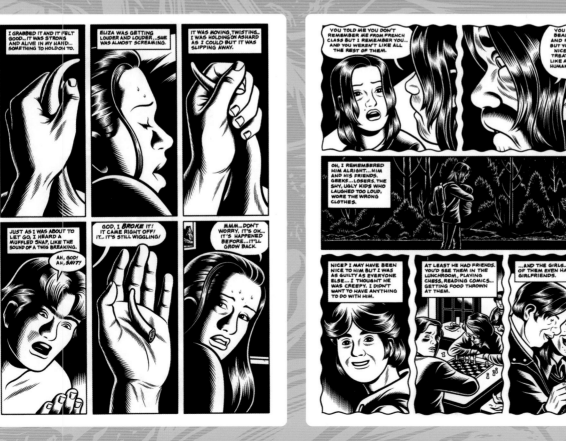

Freaks like us

Now both infected, Chris and Rob feel ostracized from their classmates and families, yet increasingly close to each other. The doomed lovers skip school and drive out to the coast for a night of sex under the stars, far left. But as Rob falls asleep, the mouth on his chest begins to speak sadly. As Burns zooms out, he shows the couple lost in the enormity of nature.

Chris has another admirer, Keith Pearson, seen here in the bathroom staring into a painting and remembering catching sight of her in the woods. Notice how Keith's static head is repeated and the panel borders ripple and return to normal. The warped perspective and sounds of lovemaking from the next room capture his stoned state of mind.

Keith knows the risks, but cannot resist sleeping with Eliza. Her mutation is a seductive tail with a life of its own, even after Keith snaps it off, far left. Phallic symbols recur, such as branches, snakes, or broken bones.

When the mutated kids are shunned by society, they take to living in the woods in a supportive community. Here, Chris is called back to the sea, and thinks back to another pupil, Dave, his face now covered in hair. She remembers how he once looked and how she used to despise "geeks" like him. Now she is on the receiving end of rejection herself. BLACK HOLE exposes in psychological and biological intimacy the cost of the desperate desire for acceptance.

Following on from Black Hole

Panorama of Hell

Born at the precise instant when the bomb destroyed Hiroshima, a demented painter recalls the sick cruelties of his childhood. Warped by daily beatings, here at the hands of his insane mother, he becomes a weird, disturbed boy, fixated on the exquisite beauty of blood and using his own to make his terrifying Hell Paintings.

Later, when the boy sculpts a clay statue of the atomic mushroom cloud, he finds that praying to it grants his darkest desires, far right. With macabre glee, manga author Hideshi Hino builds one man's history of family abuse and artistic excess to a shocking climax. Note that these pages read in the Japanese direction, top right to bottom left.

Strangehaven

Gary Spencer-Millidge's *Strangehaven* seems like a quintessential cosy English village, except that it's not on any map and nobody can leave. Newcomer Alex's car mysteriously vanishes while he is driving off on the moors. After days of hiking, he feels drawn back to the village. Here, time seems to be repeating itself as he finds his car in the same spot where he crashed it weeks ago. He also sees the girl in black and decides to follow her. Alex gets to know the locals, far right, confiding in Brian about how he rejected Janey's advances. Both men are still getting over broken marriages, but Brian's last words hint at something far worse, as the slow-burning paranoia mounts.

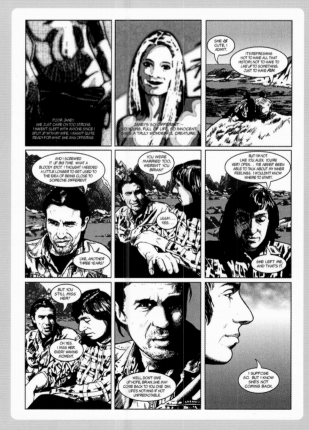

Frankenstein Now and Forever

The sanity of two young women is threatened after they find a strangely annotated, stained copy of Mary Shelley's FRANKENSTEIN. Eva starts dreaming of the sad, man-made creature and seeing herself in him. Here, far left, she gets swept over the edge, riding him along a tearful river.

When the other woman finds a photo in the book by her ex-boyfriend Michel, symptoms resurface of the breakdown she suffered after their split. Here, she starts imagining that the book's scrawls are by the man in the photo, a modern Doctor Frankenstein who has killed Michel. Swiss author Alex Baladi stitches together a tense patchwork of rejection and despair.

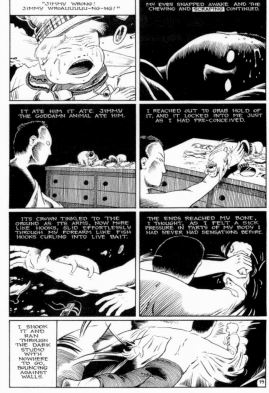

Through the Habitrails

Is work getting you down? Peak productivity requires placating Jeff Nicholson's semi-autobiographical, blank-eyed employee by tapping all his negative fluids. These are then fed to gerbils, empaths of stress and anger, running through tubes in the office, far left.

This "corporate biological mind-screw" fails to stop our hero from quitting. He sinks into debt and drink, helped by the sinister "Gerbil King," who seems intent on driving him to suicide. He wakes here from a dream to find a toy doll that he bought for comfort has been eaten by the vile rodent. Nicholson's surreal ideas examine the horror of being exploited by others.

Murder, Smoke, and Shadows

When police officers entered Room 91 at the Irving Hotel in New York's genteel Gramercy Park on August 26 1958, they found the battered body of a woman in a negligée surrounded by empty whisky bottles. Her drunken, blood-soaked murderer had told everything to a cab driver while he drove him away to another hotel. The cabbie informed the police and they brought the man in for questioning. The next morning, the newspaper report began: "Bleary-eyed, unshaven, dirty, and shaken—looking like an illustration of a trapped criminal in the *Crime Does Not Pay* magazine he once edited—horror strip cartoonist Robert Wood, 41, was held without bail yesterday on a homicide charge." Wood confessed that, after he and 45-year-old divorcée Victoria Phillips had spent eleven days drinking, he had lost his head, apparently because of her demands that he marry her, and had bludgeoned her to death with an electric iron. Convicted of manslaughter, Wood served three years in Sing Sing prison. According to Joe Simon's memoir *The Comic-Book Makers*, about a year after his release Bob Wood was unable to find work or pay back loan sharks. His body was found dumped on the New Jersey Turnpike. You can blame the boozing, but he was also a victim of the Comics Code's decimation of the industry.

Recognizing that tragedy does not come much more deeply ironic than this, Art Spiegelman is developing the libretto and sets for an operatic rendition of the story to be called *Drawn to Death: A Three Panel Opera*. Bob Wood had been the co-editor from 1942 to 1953 of *Crime Does Not Pay*, America's first and most widely read crime comic book, and yet he of all people had failed to practice what it preached. In contrast, hundreds of readers wrote in claiming to have learned their lesson from its "all true crime stories." One hand-written letter was reproduced in 1947 on a full page titled "Testimony," the correspondent's particulars obscured by "censored" stamps. Dated May 12 from the Missouri State Penitentiary in Jefferson City, it read: "I am a convict and a regular reader of your magazine. I didn't start reading *Crime Does Not Pay* until too late. I really enjoy learning the true facts in it. I hope others won't wait as long as I did to read and understand the truth, that crime does not pay. Thanks for bringing such a wonderful magazine to Americans."

Not everyone would agree that their magazine was so wonderful. It had started in 1942, when Bob Wood and his associate Charles Biro proposed a no-holds-barred "true crime" comic book, inspired by the popular "confessionals" or true story magazines, to progressive, leftist publisher Lev Gleason. Exceptionally, fair-dealing Gleason gave them a share of the profits and total editorial freedom. For all involved, it proved that crime definitely *did* pay, and in spades. Hosted by the spectral Mr. Crime in moustache and top hat, the biographies of real criminals recounted through Biro's copious dialog would regularly conclude with the title's stern message, as if to justify showing all the sleaze and brutality that led to their capture or death. By 1947, Biro's lurid covers were shouting: "More Than 5,000,000 Readers Monthly!" Nine months later that figure had leapt up by another million. Between 1947 and 1951, a copycat crime comics spree pushed the genre's market percentage into double figures, up to 14 per cent in 1948. But they were the prime target of the anti-comics campaigners. After the Comics Code curtailed violence from 1955 and restrained the prominent use of the word "crime" on covers, the genre could thrive in newspaper strips, movies, and TV shows but withered away in comic books, almost vanishing through the 1960s and 1970s.

During the 1930s gangster era, the outraged American public felt powerless reading the newspapers' front page reports of gangsters' crimes going unpunished. Turning to the comic strips, they found a champion from 1931 in the yellow-hatted, chisel-jawed *Dick Tracy*, the premier plainclothes detective, whose preferred method was "the hot lead route." Mystery writer Ellery Queen argued strongly that *Dick Tracy*'s creator Chester Gould had pioneered police procedural fiction in his detailed plotting and diagrammatic designs. He certainly ushered unprecedented gunplay, anguish, and torture into

Right: An American "picture novel" paperback from 1950

Opposite: John Wagner and Arthur Ranson's *Button Man* Harry Exton prepares for a kill

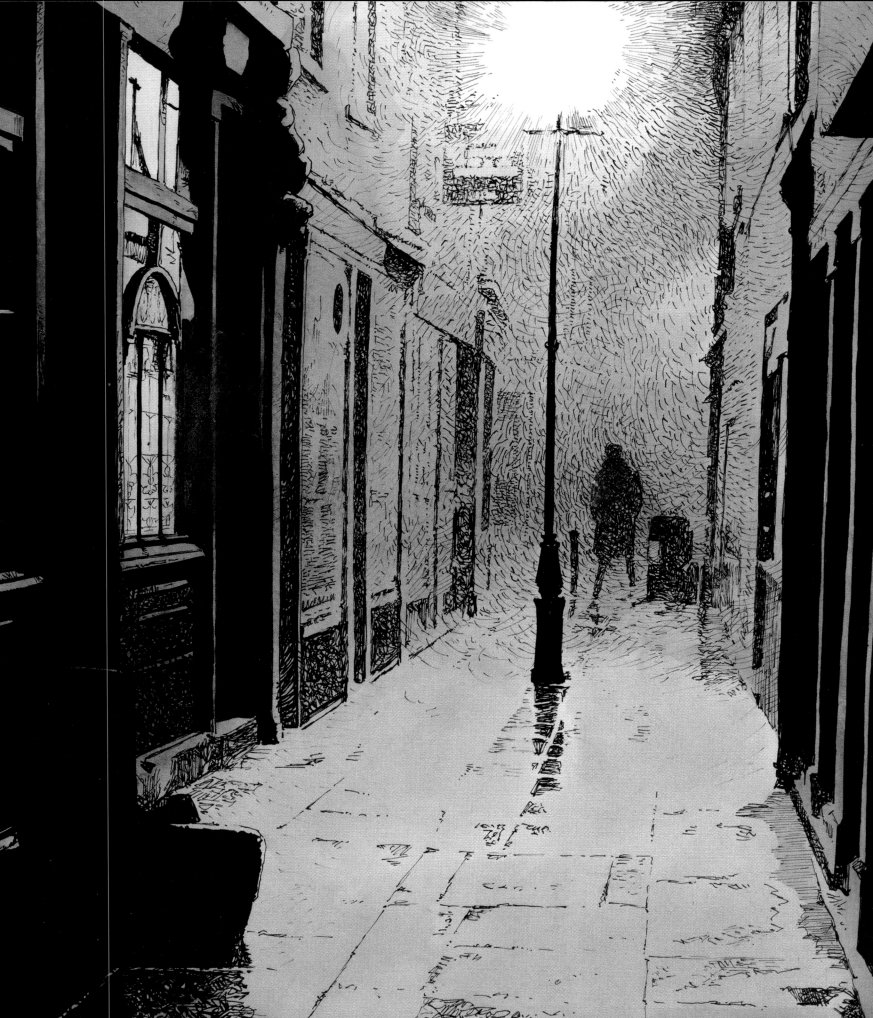

Murder, Smoke, and Shadows

America's "funny pages," as well as a slew of rival operators. The classiest act among them might be 1934's *Secret Agent X-9*, glamorously illustrated by Alex Raymond and written initially by celebrated novelist Dashiell Hammett himself. One of the most technically innovative and influential newspaper sleuths from 1940 was Will Eisner's *The Spirit*, in reality Denny Colt, long believed dead, but still alive and working from his secret crime lab beneath Wildwood Cemetery. Frank Miller credits Eisner for bringing in "a lot of expressionism into his work—stairwells that were 50 feet long, ceilings that were 100 feet high." *Tracy*, *X-9*, and other law enforcers had their completed cases compiled into assorted book packages, including cheap and chunky Big Little Books about four inches square. These extracted the illustrations from the strips and alternated them with a text commentary opposite on the lefthand pages. At ten cents for up to 424 newsprint pages inside hardcovers, they were a steal.

When paperbacks muscled in on the enfeebled post-war pulp magazines, there were a handful of bold attempts at original crime graphic novels. *It Rhymes With Lust* from 1950 was a "picture novel" in the standard paperback size, written by "Drake Waller," the pseudonym for novelists Arnold Drake and Les Waller. It was their first comics assignment and Drake had high hopes. "We wanted to do a series of classy B-movies in comic form, but looking like a book." To heighten the filmic effect, the players were drawn in black to stand out "in focus" against the sets and backgrounds tinted in gray screen tones. You can picture Joan Crawford or Barbara Stanwyck playing the power-hungry Rust Masson (it's her name that "rhymes with lust"), a mine-owner determined to keep control of Copper Town at any cost. It was a demanding job to draw at nearly 128 pages, so to keep costs down publisher Archer St. John assigned it to gifted newcomer Matt Baker, one of the few African-Americans in the industry, with superb results. Another "picture novel" was tried, *The Case of the Winking Buddha* by Manning Lee Stokes and Charles Raab, and Drake and Waller had plans for a continuing private eye character, but poor sales killed the series. It was ahead of its time, hard to market,

and perhaps the contents were not adult enough, promising much on the cover but delivering no sex or violence inside.

On the other hand, Italy's pocket-sized, paperback *fumetti neri* or "black comics" tended to keep their covers' promises, after the Giussani sisters set the trend in 1962 with their villainous anti-hero dressed head-to-toe in black, *Diabolik*. Elsewhere, variations on the paperback crime comic format caught on in the 1960s, such as the British "picture libraries," headlining master thief *The Spider* or invisible agent *The Steel Claw*, and the Japanese *tankobon* or compact books, starring macho icons like sexist scoundrel *Lupin III* and amoral assassin *Golgo 13*.

In the "clear line" style and hardback color format of the Franco-Belgian heroes *Tintin* and *Blake & Mortimer*, Jacques Tardi was commissioned in 1975 by *Tintin* publishers Casterman to create *Adèle Blanc-Sec*, a female investigator in an early 20th-century Paris plagued by cults and mad scientists. Playing with the clichés of French thriller serials, Tardi's atypical heroine is dry, determined, unglamorous, and single, and makes her living from writing detective stories. Buoyed by *Adèle*'s success, Casterman committed in 1978 to a graphic novel magazine, *A Suivre,* or "To be continued," in which to serialize chapters of her further extraordinary adventures and of other new series, including Manhattan P.I. *Alack Sinner* by Argentina's Muñoz and Sampayo, Benoît Sokal's duck dick *Canardo,* and Tardi's version of Léo Malet's robust Parisian *flic, Nestor Burma*. It makes sense that crime fiction has flourished so well since the 1970s in French-language graphic novels, given that the French were among the first to appreciate the qualities of American crime films and in 1946 branded their unique mood of doom as "noir." American director Edward G. Ulmer defined that mood succinctly: "Whichever way you turn, fate sticks out its foot to trip you."

Starting in the late 1960s, veterans and upstarts alike wanted to revive crime comics in America, but opportunities were so thin on the ground that in 1968 Gil Kane had to self-publish the aptly titled *His Name Is Savage*. Aided by writer Archie Goodwin, Kane loaded his 41-page story with lengthy captions and the sort of mayhem common to noir films of the time starring Clint Eastwood or Lee Marvin, but permissible in comics only in a black-and-white magazine beyond the scrutiny of the Comics Code. Like *Savage*, Jack Kirby's ferocious gangster

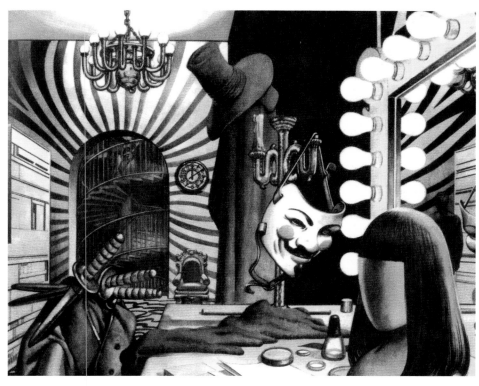

fiction. As two examples, Brian Michael Bendis and Ed Brubaker began by drawing as well as writing noir-oriented projects for low- or no-budget publishers. When they eventually got work at Marvel and DC, they applied their tastes to superheroes, from Bendis's takes on *Daredevil* and *Alias,* to Brubaker's *Gotham Central* with Batman hardly in sight. Both went on to helm their own crime series, such as Bendis's *Powers* and Brubaker's *Scene of the Crime.*

While noir is like the color black, graphic novels can now contain the whole colorful spectrum that makes up crime fiction. There's the chance to veer off into sharp satire, haunting guilt, human folly, conspiracy theory, Tarantino-esque grit, or echoing deconstruction. Alan Moore and David Lloyd's *V for Vendetta* started life in 1982 in part as a retro hard-boiled hero, then as a near-future cop, until Lloyd hit on using the famous Guy Fawkes mask, transforming him into a vitally symbolic player in a piece of heartfelt political theatre. In *Button Man*, John Wagner and Arthur Ranson, another British team, dreamt up the chillingly plausible "Killing Game" for the idle rich to gamble on hitmen who under our noses murder each other for big money. The truism *Crime Does Not Pay* now rings hollow. In these times of terrorism, gun lobbies, and corporate guile, graphic novelists can raise questions about the acts of individual or institutional violence shaping our societies. They can also entertain. As Miller puts it, "Violence in fiction has a stigma attached to it here. People feel guilty about it. I don't see the guilt as necessary."

eulogy *In the Days of the Mob* and Steve Ditko's polemical, absolutist enforcer *Mr A* never really found their public. Returning to the medium after five years with *Chandler* in 1976, Jim Steranko devised the "visual novel," more a sort of lavish Big Little Book that put two-color, same-sized, mostly silent panels on each page above a set 26 lines of separated text. It remains a one-off experiment.

Growing up on Catholicism, comics, and crime fiction in rural Vermont, Frank Miller at the age of 13 was blown away by the bruising prose of Mickey Spillane, a former comic book scribe himself. Beyond a childhood affection for Spillane, Miller rates his "machine-gun-like firing of the words, and the sheer savagery of it." Building on masters like Eisner and 1950s EC Comics' innovators Harvey Kurtzman, Johnny Craig, and Bernie Krigstein, Miller pumped out his "knights in dirty armor" but found no takers: "The only game in town was men in tights." It was only after the massive success of *Dark Knight Returns*, basically a noir *Batman*, that Miller was given free rein in 1992 to unleash his over-the-top crime romances in *Sin City*. It's fair to say that the 1980s brought some new life to detective comics, specifically the 1980 graphic novel *Detectives Inc.* by Don McGregor and Marshall Rogers, and *Dick Tracy* writer Max Allan Collins and Terry Beatty's vengeful widow *Ms. Tree*, based on Velda, secretary to Spillane's Mike Hammer. Even so, it was *Sin City* that fired up the 1990s crime renaissance and some of America's freshest scripters, all of them passionate about crime

Scene of the Crime in focus

> "With just the right mix of cynicism and sentimentality, this one's a winner, sure to thrill you, and then break your heart. The art and text work perfectly together, in the tough-minded tale of loss and redemption, revenge and forgiveness."
>
> KEVIN BURTON SMITH, THE THRILLING DETECTIVE

In business

"You know, you're kind of a strange detective." On the mean streets of San Francisco, young Jack Herriman is not your typical hard-boiled private eye. Ever since the age of 12, he has been damaged both physically and psychologically after witnessing a car bomb that mistakenly claimed the life of his police officer father.

The explosion also cost the boy his left eye. Notice how artist Michael Lark cloaks Jack's false left eyeball in shadow, while still showing the line of his scar. Irregular borders indicate here that this panel is a flashback, told in Jack's tinted captions.

Raised by his uncle Knut, a famous crime-scene photographer, Jack grew up drowning himself in drink and drugs and wrecking a romantic relationship.

Now he is trying to rebuild his life. He has moved in above the "Scene of the Crime" gallery and bookshop run by his uncle and set himself up in business there as a detective who refuses to carry a gun.

Giving Jack the family name Herriman is writer Ed Brubaker's tribute to KRAZY KAT comic strip creator George Herriman.

Scene of the Crime

Ed Brubaker, Michael Lark & Sean Phillips
1999, 1 volume, 112 pages

Missing person

A case comes Jack's way from his father's ex-partner Paul Raymonds, the SFPD detective sergeant who was the intended target of the car bomb

Jack is hired by Alexandra Jordan, a woman he realizes is Raymonds' mistress, to find her missing sister Maggie. He follows up the single lead to a hippy commune called Lunarhouse where Maggie has recently stayed.

Tracking down Maggie to a Santa Cruz motel, Jack tries to get to know her in an all-night diner. They find they have a lot in common in their painful childhoods and self-destructive urges.

Jack may think that he has solved this missing-person case, but the next morning it becomes a full-blown murder mystery when Maggie is found shot dead with a gun in her bag and a suitcase full of cash.

Brubaker has said that the inspiration for his plot came from the lives of two sisters that he knew when he was in his late teens. He writes that Maggie just wanted "a little piece of goodnight" she had never known as a child; he makes this the book's tender subtitle.

Unforgivable

Jack suspects that he has been set up. Here, far left, he confronts Raymonds, fittingly doing some target practice, who admits that he referred Alexandra to "keep this in the family." Jack is determined to get to the truth of why Maggie Jordan was killed. His parting remark hints again at his distaste for guns, rooted in a guilty secret.

Jack has been drinking again. When a pal tells him where his jilted girlfriend Gwen is working, he tries to apologize but falls down drunk. Writer Brubaker deftly reveals Gwen's conflicted feelings of concern and anger towards him. Notice how she can't leave him on the sidewalk and flags him down a taxi.

Home late, Jack finds that Uncle Knut and his friend Mollie have unearthed new evidence in their files, far left. Knut's crime-scene shot shows that years ago the Jordan family had lived in another local commune, "The Earthlings." What is more, Maggie's and Alexandra's father Geoff died in the fire that destroyed it. How does this connect to the drug-farming cult Lunarhouse and its leader Mitchell Luna? Here Jack shows the photo to the sisters' mother.

While there may be no escape from the damaging mistakes of the past, writer Brubaker shows how denying them and covering them up drag the Jordan family down even further, and how facing up to them lets Jack start to heal from years of self-torture.

Following on from Scene of the Crime

Kane

It's a jungle out there for the officers of New Eden's 39th Precinct. When two deliveries get mixed up, "big man" Rico gets a giant novelty carrot, while a man in a pink rabbit suit named Mr. Floppsie Woppsie receives a hot package of drugs. When he is picked up by the crooks, the police are not far behind. Notice how Rico's shocked outburst fills the penultimate panel.

Moments later, far right, female rookie Felix holds up Rico's gentle thug Frankie, who ends up floored by the bunny man's carrot. In his captions, Englishman Paul Grist sends up Frankie's grandiose internal monolog, a nod to Frank Miller. Grist subverts overearnest cop shows with faultless timing and crisp graphic economy.

Torso

In 1935, lawman Eliot Ness, the "Untouchable" who put away Capone and the Mob, is eager to pursue his fame and political ambitions as Cleveland's new Safety Director. When a string of mutilated bodies point to America's first serial killer, Ness vows to catch the "Torso Killer." His failure to do so thwarts his career.

Here, Ness confirms that the killer is preying on dwellers in the city's shantytown like this hobo. Ness's decision to clear the slum and torch it is decried by the press and gets him no closer to locating the murderer. From this true story, co-written with Marc Andreyko, Brian Michael Bendis uses photo collage and stark graphics, putting the text into dialog woven across the panels.

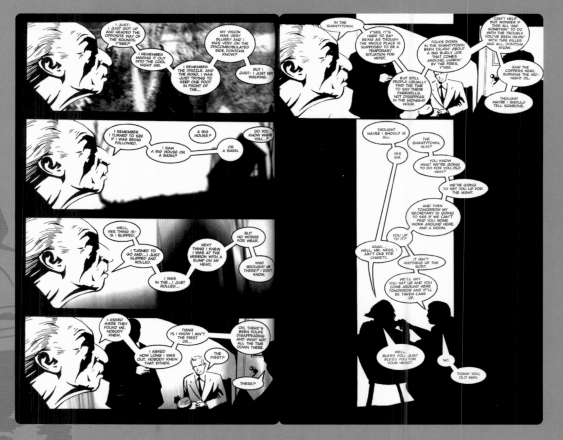

READING ON: MURDERERS 138 | FUNNY ANIMALS 139 | GANGLAND 124 | DETECTIVES 122

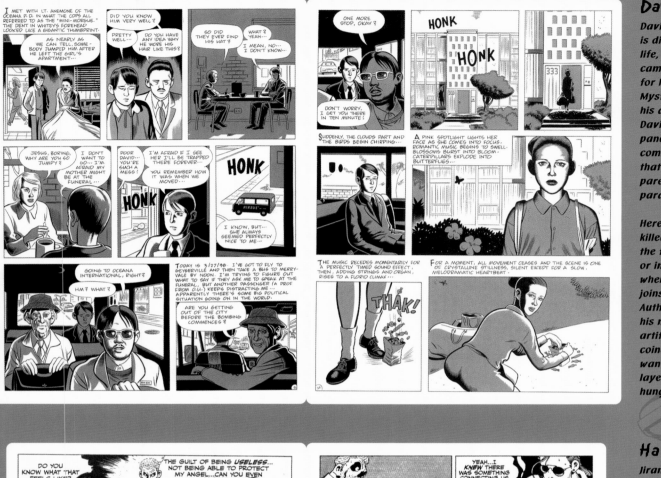

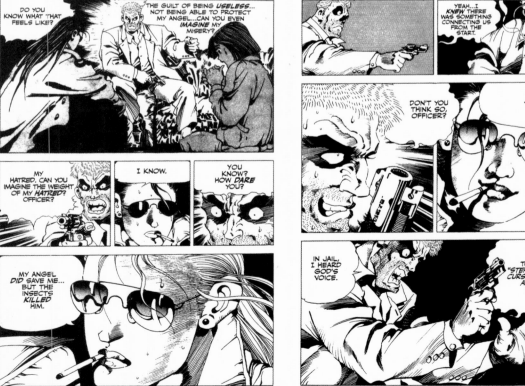

David Boring

David Boring lives as if he is directing a movie of his life, detached behind the camera, always casting for his "feminine ideal." Mysteriously abandoned by his artist father, every night David closely studies two panels from a YELLOW STREAK comic that he drew, sure that it holds answers to his parents' lives and maybe parallels to his.

Here, after his pal Whitey is killed, any worries about the funeral, his own safety or imminent war evaporate when his dream woman joins him in the minibus. Author Daniel Clowes makes his mystery beautifully artificial, full of luck and coincidence, because he wants us to savor all his layers of clues and not hunger only for a solution.

Hard Boiled Angel

Jiran Ha, a ravishing, three-packs-a-day loner in shades, is Korea's first female detective working hard for Seoul's Hard Crimes Unit. She has to be tough, even tougher than her macho colleagues, using her perception to get inside the heads of the killers she hunts down.

Jiran was driven to become a cop out of her feelings of helplessness, after she fled from a sexual assault, leaving behind her boyfriend who ended up dead. Here she has to keep her cool in a hostage crisis, when a man's similar past tragedy has turned him into a fanatical murderer with a mission. Author Hyun Se Lee is a master of "manhwa" or Korean comics.

Sin City in focus

"What's most distinctive to me about Frank Miller's work is the voices of his characters.
They're all looking for real estate–literal or psychological–to call their own... and
Frank has the good grace to comment on this neurotic drive with a sense of humor."
ELVIS MITCHELL

Pure motives

It's not hard to see why everyone calls Basin City "Sin City." Frank Miller has taken the bleak, venal American metropolis of classic crime fiction and films and pumped it up to hyper-real extremes. He gets to make all the cars vintage, all the women gorgeous, and all the guys big and tough with big guns.

What began as a short serial in June 1991 ended up stretching to 13 months and 200 pages of "The Hard Goodbye." According to Miller, "This one ran away with itself. I'd planned it as 48 pages, but I got carried away. It's all Marv's fault. The big lug started bossing me around. It's like that sometimes."

Marv and his other tough guys are heroes, in their flawed, tragic ways: "They might be disturbed, but if you look at it, ultimately, their motives are pure." As Miller puts it, to them "the ends justify being really mean."

Beyond the blood-soaked violence, Miller asserts that at heart each story is a romance of some sort: "You can't have virtue without sin. What I'm after is having my characters' virtues defined by how they operate in a very sinful environment. That's how you test people."

Imprisoned

Marv will avenge girlfriend Goldie's death, no matter how high up he has to go. Surprised and knocked out by the silent psychopath Kevin, Marv has woken here to find himself locked in the cannibal killer's tiled prison cell-cum-trophy room.

Inside with him is the killer's current victim, Marv's parole officer Lucille. She breaks the news to him about Goldie being a hooker and about what Kevin did to her left hand, all the while gazing at the decapitated heads of his previous victims lining the wall.

Marv tries using brute force to shift the bars. It's only in the last panel that we realize that from the start Marv has been staring through the bars at Kevin, crouching in the dark outside.

Miller slyly matches the zigzag on Kevin's jumper to the pattern on Charlie Brown's from the PEANUTS strip.

Miller's stories are propelled by the characters' huge passions, like a high-octane automobile careening off the road. There is also a jugular vein of black humor. Marv loves his gun so much, he has named it Gladys,"after one of the sisters from school."

Sin City

Frank Miller
1991–2000, 7 volumes, 894 pages

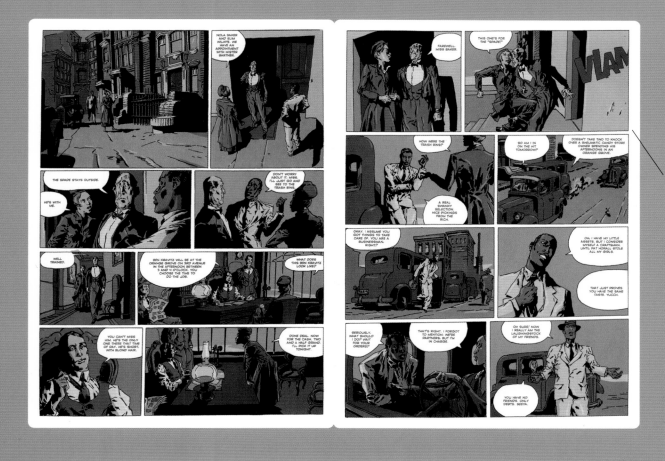

Miss

The seedy underbelly of New York's roaring 1920s brings together expelled convent girl "Miss" Nola and former Harlem pimp Slim. When their luck and cash run out, they hook up as guns for hire. Here, on a visit to a client to arrange a hit, they come up against the racial bigotry of the day, but Nola gets the last word. Survival may be more important to them than scruples, but their unusual partnership means that they wind up looking out for each other and slowly, warily, falling in love.

Subtitled BETTER LIVING THROUGH CRIME, the American paperback collects the quartet of gritty French albums by writer Philippe Thirault and artists Marc Riou and Mark Vigouroux.

Stray Bullets

"How's the old gang?" Wild girls Beth and Nina easily manipulate gullible kid Orson into their scam to steal cash and drugs from hard man Harry and then go on the run, hiding out in a trailer home in the sleepy town of Seaside. Their theft catches up with them when gangster Scott surprises them in their bedroom.

Here, Scott asks Orson "Where's my coke?" Grabbing Orson by his balls, volatile Beth insists on doing all the talking. There's a palpable menace with Scott's knife and his creepy cohort Monster looking in. These desperate lowlifes are caught in writer David Lapham's tightening web, which he spins out in a grid of uniform panels like a movie storyboard.

V for Vendetta in focus

> "I didn't expect to leave with days and days of thinking about all the questions it brought up—the moral issues, the philosophical issues and political issues. It's really relevant to our times."
>
> NATALIE PORTMAN

England prevails

In a debased future not unlike Aldous Huxley's BRAVE NEW WORLD, *ideas are dangerous. After a near-miss nuclear holocaust, England succumbs to a fascist dictatorship, which represses all human rights, individual freedoms, tolerance, culture—and the idea of living, fighting, and if necessary dying for these principles.*

Terrorist or freedom fighter, V will not let us forget these ideas. The authorities strive to uncover who V really is behind that papier-maché mask, but that revelation finally does not matter. Evey, the young woman whom V rescues and transforms, comes to understand that "whoever you are isn't as big as the idea of you." He may be killed, but she sees that what he has come to mean will live forever, because "ideas are bullet-proof."

The series was created for the British magazine WARRIOR *in 1983. David Lloyd formulated the practice of omitting all sound effects, thought balloons, and outlines on speech balloons and captions. He also chose the polarized graphics of either deep shadow or blinding light. Left unfinished, the saga was re-started and concluded from 1988 in ten "colorized" DC comic books.*

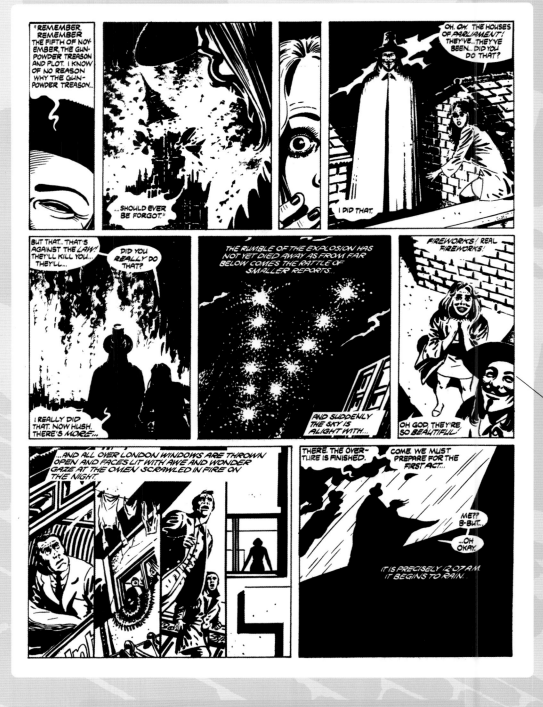

November 5th

Appearances are also vital here, the theatre of disguises, big gestures, and dramatic effects. The grinning, moustached mask, conical, wide-brimmed hat, and billowing cloak worn by "V" may be all but forgotten in this nightmare future, but they are instantly recognizable to anyone in Britain today.

Every year, on the fifth of November, bonfires and fireworks are lit across the land to commemorate Guy Fawkes (1570—1606), executed for his role in the "Gunpowder Plot," an attempt to blow up King James I and the Houses of Parliament in London in 1605.

Here, for an "overture," V succeeds where Fawkes failed. He recites to Evey the old rhyme that she was never taught and sends up a signal, the first firework she has seen.

This book's title plays on the patriotic slogan "V for Victory." Words and phrases beginning with V fill the pages. So does the shape of the letter, in V's signature symbol, people's outstretched arms, even a road's receding lines in the last panel. Its translation into Polish drew great acclaim, suggesting that wherever it is published, its message of liberty will strike chords among readers.

V for Vendetta

Alan Moore & David Lloyd
1990, 1 volume, 288 pages

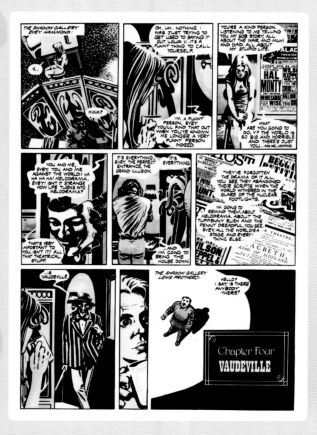

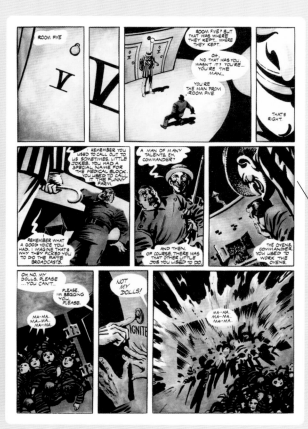

Stage fright

The Shadow Gallery is V's base of operations, where he takes Evey. It is filled with the artistic wonders banned by the new government, as well as housing a flexible stage set for V's performances for others. Here, far left, V gets changed behind a screen into a vaudeville costume and Mr Punch mask.

Broadcaster and doll-collector Lewis Prothero, loved as the official "Voice of Fate," finds himself trapped inside a terrifying psychodrama that V has created to return him to Larkhill Resettlement Camp. This was where V was kept in Room 5, or V in Roman numerals, and where Prothero was in charge of the ovens. It may all be a stage set, but its impact on him is shattering.

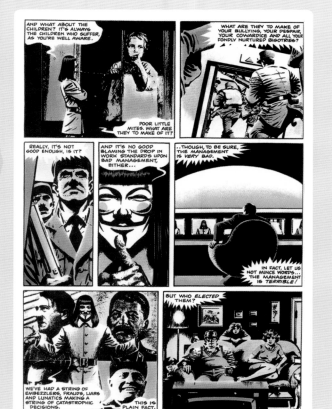

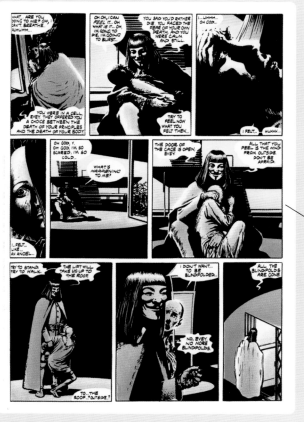

Values

Like the government, V understands the power of television and hijacks the only channel to transmit an address to the public. Here, far left, we hear his video, but what we see cuts away to security closing in on him, to the "management" monitoring him, and lastly to the stunned viewers, the people who are to blame. In other words, ourselves.

In a deeply moving, pivotal chapter, V comforts and guides his confidante Evey after she has endured torture and faced her own death, and not at the hands of the state police as she believed. Her ordeal proves transformative, as now "all the blindfolds are gone." Moore and Lloyd ask us to think how highly we as a society value our freedom.

Following on from V for Vendetta

Roach Killer

Brooklyn, 1983. Walter Eisenhower works for New York's Blitz Exterminating Corp. His mistake is taking the elevator to the 13th floor. He stumbles across a sinister operation which manipulates expendable misfits like him into assassinating prominent targets, knowing that they will be arrested on the spot as the "insane" culprits.

Here, standing out like a target in his red uniform, Walter recalls "the point of no return." Later, far right, he confides in a colleague, the Puerto Rican Luis, whose murder will soon be blamed on him. Parisian writer and artist Benjamin Legrand and Jacques Tardi ensnare their rootless bug-killer in a web of paranoia and political conspiracy.

Mauretania

In this "tale from a darker world," bored clerk Susan discovers that her employers are actually the state's thought police, "Rational Control." She becomes a reluctant agent in their inquiries into the motives of "Jimmy," a man always in a helmet and visor who is operating from the building opposite. What is his connection to the closing down of "harmful" businesses? How will he "make a new world?" To find answers, here she goes to him for a job interview.

Welsh-born Chris Reynolds' bold, woodcut-style art, framed by thick borders, and his sensitive writing and pacing imbue the most uncanny concepts with a matter-of-fact solidity.

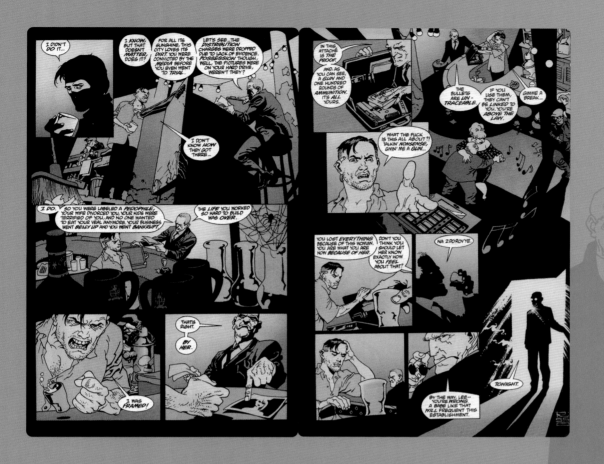

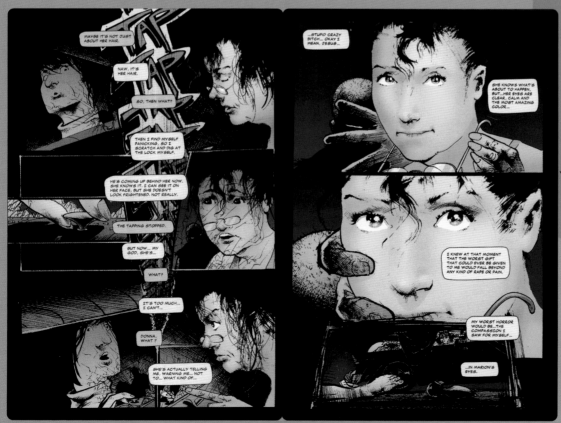

100 Bullets

Revenge is sweet and, it seems, fully guaranteed, when Agent Graves offers powerless individuals one of his briefcases. Inside each case are proof of who wronged them, a gun that cannot be traced, and 100 rounds of ammunition.

Here, Graves gives a rich restaurant owner, reduced to slaving in a seedy bar, the chance to kill the woman who framed him and get off scot-free. But why has Graves, once a hitman for criminal cartel The Trust, gone renegade and turned on his former bosses, baiting them through their victims? Chicago writer Brian Azzarrello's street talk and tight characterization are teamed perfectly with the sharp art of Argentina's Eduardo Risso.

Four Women

Midnight, the middle of nowhere. Four women stuck in their broken-down car. All that protects them from two rapists outside, whose truck has crushed the women's car, is the car's power locks. Each woman has to decide if she will be victimized or fight back.

Here, Donna recounts events to her therapist in dialog captions (Donna's are light yellow). We stare through her eyes into the eyes of Marion, who gets out of the car to divert the men from the youngest woman trapped in the trunk, before she is seized from behind. Author Sam Kieth's claustrophobic scenario asks what is stronger—friendship or self-preservation?

There are mysterious things in this land...
but tell me, where will you go now?
Hugo Pratt, Corto Maltese in Africa

Behind the Smile

Marriage to an overworked, underpaid cartoonist does not always run smoothly. When deadlines loom, quite a number of "comic book wives" end up assisting their husbands, perhaps on lettering or tidying up their pages. Carl Barks' second wife used to help him with his artwork for the uncredited *Donald Duck* and *Uncle Scrooge* stories that he wrote and drew for Walt Disney's multi-million-selling comic books. All this changed when she became addicted to alcohol, which made her self-destructive and destructive to others. She was prone to tearing up file copies of his comic books and threatened to do the same to his originals. By 1951, as she succumbed to alcoholism, their rocky marriage was disintegrating. At one lowpoint, when Barks was forced to move out, he was reduced to "living in a little room they made in a corner of a little warehouse. I had two blankets that I had gotten out of the whole deal and my drawing board, of course, and my [*National*] *Geographics*." When they were divorced, she took him for everything he had, even "a car that she couldn't drive."

Incredibly, Barks created some of his greatest work while living through these dire personal circumstances. Looking back, he wondered whether they might have actually helped him. "It seemed like the more difficulties I had, why, the bigger the inspiration that would come when there was just a moment of calmness." As a result, he found that "doing these stories was such a relief from my own everyday troubles and problems." Barks created his duck stories first of all to delight himself. Perhaps it is their almost therapeutic quality, like soothing balm for the troubled soul, that may help to explain why his Disney adventures are ceaselessly reprinted and enchant readers worldwide to this day. To those who know Donald and company only from the animated cartoons, it can come as a surprise to discover that Barks' comic book incarnations of them, supposedly intended solely for children, are

so clever and multi-levelled. In Europe, and especially Scandinavia, Barks' oeuvre has become an institution.

Easily overlooked as juvenile, the "funny animal" trappings can express so much about our feelings and failings. Popularized in early cartoon films, these anthropomorphic characters may look like bizarre, oversized, upright ducks, cats, mice, and other critters, but we identify with them because they share the same hopes and fears as us. Their modern counterparts in graphic novels include Jim Woodring's Frank, Kim Deitch's Waldo, and Chris Ware's Quimby, who manage to hark back

wistfully to American animation's golden age while also probing into less innocent psychological areas. Carl Barks also exerted a formative influence, for example on the young Robert Crumb, and on France's Joan Sfar and Lewis Trondheim. Could their hopeless warrior-duck Herbert be a distant ancestor of Donald's? And surely an aardvark must be about the most improbable "funny animal" star in the form of Cerebus, protagonist of Dave Sim's magnum opus.

In the human comedy, we also enjoy laughing at ourselves, or preferably at others, at rogues and fools, and their schemes and misfortunes. One of the earliest of these to captivate the British public was the bald, bulbous-nosed, Micawber-like reprobate Ally Sloper. His Dickensian name says it all, derived from the way he slopes down the alley to avoid those he has swindled. His first con game filled a one-page strip in the August 14 1867 edition of *Judy*, a new twopenny rival launched that year to undercut the threepenny humor magazine *Punch*. Judy was the name of the long-suffering wife of Mr. Punch in the street puppet shows, so it was an apt title for a magazine aimed at lower-class, lower-income readers, including women. Unusually, Sloper's illustrator was a woman, one Marie Duval, using a deliberately simple style and signing herself "MD." This was the pen-name of Isabelle Emilie de Tessier, born in Paris in 1850 and the new young wife of *Judy* creator and writer Charles Ross, fifteen years her senior. Nearly 80 of their collaborations were compiled with extra material into a one-shilling paperback in 1873, to make up a supposed "biography" of comics' first Cockney rascal.

Above right: A mock biography of East London rogue Ally Sloper by Marie Duval from 1873

Right: Father-turned-infant Leo Quog flees his responsibilities in Jules Feiffer's 1979 *Tantrum*

Opposite: Jim Woodring's Frank grins and bears his silent panic

Behind the Smile

Right: The satirical 1960s kick off in Harvey Kurtzman's wild paperback and in Goscinny & Uderzo's *Asterix*, both from 1959

Below: Claire Bretecher sends up test-tube pregnancy in *Where's My Baby Now?* from 1983

Opposite: Rainy days in Seattle for Peter Bagge's *Buddy Bradley*

Two decades later across the Channel, on July 20 1894, the Russian-born emigré Emmanuel Poiré, famed as Caran d'Ache for his elegant silent cartoon strips, wrote to the Paris director of the newspaper *Le Figaro*. Bursting with enthusiasm, he proposed to create a new genre, *le romain dessinée* or "drawn novel," told purely in drawings. He had his story already mapped out for some 360 pages, entitled *Maestro,* about a musical composer of genius. It was never published and was long believed never to have been drawn, till dozens of pages of the sadly unfinished *Maestro* recently came to light. Published by France's comics museum in Angoulême, they give a glimpse of Caran d'Ache's vision that was ahead of its time.

The time for the "drawn novel" would come, when the screwball lunacy of American cartoonist and humor writer Milt Gross spilled over onto the silver screen by collaborating on the script for Charlie Chaplin's silent 1928 film *The Circus*. Out of this experience Gross developed the cartoon book *He Done Her Wrong* in 1930. With nothing spoken in all its 246 pages, Gross lampoons Hollywood's hammy, over-the-top acting and repertoire of riotous slapstick and weepy melodrama. From the Frozen North of the Alaskan Gold Rush to the crooked wheeler-dealing of New York City, it follows a big, simple-minded lumberjack of exceptional strength, exploited by a conniving robber baron, who steals his wilting saloon-singer heartthrob. Gross jokingly proclaimed it "The Great American Novel and not a word in it—no music too."

Gross and his early 20th century contemporaries on the newspaper funny pages came out of the previous century's great cartooning traditions. Before the silent comedy movies, it was the routines of music hall, cabaret, vaudeville, and street performers that used to be echoed in the knockabout physicality and broad verbal repartee of many comic strips. Cartoonists like Wilhelm Busch and Caran d'Ache brought such expressionistic energy to their comics by distorting manic faces and bodies warped by motion or emotion. In addition to admiring these two pioneers, Harvey Kurtzman, creator of America's most subversive post-war satire magazine, *Mad*, in 1952, was struck particularly by the work of one Englishman who followed in their line. "You know who really affected me more than anyone else? A guy by the name of H.M. Bateman. He

did continuities with such a heightened sense of movement, he affected a whole generation of *Punch* and *Judge* cartoonists." Kurtzman would go on to do the same himself for successive generations in America and in Europe. After masterminding the scathing parodies of comics, TV, films, and advertising in *Mad* from color comic book to black-and-white magazine, he quit in 1956 to head up a new glossy for *Playboy*'s Hugh Hefner. *Trump* was axed by an overextended Hefner after two issues. By 1959, after the failure of his self-published *Humbug*, Kurtzman was without an editorial position and at a loose end.

Meanwhile, *Mad* was going from strength to strength and Kurtzman's classic issues were being reprinted in popular paperbacks. When their publisher, Ian Ballantine, lost the *Mad* license, he approached Kurtzman about producing an all-original humor paper-back. There had been a few sophisticated cartoon strip hardbacks by then, such as *The Juggler of Our Lady* by *Humbug* contributor R.O. Blechman in 1952, and *Sick, Sick, Sick* in 1958, the first collection by *Village Voice*'s Jules Feiffer. For his *Jungle Book*, Kurtzman chose the highly populist media targets of cool 1950s private eye *Peter Gunn*, new TV western *Gunsmoke*, sex and politics in the Deep South, and the shoddy business of cheap magazine publishing, a field he knew only too well. "I wish [Ballantine] could have broken through with this, because I truly liked the format." In the end, it was a one-off. Kurtzman saw a future for new comics in book packages, but had to abandon a color interpretation of Charles Dickens' *A Christmas Carol* that he had started when he was unable to secure a publisher. The future for Kurtzman would once again lie in magazines. First came *Help!* in 1960, where he brought back his naive innocent Goodman Beaver, introduced in *Jungle Book*. Then came *Playboy* in 1962, where he gave Goodman a sex change into the pneumatic Little Annie Fanny, whose racy, lavishly

painted satirical romps became a *Playboy* staple till 1988.

After Kurtzman's death in 1993, Art Spiegelman created the tribute strip "A Furshlugginer Genius" for *The New Yorker*, in which he hailed the original *Mad* as "an urban junk collage that said 'Pay attention! The mass media are lying to you ... including this comic book!' I think Harvey's *Mad* was more important than pot and LSD in shaping the generation that protested the Vietnam war." Belonging to this same generation were America's 1960s underground comix artists, who saw Kurtzman as their undisputed godfather. At *Help!* he had given Robert Crumb, Gilbert Shelton, Terry Gilliam, and others early exposure. It's hard to overestimate his influence, which remains strong today among graphic satirists like Daniel Clowes, Peter Bagge, and Kyle Baker.

Equally unmistakeable is the impact of Kurtzman and *Mad* on European comics, in particular on Franco-Belgian bandes dessinées. For instance, Morris, artist on laconic cowboy *Lucky Luke*, knew Harvey in New York in the early 1950s and helped him out on the birth of *Mad*. This was clearly one model for the new French weekly *Pilote* in 1959, home of *Asterix*. Writer René Goscinny and artist Albert Uderzo wove several layers of comedy for children and for older readers into their battle of wills between Rome's conquering armies and one last Gallic village, which helped the book collections sell in their millions to all ages. The 1960s also brought more biting humor to French comics inspired by *Mad* and the American underground, in magazines like *Hara-Kiri* and later *L'Echo des Savanes* and *Fluide Glacial*. Among the best is the withering social observer Claire Bretecher.

Tougher, angrier, more politically charged adult satire has become possible as the graphic novel gained ground. Who would have expected the gentlemanly English children's book illustrator Raymond Briggs to speak out so passionately against nuclear weapons? His 1982 book *When The Wind Blows* takes its title from a lullaby, but its message was a wake-up call to many about the terrors of the bomb. It was even noted in Britain's parliamentary record Hansard as "a powerful contribution to the growing opposition to nuclear armament."

It does not always help our understanding to boil down a complex political issue to a single pithy editorial cartoon in a newspaper. These can be effective for rapid, mocking strikes against politicians that provide a brief, forgettable morning chuckle, but comics and graphic novels allow a fuller, more insightful narrative, to explore all sides, to open up the debate. Steve Darnell and Alex Ross rescued America's patriotic symbol Uncle Sam, all but worn out by political cartoonists, and gave him a new lease of iconic life. Yesterday's scandals can easily get forgotten in the constant flurry of fresh headlines. British team Peter Milligan and Brendan McCarthy felt strongly that the corporate violence of the drug Thalidomide, which caused birth defects in thousands of babies, should not be allowed to slip from public consciousness. Their livid, foul-mouthed revenge fantasy *Skin* for the Fleetway comic *Crisis* minced no words, but it upset the reproduction company, who refused to handle it. Fleetway's lawyers advised them not to publish it. Silenced, like Thalidomide's victims, *Skin* was bounced like a ticking bomb from publisher to publisher, until it at last saw print in 1992. Many cartoonists and commentators have tried to deal with the attacks of September 11 2001, but only Art Spiegelman dared to do so using the huge, colorful canvas and bag of tricks of the old-time Sunday newspaper strip pages to grapple with that day's personal and political aftereffects.

Some might wonder, is the only good graphic novel a serious graphic novel? If graphic novels run the risk of acquiring a reputation for being in deadly earnest, luckily there are always plenty that are genuinely, wonderfully funny. For "quality jollity," few can compete with African-American cartoonist Kyle Baker. His *Cowboy Wally* is a much-needed assault on the worst of American showbiz, a fat, drunk, blissfully stupid celebrity, the sort who is famous only for once being famous, but whose career somehow keeps going. What is chilling is how *Cowboy Wally*'s lamest fiascos are now being surpassed by "reality" television. The reality of the 2000 Bush–Gore election triggered *Birth of a Nation*, drawn by Baker, in which Aaron McGruder and Reginald Hudlin show how angry, disenfranchised black voters found their own separate state. It's the sort of wild but plausible and pointedly topical "what if" that the free-wheeling, flexible comics medium can pick up and run with so successfully. It's more proof of what Peter Ustinov once said: "Comedy is a simply a funny way of being serious."

The Frank Book in focus

"The ancient myths and folk tales of all cultures which have been preserved for so many centuries have meaning for us today because the fantastic elements in them are rooted in immutable reality. The *Frank* stories belong to this class of literature."

FRANCIS FORD COPPOLA

Unreality

"Hardcore oddball" Jim Woodring was a highly imaginative child who always inclined towards the mysterious and the hidden. His discovery of the art of Surrealism and Boris Artzybasheff sealed his fate. Turning to comics, he drew the radially symmetrical shapes that he used to see hovering over the foot of his bed as the gyrating ghostly "jivas."

In silent comics, no one can hear you scream. The lack of any spoken words or sound effects sends us back to our pre-literate, childlike state, where we had to make sense only from what we could see.

Woodring's fables challenge rational understanding, but they incite primal awe and instinctual recognition, like folk art or cave paintings that illustrate profound human truths. He avoids explanations "because the stories are more powerful when their mysteries are undiscovered."

What is Frank?

Frank began in 1989 as a doodle while Woodring worked in animation. He is not a cat, or a mouse, or a beaver, or any other creature, but a generic anthropomorph. His name was given by a friend's mother, because he reminded her of her cat. Frank is innocent but not noble.

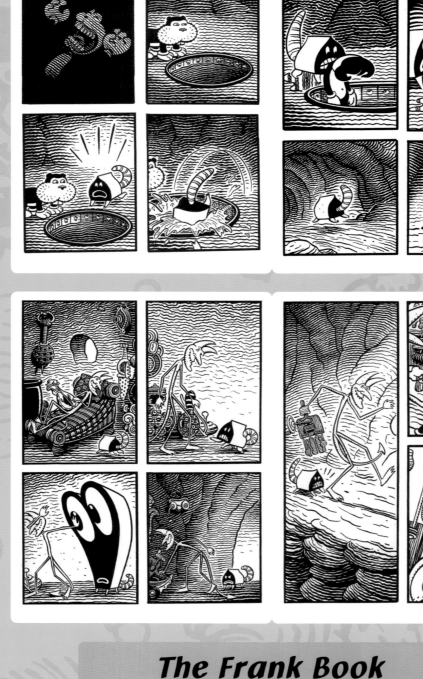

Transformation

Things rarely stay the same for long in the transformative world of Frank, where a pastoral Eden can mutate into purgatory in the blink of eye. In these four pages from "Frank's Faux Pa," one wrong step leads to disaster. Once again, Frank's wide-eyed curiosity and dream-driven desires have landed him in trouble in an underground well where he is in danger of drowning.

While one of his two fathers, the Faux Pa or Real Pa, looks on ineffectually, Frank's best friend, his tough, devoted Pushpaw, dives in to rescue him. Dragged to the surface, Frank is now in an altered state with multiple eyes and an expanded upper head.

Pushpaw might look small, but she can enlarge herself to a threatening scale. This helps her to hound the spindly, grinning trickster Whim, horn-headed and fork-tailed, into restoring Frank with a twirl of his Whim-Grinder.

In the tradition of cartoons, no matter what befalls him, Frank always emerges unharmed, and, like many of us, none the wiser for his puzzling experiences.

The Frank Book

Jim Woodring
2003, 1 volume, 344 pages

Guilty stares

In this conclusion to the short story "Frank's Fish," our hero has caught a big, staring fish with a Dali-esque moustache. Bringing it home to cook, Frank becomes unnerved by its staring eyes and grimace.

No amount of chopping and slicing will get rid of them. Frank regularly reaches a state of panic, climaxing here with the final twist, as if he has been possessed by the fish. Whether this is a plea for vegetarianism, a surreal nightmare about guilt, or something else is open to interpretation.

Notice the Arabian Nights architecture of Frank's home and its exotic fixtures inside. Woodring's colors add a radiant lustre that harks back to classic animated cartoons.

High horse

Whim is up to his tricks again, tempting Frank to try strange instruments that retrieve a critter like a flying manta ray. Nursing it back to health, Frank finds it becomes aggressive and overprotective, and willing to do whatever he asks of it. Frank's character grows cruel and superior.

Here, Frank sets him on Manhog, a pink, bristly, naked man on all fours with a pig's head and curly tail. Manhog is described by Woodring as "a lamentable father figure," reduced here to Whim's beast of burden. This weird, worm-like thing seems to live inside Whim's head. Frank's jape fails to amuse Pushpaw, who has to rescue her master from a sorry state yet again. Will Frank ever learn?

Following on from The Frank Book

The Boulevard of Broken Dreams

Growing up around his father's animation work, Kim Deitch hoped to follow in his footsteps until he realized that the business discouraged much original thinking. Out of accounts of America's first studios, from pioneer Winsor McCay to the Disney factory, he and his brother Simon fashioned the life of frustrated alcoholic Ted Mishkin, whose character Waldo the Cat, a hybrid of Felix and Mickey, is also his imaginary companion.

Here, Ted's doctor theorizes that Waldo is a spirit of self-destruction which has plagued the animator and embodies his struggle between madness and genius, between "mortality and art triumphant."

The Wipeout

Imagine Dostoevsky's CRIME AND PUNISHMENT played by sordidly human cartoon mascots from Italian 1960s advertising and directed by Luis Buñuel and you'll have some notion of Francesca Ghermandi's noir fantasia of desire and deceit, painted in the lustrous palette of vintage cartoons.

Here, big-nosed die-cut Jim meets lozenge-headed Virgin Prunes. When they discover that Jim's miracle cleaning fluid mixed with milk literally wipes people out, Virgin lures Jim into murdering her husband. But her true motives are far more devious. Since Jim is the same shape as her hubby, Virgin plots to wipe Jim out and pass off his blank corpse as Mr Prunes' to claim his life insurance.

Space Dog

In the Sputnik era, a little red pup gets more than he bargained for when he leaves the farm for adventure in the big city and winds up as NASA's first dog in space. After a close encounter with benign aliens boosts his brain, he returns as a canine celebrity walking on two legs with a mission to save the planet.

Here, he says goodbye to his former master when he is invited to address the United Nations about the stark choice between the green aliens' vision of harmony or humanity's destructive path. German designer Hendrik Dorgathen cleverly uses icons as words and thoughts, and bold, almost woodcut graphics in his endearing, allusive animal fable.

The Princess Mermaid

Worlds apart from Disney's sugar-coated adaptation, Junko Mizuno has recharged Hans Christian Andersen's original with the "kawaii" or cute stylings of "shojo" manga or girls' Japanese comics. She spices up their doe-eyed, doll-like Lolitas with sex and horror, making them into wilful, empowered females, like Junko herself.

In revenge for the humans' cruelties to their mother, siren mermaids Tara, Julie, and Ai devour the sailors they lure to their aquatic bordello. Julie, however, falls for sulky human Suekichi, even if it means becoming human herself. Mizuno's underwater romance slips easily between fairytale charm and unbridled passion.

Cerebus in focus

> "Dave ploughs his own furrow philosophically, ideologically, commercially, and spiritually. *Cerebus* cannot be compared with anything anyone else has done. It's unparalleled in its evolving portrait of its subject and its subject's creator."
> NEIL GAIMAN

Committed

Nobody in comics before Dave Sim had the guts to commit themselves to something this big and this daring: a closely examined life told without fear in 6,000 pages, serialized in 300 issues, a labor of 26 years and 3 months.

Sim aspired to the comics equivalent of a Russian novel, so as to try many themes and approaches. A life story with all its echoes and questions overarches the 16 "phonebook" volumes, many of them accessible separately or grouped together as greater wholes. Raucous parody can sit beside philosophical musings, Oscar Wilde's fate, or the Origin of Everything.

A happy ending was never likely after Cerebus was told he would die alone, unmourned, unloved. Still, the "Earth-Pig" lives to giddy heights and depths, as a barbarian brute, papal tyrant, bar-keeper, lover, father, and more.

Sim's fascination with religious, political, and sexual debate led him to devise a plausible post-industrial matriarchy and its opposing force based on daughters, which resembles feminism. As a personal soapbox and pulpit, CEREBUS was the outlet for Sim's evolving belief systems, unafraid to ruffle feathers and raise thorny questions.

Cerebus
Dave Sim & Gerhard
1977–2004, 16 volumes, 6,000 pages

Power corrupts

CEREBUS is the story of the life and death of a short, greedy, irritating aardvark, apparently alone in a world of humans. "High Society," a good entry point, is where Sim embarks on a sweeping satire of the political machine.

Cerebus is a guest of Groucho double Lord Julius in the city of Iest. The Lord's ex-wife Astoria plots Cerebus' campaign and gets him elected Prime Minister. Nobody's puppet, Cerebus soon shows his true nature by planning to pillage riches from neighboring lands.

Here, after making a painfully persuasive point to a government spokesman, Cerebus meets a former fellow rogue, Mr "Baldy" Pate. Their "old days" are over now and Cerebus demands subservience. In a cunning plan worthy of BLACKADDER, he gets Baldy to steal his official jewels, but offers no protection if he is caught.

One of Sim's strengths is his skill at showing nuanced dialogue through the size, style, and font of speech and placing and shape of balloons. Here, he uses icicles to accentuate coldness and jagged underlining for exaggerated emphasis. No sooner is the door slammed than the press is headlining the theft and scandal.

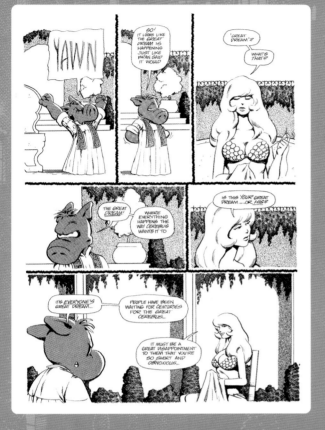

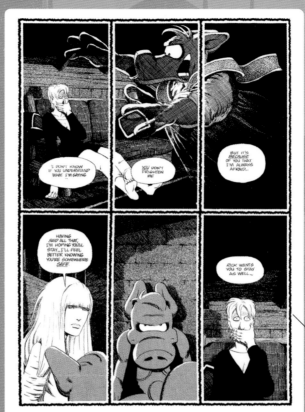

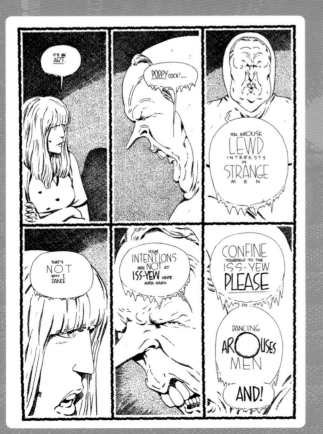

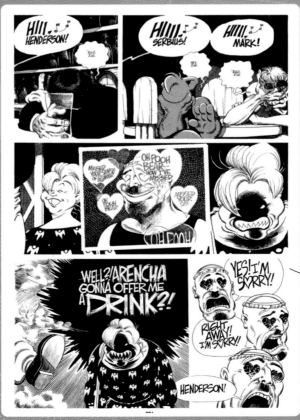

Mind games

In "Church and State," far left, Cerebus is a selfish, uncontrollable pawn in a chaotic power struggle. He has been elected Pope and tricked into marriage with Sophia. His great dream of adoration, wealth, and power seems to be coming true, until his wife decides to leave him. Notice how Cerebus refers to himself in the third person. Sim sets up the factions as he looks into the effects of power on belief and vice versa.

"Jaka's Story" focuses on Cerebus' one true love, her painful childhood, and her strained marriage to Rick. In a tense love triangle under one roof, Rick, hand over his mouth to hide his shock, overhears Jaka offering Cerebus refuge. It's the last thing Rick wants, as he recalls the aardvark in his papal regalia.

Jaka is arrested for working as a tavern dancer. Far left, she is interrogated by Mrs Thatcher caricatured as a poisonous abbess. Sim makes us consider the plight of art and artists under a repressive state. Thatcher's deviousness will destroy Jaka's marriage by revealing to Rick the truth behind her miscarriage.

After lots of boozy male bonding in the bar in "Guys," Bear's duplicitous wife Ziggy, part vixen, part shrew, arrives and totally controls her lovesick husband. Hearts fill his eyes and his words, as she switches from her sing-song "Hiiii" to her irate demand for a drink. Sim dares to ask if the benefits to men of celibacy might outweigh the price they pay for being neutered in a manipulative marriage.

Following on from Cerebus

Dungeon

French madmen Joan Sfar and Lewis Trondheim are spinning out a joyfully sprawling epic, which can be enjoyed, like Terry Pratchett's DISCWORLD saga, equally as parody and as inventive genre fiction.

Their heroic odd couple are the timorous duck Herbert and Marvin, a blood-thirsty, vegetarian dragon. Here, Herbert pretends he has stomach ache to cover up the complaints from his magic belt, which refuses to let him draw his sword until he has accomplished three great deeds. He achieves one of these, far right, by winning the Goblin King's ripe socks at cards. The cross on his chest shows where he had his heart plucked out to ensure that he completes his mission.

Louis

The Hamlet might look quaint, but its environment is polluted and its citizens stultified. One of them is the isolated, sensitive dreamer Louis, a model citizen and worker, his only company the caged bird Formulaic Companion. Instead of accepting his barren subsistence, Louis hungers for a fuller life. To keep him in line, his neighbors invent an aunt for him to write to, but they have reckoned without a visit by the free-thinking Mr. Slow and his gift of healthy food.

In their "scary-cute" allegory, Metaphrog adapt the gentle nature of children's stories to show the suffocating effects of state and media manipulation on the non-conformist individual.

Following on from Cerebus

Jungle Book

In "The Organization Man In The Grey Flannel Executive Suite," Harvey Kurtzman introduces us to his Candide-like innocent abroad, Goodman Beaver, a good man and eager beaver, here on his first day at Shlock Publications. Exorcizing his own experiences in comics and magazines, Kurtzman pillories the cheapness and greedy capitalism of exploitation publishing as he charts Goodman's metamorphosis from idealistic underling to ruthless go-getter.

Drawing in lively line-and-wash breakdowns, Kurtzman times his speech balloons perfectly, here pitching Goodman's awed, overblown soliloquy before the inane office babble about coffee.

The Freak Brothers

When the dope-loving trio decide to fly to Colombia, "source of many miraculous substances," they get separated on the wrong planes and become THE IDIOTS ABROAD. Franklin lands in a Central American mountain settlement, where an ancient calendar, far left, records his past and future. Afraid that he is to be sacrificed, Franklin flees to a village, left, where a jumped-up colonel uses him to test his Cadillac for bombs and provides him with a new set of wheels. Aided by Paul Mavrides and Guy Colwell, Gilbert Shelton sends his Fabulous Furry Freak Brothers on a zany world tour with the F.B.I.'s Norbert the Narc hot on their trail.

American Splendor in focus

Off the streets

Tales from the city of Cleveland sum up ordinary American life, if any life is ordinary. Resident file clerk and writer Harvey Pekar started recording his life and reflections and those of his friends and co-workers by scripting them into stick-figure storyboards.

Pekar had been a neighbor of Robert Crumb's from 1962–66. By the mid-1970s, Crumb's counterculture success was waning, so the timing was perfect for Pekar to persuade him to draw some of his scripts. In 1976 he published them in the first issue of his irregular magazine AMERICAN SPLENDOR.

Pekar brought a new approach to stories in comics. In Crumb's view, "He brings this mundane work-a-day world to life, gives us its poignant moments, its humor, absurdity, irony... and mostly, its absolute truth. There is no exaggeration in these stories. What you read is what REALLY happened."

The silhouette of a slouched Pekar here reflects his gloomy state of mind. As a former Clevelander himself, Crumb draws the city's landscape with a perceptive eye.

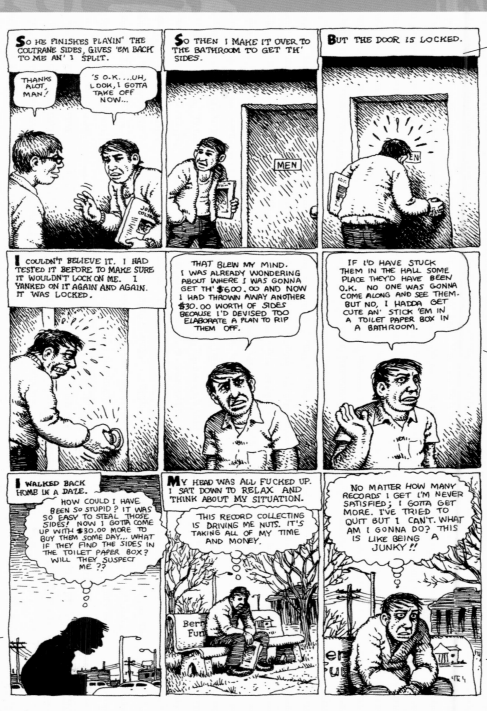

Collecting

To help finance his addiction to collecting jazz records, Pekar hustles second-hand records to his fellow workers. In the true tale "How I Quit Collecting Records And Put Out A Comic Book With The Money I Saved," Pekar has gone to a college radio station where he plans to sneak out with some choice LPs he is after.

To be clever, he has hidden the sides in a men's toilet, but his plan backfires on him. The narrative switches from a captioned flashback to a present-day confessional, in which Pekar addresses the reader face to face. Then we return to the past and overhear his self-reproachful internal monologue.

It is this example of his addictive behavior that convinces Pekar finally to kick the habit and quit collecting records. This enables him to save enough money over a year to finance the publishing of the first issue of his AMERICAN SPLENDOR magazine.

Fittingly, here in the urban wasteland, with the trees bare, Pekar is sitting on a public bench which advertises a funeral home.

American Splendor

Harvey Pekar and various artists
1987–2005, 5 volumes, 1,376 pages

Write about it

When things get him down or angry, Pekar has an outlet. "That's about what I can do when things bother me—write stories about them." Few people before Pekar had considered such minutiae as the irritation of choosing the wrong check-out, far left, as subjects for short stories in comics. Notice how Crumb puts him inside a stage spotlight to speak to the reader.

To record Pekar's battle with cancer, artist Frank Stack moved in for a while with him and his wife and co-writer Joyce Brabner to observe them. "It was a bit like being tailed by NATIONAL GEOGRAPHIC." Pekar's first full-length story, the 224-page "Our Cancer Year," records the strains on their relationship. Here, he finds it hard to take any sick leave, until his falling weight and Joyce's "permission" let him do so.

While loathing the cult of celebrity, Pekar has had his brushes with fame, notably his appearances on THE DAVID LETTERMAN SHOW, drawn far left by Joe Zabel and Gary Dumm. Expected to perform as an amusing eccentric, Pekar tries to hijack the chat show and make some serious political points. It fails to lead to a career in television.

Pekar expected no return from his comics, but since 1980 he had tried to get people to base a movie on them without success. Finally, HBO backed a film version in 2003 which became a surprise hit. It mixes actors with Pekar and the other real people they portray, like "genuine nerd" Toby Radloff, illustrated here by Bill Knapp.

Following on from American Splendor

Buddy Does Seattle

It's 1990 and misanthropic slacker Buddy Bradley has moved out to the Pacific Northwest to share a scuzzy apartment with resident "intellectual" George and disgusting wannabe rockstar Stinky. Ever the opportunist, Buddy agrees to manage Leonard and the Love Gods, a hopeless band formed by Stinky and three guys called Kurt.

On tour and stuck in their van, tensions erupt when Stinky reads out a rave fanzine review, and Buddy finally snaps. Wildly elastic and painfully funny and honest, Peter Bagge's cartooning documents Seattle's peak as the cultural nexus of the "grunge" generation, venereal warts and all.

Tantrum

Weary of life's demands, 42-year-old family man Leo Quog thinks that he can escape by reverting to infancy. Deserting his wife and kids, he finds no welcome from his parents nor help from his siblings. Here, on his return, his wife takes him to her lawyers, where he is hounded by his responsibilities, driving him away once more.

Leo's flight takes him from a militant movement of other adult children like him to the absurd starvation diet of his brother's estranged wife. In his energized whole-page cartoons, Jules Feiffer targets a parade of human delusions, above all our self-involvement and our failure to communicate and connect.

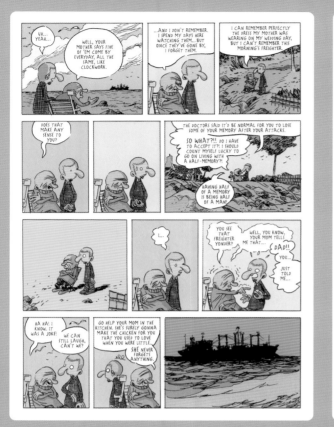

Ordinary Victories

Prone to panic attacks, Marco has found no help from psychoanalysis. His globe-trotting photography no longer motivates him. Unattached and unfulfilled, he decides to stop working and withdraw to his run-down place in the country with his cat. On the way he drops in on his parents, far left. He finds that his ill father's short-term memory is fading, though luckily not his sense of humor.

When his moody cat Adolf is injured, left, he meets the local vet, who inspires him to take a photo of her. Against all odds, she seems to take to him, but Marco finds it hard to commit to a relationship. France's Manu Larcenet makes Marco, based partly on himself, a flawed but likeable soul.

Slow News Day

In this clash of cultures, Katharine Washington, a young American graduate, is only sticking to her dull journalist's job on the WHEATSTONE MERCURY because her mother insists that she help the ailing English provincial paper that she once worked on. But Katharine has her own reasons for staying: secret research for her TV sitcom proposal.

She is joined here by rival English reporter Owen to cover the "big story," a turkey that has broken his leg, inviting more Anglo-American comparisons. British author Andi Watson excels in developing their sparky special relationship in his "fish-out-of-water" comedy of manners.

When the Wind Blows in focus

> "... a devastating book—great tenderness, dignity, and compassion.
> It is *that* story which we should tell to the children,
> and we should tell it to them young."
> BEL MOONEY

Jim and Hilda

The Bloggs are largely based on Raymond Briggs' parents, whose real-life story he narrated in ETHEL & ERNEST. Jim's other incarnation was as the dreamer GENTLEMAN JIM. Their isolated home is situated in the Sussex countryside where Briggs lives.

We listen in on a duologue between down-to-earth Jim Bloggs and his prim and proper wife Hilda, which unfolds over 28 pages of mostly small panels, up to 30 of them per page, stacked seven tiers high. Their chatter is interrupted by silent, alarming, two-page panoramas of a missile launch site, bombers overhead, and a nuclear submarine, portents of the approaching bomb.

The only other voice heard is the radio announcer's three-minute warning in the pointed balloons.

Notice how Jim's face blanches at this news, his speech balloons and lettering wobbling with panic. Then, as Hilda refuses to act, Jim's voice grows louder and angrier, until he has to grab Hilda to hide under their flimsy, make-shift shelter.

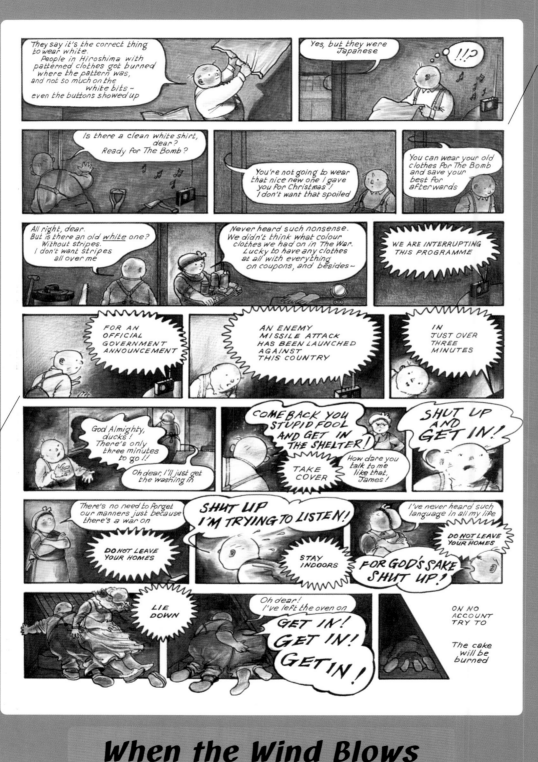

Conversation

"Save your best for afterwards." Briggs conveys Hilda's obliviousness to the impending danger and her insistence on good manners and decorum. Her concern as the bomb drops is that her cake will be burned, a pointed last comment because the bomb will burn much more than her baking.

The awful power of this quietly damning piece lies in the Bloggs' continuous, often banal chatter, their need to speak, their need for company, to make the unbearable bearable.

After the impact, they talk back and forth in every panel, pausing only three times, until the final page when, out of view under the shelter, they turn to hesitant prayer and their talking finally breaks down.

Today, the Bloggs' naive faith in the government might seem a thing of the past, but how much better informed or prepared are we in the current war on terrorism? We might not be so laughably trusting as the lamb-like Bloggs, but how many of us would be so much smarter in similar calamitous circumstances, far from civilization?

When the Wind Blows

Raymond Briggs
1982, 1 volume, 44 pages

READING ON: ATOMIC BOMBS 64 | MARRIAGES 47 | WARS 68 | POLITICAL SATIRES 78

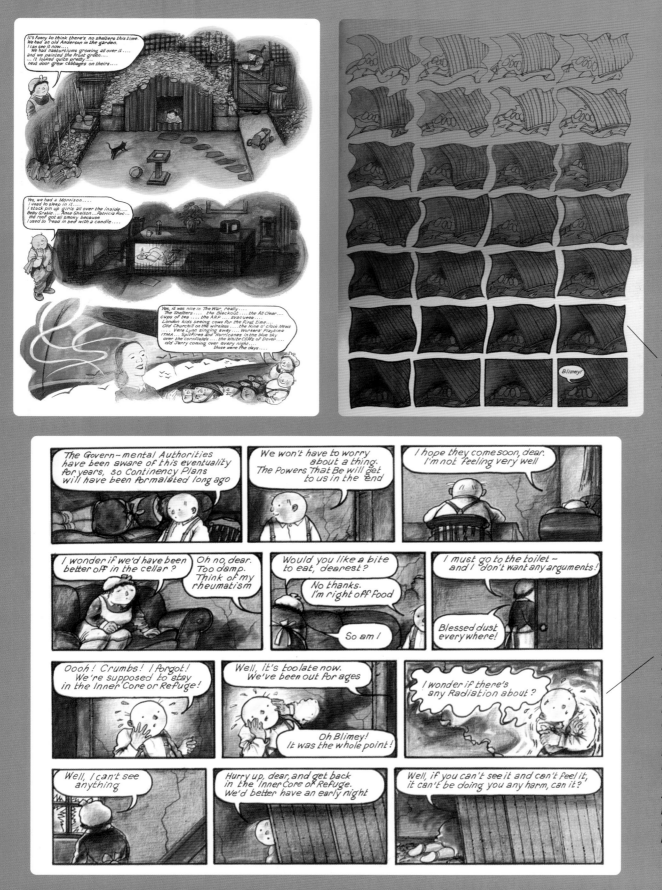

Shelter

"Those were the days." In their rose-tinted view of the Second World War, far left, Jim and Hilda imagine that the old-style Anderson and Morrison shelters which got Britons through the Blitz will enable them to survive a nuclear bombing.

Briggs comes up with a brilliant graphic device to represent the impact of the bomb: a double-page spread of almost pure white, haloed by a reddish glow. He follows this with two pages of our last view of the Bloggs, two pairs of feet under the door. This slowly returns, at first distorted in white lines, then red. Then, the quaking panel borders gradually settle, left, as the abstract image fills with shade, color, reality, and sound.

In this extract of four tiers of panels from a page, Jim maintains his belief that normality will soon be restored. He tries to sound confident, misusing the official language and terms like "continency plans," a reference to incontinence rather than contingency. It's an example of the slip-ups and malapropisms that convey Jim's ordinariness. The Bloggs may think that what they can't see, can't hurt them, but here, Jim shudders as he realizes the risk of their exposure. It's almost funny that they did not use their cellar for fear of the damp, not that they would have survived much longer in it. Insidiously, killer radiation overcomes this loving couple who share their last throat pastille. Briggs bleaches the colors from his pages, the palette growing sickly like their own complexions.

Following on from When the Wind Blows

Skin

Thalidomide was a German "wonder drug" marketed as a sedative pill, but found too late to cause terrible deformities in babies if taken by pregnant women. In 1970s London, skinhead Martin "'Atchet" Atchitson, born with shortened arms and legs, is nicknamed "seal boy." When he and his friend Ruby break into the library, he learns about the drug company directors behind his birth defects. He will not be stopped from exacting his fitting revenge.

Fuelled by the clarity of fury, British writer Peter Milligan and artists Brendan McCarthy and Carol Swain pull no punches. Notice how they avoid using borders, dividing panels with a lamppost, bookcase or other graphic elements.

Where's My Baby Now?

Pregnant film actress Raquel is just too busy to have her baby herself, so here she pays her Italian cleaning lady Gigina to bear it for her. But this arrangement gets out of hand when Gigina has to stop. She returns the embryo to the clinic, where, unknown to Raquel, it is frozen and flown to Japan.

To cover up this error, the doctor's assistant finds a genetically engineered substitute, which Raquel cuddles here like her own. Meanwhile, her true embryo has been stolen and implanted inside a cow. Claire Bretecher's French farce takes test-tube motherhood to its most laughable limits.

Following on from When the Wind Blows

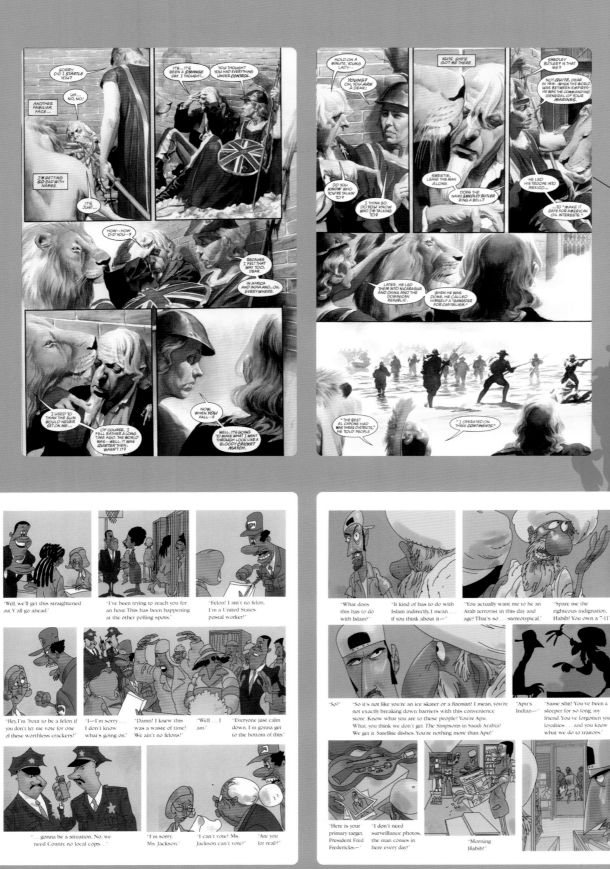

Uncle Sam

It's been a strange day for this once proud symbol of America, found dishevelled, lying in the gutter, his mind and body wandering through the kaleidoscopic landscapes of his country's turbulent history, blurring past and present tragedies. Sam is met here in a back alley by Britain's equivalent patriotic figurehead, Britannia, who ponders their empires' rise and fall.

This tired old man's journey leads to Washington, where he finally confronts his modern self at his worst and reaffirms the ideals of democracy at its best. Steve Darnall writes a thoughtfully radical and inspiring political treatise, painted by Alex Ross with a photorealist precision akin to Norman Rockwell.

Birth of a Nation

Fred Fredericks, mayor of the real, underfunded East St. Louis, is among the African-American voters who are all disenfranchized as felons, far left. His response is to secede the city from the Union and found a new nation, "Black Land," whose "offshore" bank turns it into Middle America's own Switzerland.

External threats and money woes soon arise. Habib, a 7–11-owning Arab sleeper terrorist, is pressed here by an OPEC agent to kill Black Land's president, while the CIA want him dead too. Writers Aaron McGruder and Reginald Hudlin and artist Kyle Baker run with the idea of a downtrodden public taking control of the tools of capitalism and somehow winning the day.

Travels in Time

Above: Rodrigo rides the road to battle in Hermann's *Towers of Bois-Maury*

Below: Tintin and Snowy meet Chang in Hergé's *The Blue Lotus*

Opposite: Raymond Briggs tells the story of his parents' lives in *Ethel and Ernest*

Long before Pearl Harbor, he was dealing with its repercussions head-on in his strips, although the syndicate insisted that he should not offend the Japanese by naming the otherwise clearly identifiable "invaders." Whereas Tintin was able to return from the Orient, Terry was stuck out there, caught up in the action, and forced to grow up. As current events and strip fiction edged closer, at one point Caniff predicted the Allied invasion of Burma in his strip, which appeared in print two days before the actual invasion. The strip was reprinted on the front page of one London newspaper and heated questions were asked about how he knew. Caniff explained that he was privy to no secrets; he had simply seen what was coming by playing "armchair general."

When cartoonists do get out of their armchairs and leave their drawing boards behind, several of the observant ones have turned their impressions and sketches of their journeys abroad into perceptive graphic travelogues. One early humorous example, published in 1854 and probably based in part on his own excursions, came from the pen of former *Punch* magazine contributor Richard Doyle, uncle to Sir Arthur Conan Doyle of *Sherlock Holmes* fame. The travels and travails of a short, tall, and fat trio of Englishmen on a less-than-grand tour of Europe were recorded by Richard Doyle's 172 captioned drawings in *The Foreign Tour of Messrs. Brown, Jones and Robinson, Being the History of What They Saw, and Did, in Belgium, Germany, Switzerland, and Italy*. Doyle milked now familiar comedy out of this "vacation from hell," from transport nightmares, surly customs officers, and eccentric fellow travellers, to puzzling foods and habits, run-ins with the law, accidents and worthless souvenirs. It's tempting to see Doyle in the diminutive Brown, sketchbook always at hand, who en route presents the reader with some images of the scenery they see.

Updating this approach, contemporary comic artists like Americans Peter Kuper and Craig Thompson, and France's Jacques de Loustal, have had their travel journals published, based on the drawings and strips that they made while uprooted on a "foreign tour." During Kuper's voyages in Africa and Southeast Asia, "I begin to shed my skin and replace it with a travel hide, redefining vacation to mean a trip away from routine and a break from the shackles that keep my brain stuck in a rut." Influences of local art permeate his book *Comics Trips*, which was later reissued in Japan with a CD-Rom of extra art, photos, animation, and sound recordings. Before Thompson left on his two-month tour through Europe and Morocco, he committed to his publisher that he would draw on location every day and produced a remarkable 224-page first-person diary *Carnet de Voyage*. Other travellers, such as Glenn Dakin, Josh Neufeld, and Rick Smith have chosen to savor their moments off the beaten path more fully, crafting their comics only upon their return, from notes, but mainly from memories and feelings.

While most travel brings its risks as well as its rewards, the acclaimed Swiss writer and traveller Nicolas Bouvier recommended it: "You'll never learn anything from travelling if you don't give the journey the chance to destroy you. A journey is like a shipwreck, and he whose boat has never sunk beneath him will never make an old sea dog." Bouvier could almost have been describing the first appearance of "sea dog" Corto Maltese, tied spreadeagled to a raft, left to the mercy of the Pacific Ocean, his boat and weapons stolen from him by his boatswain. Like Corto, his Italian creator Hugo Pratt was a traveller, a nomad, a gentleman of fortune and of many cultures. Pratt himself had seen his share of "shipwrecks," at one point in 1964 becoming lost, presumed dead, in the Amazonian rainforest until he was rescued by Indian tribesmen. His crisscrossing of the globe was a constant source of ideas for his comics. Other influences were Milton Caniff's black-and-white or chiaroscuro graphic approach to Terry and his enthusiasm for research.

Out of these ingredients Pratt imagined the rugged, enigmatic adventurer Corto, whom he could involve with the real events, places, and people of early-20th-century history. A passionate bibliophile, in later life he designed his mansion outside Lausanne, Switzerland, as a library to house his collection of 30,000 books, each room devoted to a different country, period, or subject. Often it was a mystery from the past in one of his books that would trigger his desire to set out for another destination and look for clues there himself. He told his biographer Dominique Petitfaux, "For me, my travels have been the chance to go to a place that already exists in my imagination." First-hand experience from travel or knowledge gleaned from books, Pratt embraced them both and made no distinction between them, in his life and in his dozen captivating *Corto Maltese* graphic novels.

The line between creator and creation was also blurred. Writing a tribute to his friend Pratt after his death, the author Umberto Eco recalled introducing him to his daughter in Milan. "At one stage, she took me aside to whisper to me, 'But Corto Maltese, it's him!' Only children can see that the emperor has no clothes. Corto Maltese is long-limbed, thin, athletic, with an art nouveau grace, virile yet effeminate. Pratt was rather short, stocky, almost portly, with a heavy face. But that day, I took a good look at him, lit from behind: yes, it really was Corto Maltese." As for the sailor's eventual fate, Pratt never confirmed it and rumors abounded. One clue, however, was given by Pratt from the very start in first issue of *Sgt. Kirk*, in his 1967 introduction to *The Ballad of the Salt Sea*. This consisted of a letter dated 1965, which quoted from another undated letter by Pandora Groovesnore reporting the death of Corto's friend, the Maori warrior Tarao: "His death leaves a great emptiness among us, but especially for Uncle Corto, whom I am worried about at the moment. Those two understood each other perfectly, they were inseparable. Now, when I see Uncle Corto sitting there alone, his eyes dimmed, facing the great sea which used to be his, my heart breaks." It seems that to the end, Pratt, like Corto, would hear the call of the high seas, of one last great adventure. Three years before his death, Pratt and his close collaborator Patrizia Zanotti realized a dream of a long journey around the South Pacific, to visit Samoa and Robert Louis Stevenson's tomb, and to complete the circle by seeing the islands where Corto's voyages had begun.

Embedding imaginary characters in history has resulted in other striking graphic novels, from Germany's Weimar crisis in Jason Lutes' *Berlin* to knights in 14th-century France in Hermann's *Towers of Bois-Maury*. In *Deogratias* in 2000, another Belgian author, Jean-Philippe Stassen, was among the first to denounce the genocide in Rwanda. The genre of the western has all but vanished from American comics, but in Europe it has enjoyed a new lease of life. One of its great exponents is Frenchman Jean Giraud, later also known as Moebius. In 1956, as an avid reader of cowboy comics in his late teens, Giraud went with his mother on his first trip to Mexico. Those eight months opened his eyes to the beauty of the landscape and back in France he was more determined than ever to draw westerns himself. Assisting the Belgian artist Joseph Gillain, alias Jijé, on *Jerry Spring* was a start, but Giraud was eager for a series of his own. His requests to Belgian writer Jean-Michel Charlier, co-founder of *Pilote* in 1959, came to nothing, until 1963, when Charlier was sent on assignment to California's Mojave desert. Out of Charlier's inspiring trip came the desire to reinvigorate the formularized western, with Giraud as the artist.

As with Corto Maltese, Lieutenant Blueberry began as merely one of several major protagonists in the first episode *Fort Navajo*, but he soon emerged as the series' personable, principal character, modelled initially on movie actor Jean-Paul Belmondo. Feeling that the fearless lawman had "been done to death," Charlier opted to make Blueberry into "the very opposite of these classic heroic archetypes. He is dirty, ugly, and bad-tempered. He drinks, smokes, gambles, and swears." Blueberry might be a soldier in the U.S. Cavalry, but Charlier insisted that "he is undisciplined, cynical, and hates authority." The outcome was an atypical western series with a heart and a brain, whose every story started from meticulously researched facts. The first 320-page serial contrasted the violence and prejudice of European settlers with the culture and pride of Native Americans. Absorbed in Wild West lore, Charlier even wrote a spurious prose biography of Blueberry as if he had really existed.

Biographies of real people, both famous and "ordinary," can come alive via the comics medium, although certain *Beginners', Introducing*, and *Graphic Non-Fiction* efforts come close to summarizing a life into a dry textbook of dates and facts. In one better example, the young British comics illustrator Frank Bellamy was given the chance in 1957 to produce his first strips in painted color, a 48-part biography of Sir Winston Churchill printed on the back pages of the weekly *Eagle*. After Churchill approved the early episodes, Bellamy started to experiment in his layouts and panels, his subtle washes captured by the quality photogravure printing. *The Happy Warrior*, compiled as a hardback in 1958, was an undeniably pro-British hagiography. It reveals the hazards of shaping any biography into comics, of interpreting the facts and legends, from the ancient Buddha or Paris and Helen of Troy to the modern Billie Holiday, Franz Kafka, or Martin Luther King. As Alan Moore observed when embarking on *From Hell*, his account of the Victorians linked to the Jack the Ripper murders, "It's worth remembering that *all* history is to some degree fiction: that *truth* can no longer be spoken of once the bodies have grown cold. The side that wins the battle decides who were the heroes and who the villains; and since history is written by those who survive it, their biases often survive with them." It may be advisable sometimes to read between the lines, or between the panels.

Corto Maltese in focus

> "When I want to relax I read an essay by Engels.
> When I want something more serious, I read *Corto Maltese*."
>
> UMBERTO ECO

Who is Corto?

Wherever, whenever, this globetrotting free spirit washes up, Corto Maltese is bound to become a part of history in the making. Corto was born in 1887 in La Valletta on the isle of Malta, which gave him his name. As the illegitimate son of a gypsy woman from Seville and a British sailor from Tintagel, Cornwall, his choice of a wandering, seafaring life seemed inevitable.

The life of his Italian creator Hugo Pratt was almost as adventurous. Living in a variety of countries, multi-lingual and widely read, Pratt was fascinated by the cultures of the world. He was also a relative of William Pratt, better known as Boris Karloff.

In THE BALLAD OF THE SALT SEA, right, serialized first from 1967 in the Italian magazine SGT. KIRK, Corto began as a secondary player. The first sighting of him is through the pirate Rasputin's telescope, half-naked on a raft.

Corto is rescued by the pirate Rasputin, whose crew have also picked up two teenage cousins lost at sea, Cain and Pandora Groovesnore. THE BALLAD OF THE SALT SEA relates their encounters in the South Seas with pirates, natives, and opposing navies around the time of the outbreak of the First World War.

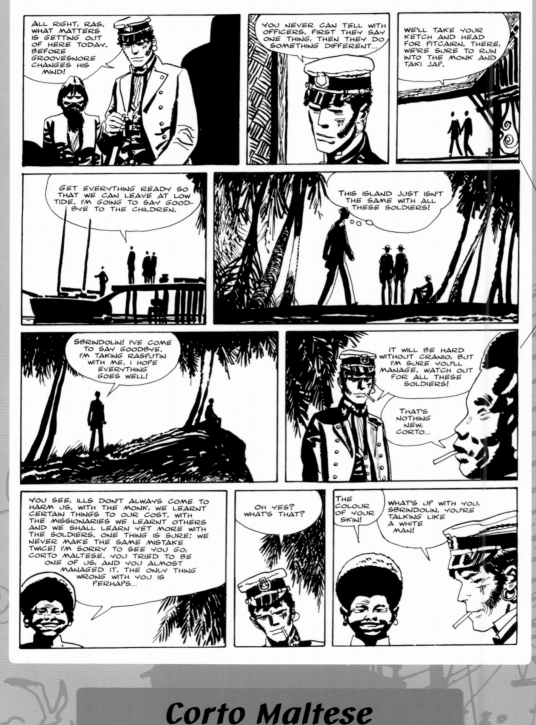

Setting sail

This page opens with Ras, short for Rasputin, and Corto taking their chance to leave the isle of Escondida. Because Corto has proof of the Groovesnore family's scandal of murder and madness, he uses it to blackmail another Groovesnore, now the commanding officer of the occupying British forces, to let them go.

Notice Pratt's use of daringly minimalist silhouettes to give a sense of space and nature around them.

Having taken Rasputin to his ship, Corto heads off to see Sbrindolin, an islander with whom he has built a trusting relationship across the divide of color. The anarchic Corto never sides with colonialists or others in authority.

Who is Rasputin?

He may not be the infamous Rasputin of Russian history, but this Rasputin is a rogue and opportunist, and Corto's old nemesis, going back to 1904 and the Russo-Japanese war, when he was introduced to the Russian deserter by the writer Jack London. As Corto once said of him: "I'd rather have a tarantula for a friend."

Corto Maltese

Hugo Pratt
1986–98, 8 of 12 volumes, 894 pages

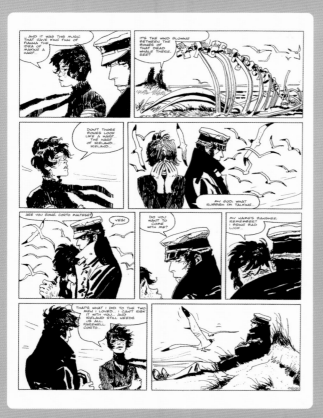

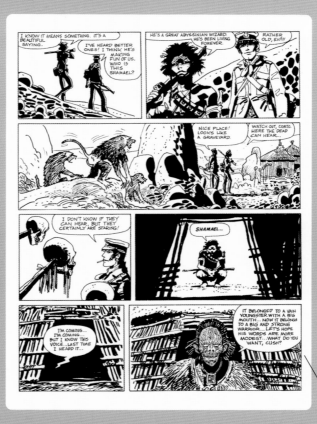

Living history

In THE CELTS Corto plays a part in Irish Easter Rising by helping the nationalists take revenge on British officers for murdering a Sinn Fein informant. Here, far left, as Corto says farewell to Banshee, widow of Pat Finnucan, he decides not to tell her the truth that he has just learnt: that her husband was no hero, but was lured by British gold to betray his countrymen, who killed him to make a traitor into a martyr.

In 1940, Pratt aged 13 was enrolled by his father in Italy's fascist army in Ethiopia: "I was Mussolini's youngest soldier." By the end of the war, Pratt was on the Allies' side and steeped in the country's culture. Here, Pratt takes Corto to Abyssinia, where the Beni-Amer freedom fighter Cush takes him to a shaman to look into their future.

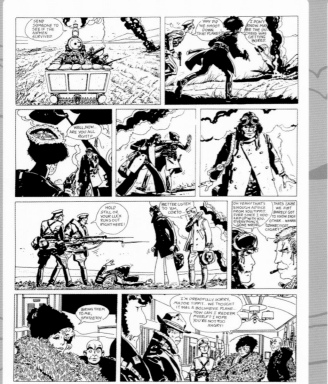

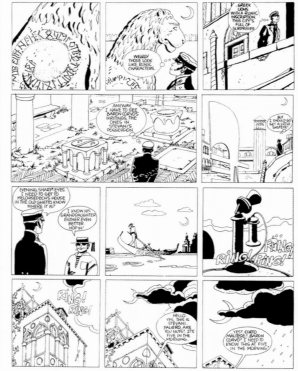

In 1919, Corto winds up in another hotspot, the Trans-Siberian Railway. Here, far left, Corto and the American Major Tippit are mistakenly shot down by an armored train and presented to the Russian Duchess Seminova. CORTO IN SIBERIA was made into a color animated feature film in 2002.

Born and raised in Venice, Pratt sends Corto there to trace a legendary emerald. Here, the trail brings him at night to cryptic runes carved on a Greek lion and the secret world of Masons. Pratt's 1981 FABLE OF VENICE marked a new mature simplicity in his line and form. In all he worked on 12 CORTO books, the last left incomplete on his death in 1995, of which 8 have so far come out in English.

Following on from Corto Maltese

Blueberry

The life of ornery, rebellious U.S. Cavalry lieutenant Mike S. Donovan, known to all as "Blueberry," is about to change forever, after he is volunteered by the President's chief military advisor for an unofficial mission to trace a man in Mexico who can lead him to half a million dollars in missing Confederate gold. Greed and treachery turn Blueberry from hunter to hunted, with a bounty on his head. While hiding out, far right, he confers with the once-glamorous Guffie. Her past romance with a Ulysses Grant, who is now the President, may help Blueberry get a pardon, the only way to keep him from swinging. A gritty, world-class western from French team Charlier and Giraud.

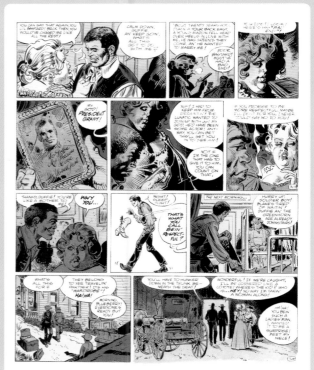

Isaac the Pirate

Isaac Soper is a gifted but penniless painter in 18th-century Paris, who dreams of bringing back riches from the high seas so that he can marry his lovely Alice. A wily ship's surgeon offers him a voyage that will take only a few days, but here, once on board, Isaac finds himself bound for the Americas.

When the ship is taken over by pirates, Isaac discovers that he has been lured into this adventure in order to paint the exploits of the notorious pirate captain, John "The Pillager." Here, far right, for an "audition," John orders Isaac to sketch his portrait. French author Christophe Blain shows how painter and pirates form a bond as John recklessly sets out to explore Antarctica.

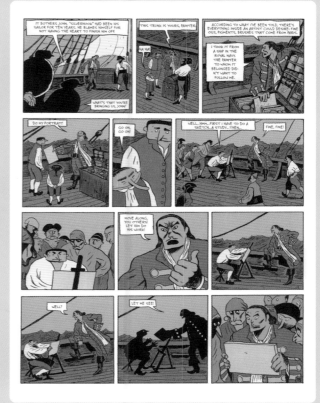

Abe: Wrong for all the Right Reasons

English cartoonist Glenn Dakin uses his character Abe as an alter ego to examine his feelings about life. Here, Abe travels to Finland, home to Tove Jansson's magical MOOMINS. Rather than sketch or take photos while he was there, Dakin preferred to work after his return from memory and emotion and draw straight on the page. "I produced all these squiggly, minimal versions of things that expressed how they felt to me rather than what they looked like." His loose sketches and brief notes convey the immediacy of being there, appreciating the unfamiliar. This almost abstract panel evokes the great outdoors at night.

A Few Perfect Hours

Fresh out of college, hungry for experience, New Yorker Josh Neufeld and partner Sari Wilson embarked on an 18-month tour of Southeast Asia and Central Europe. The people they met, their observations and experiences, became the subjects of Neufeld's graphic travelogue.
Here he has to confront his romantic illusions about adventure when spring rains flood Thailand's underground "Cave of Fear," forcing them through a half-submerged passage so narrow that they have to slide along it belly down like a snake. Different type and captions distinguish Josh and Sari's viewpoints, such as Sari's brief comfort in remembering Christmas.

Buddha in focus

God of manga

In post-war Japan, a young qualified doctor named Osamu Tezuka (1928–89) chose comics rather than medicine for his profession. Comics at the time were basically for children, so Tezuka took the opportunity to revolutionize them with his exciting stories, strongly influenced by movies and American animation. His approach inspired many other artists to enrich the field and he came to be revered as Japan's "God of manga."

Tezuka's firm belief in the validity of his medium, coupled with his restless drive to outdo his peers, spurred him in 1972 to create a 9-volume retelling of the life of Buddha. Though Tezuka was not a Buddhist himself, he was a humanist who always dealt with moral issues in his work.

Nature

The grandeur of nature features prominently in vibrant landscapes, and especially impressive trees. Tezuka usually draws landscapes in great detail to contrast with the more simplified figures within them.

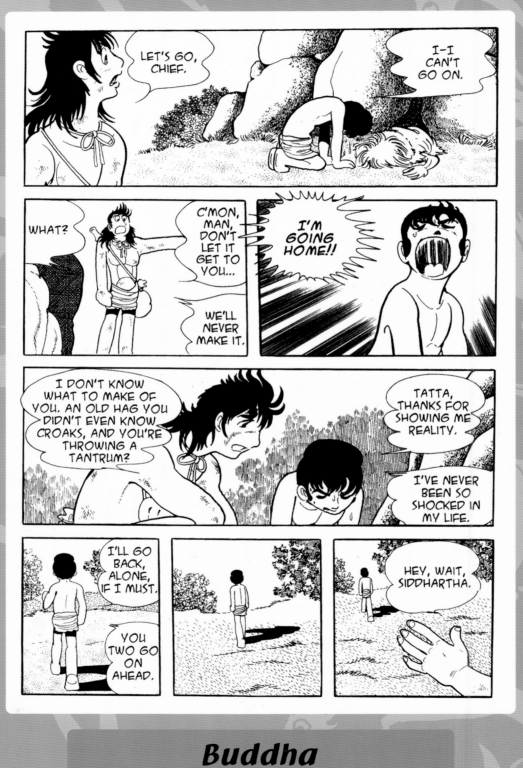

Buddha
Osamu Tezuka
2003–5, 5 of 9 volumes, 1,884 pages

Siddhartha

Siddhartha leaves the stifling luxury of his royal upbringing, because he wants to experience the real world and find answers to why people suffer and die. After he and his pariah friend Tatta have rescued Migaila, the female leader of a bandit gang, they come across a dying grandmother begging for water.

The old woman has been abandoned by her son, a poor slave, but she accepts her fate because it makes life easier for her son and his wife and eight kids.

For Siddhartha, her matter-of-fact suffering and death reveal the shocking reality of the lives of slaves and pariah. Before returning home, Siddhartha turns back to the old woman's corpse and thinks, "Madam... Goodbye... You didn't die in vain."

Tezuka demonstrates how the Indian prince Siddhartha comes to understand the purpose of life beyond suffering and manages to transcend the mystery of death. He also takes the time to explore the lives of many other characters in crisis, all of whom are profoundly changed by Buddha's example and teachings.

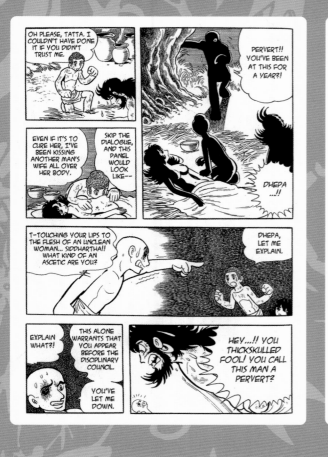

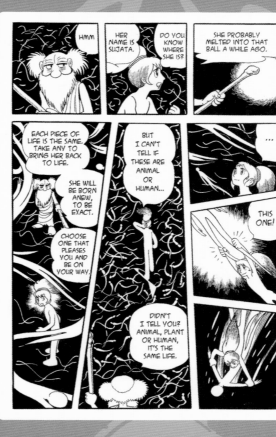

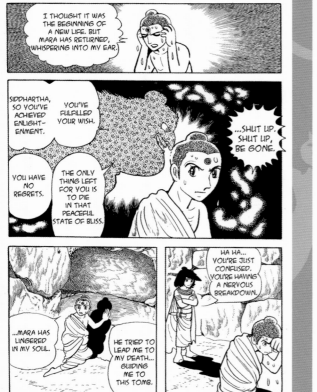

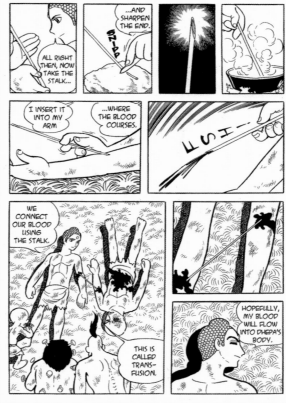

Pieces of life

India was regimented by a caste hierarchy. To cure his "unclean" wife Migaila, Tatta and Siddhartha have sucked the poison from her body. When Siddhartha's strict ascetic teacher Dhepa discovers this, far left, he accuses his pupil of perversity. Tezuka never worries about breaking the illusion of reality, here making the prince aware of being inside a comic, exaggerating Tatta's fury, and reducing Dhepa to his comedy icon, a "gourd-pig."

Tezuka's extraordinary imagery, left, transports us to Siddhartha's vision of the universe swirling with linked, living souls. Acting on advice from his wise spirit guide Brahman, he takes back a piece of life so that the dead princess Sujata can be born anew.

Among Tezuka's other characters whose lives are affected by Buddha is Devadetta. He grows up into a fearsome swordsman and becomes a symbol of war and the law of survival. Here, far left, he tracks down Siddhartha, who is now enlightened and called the Buddha, in a tomb. He has been driven there by his long battle with the temptations of the "mara" or devil. Enlightenment does not come easily.

Another key player arrives, left, the arrogant Prince Crystal, who is insulted by Buddha's disrespect. The reason he cannot get up is that he is trying to save his former tutor Dhepa by giving him a primitive blood transfusion via a hard, hollow stalk, a nod to Tezuka's medical expertise.

Following on from Buddha

Louis Riel

Martyr or madman? To some Canadians, Louis Riel was a founding father of their nation but to others he was a murderer who almost tore the country apart. In his 241-page biography, the Toronto-based Chester Brown concentrates on Riel's antagonism with the Canadian government from 1869 to his trial for treason and hanging in 1885.

A passionate supporter of his fellow Métis, people with both Indians and whites in their family trees, Riel, right, forces his way into a church to hold a vote on armed rebellion. Later, far right, he decides to give himself up, sure that a trial will aid his cause. Brown's monumental figures and detailed textures are inspired by Harold Gray's LITTLE ORPHAN ANNIE strips.

The Time of Botchan

By the early 20th century and the last years of the Meiji period, the rush to modernize and Westernize was deeply affecting the Japanese, intellectuals and ordinary people alike. Some were resigned to change, even embracing it; others suffered because of the contradictions it stirred up. To record these tensions, creators Jiro Taniguchi and Natsuo Sekikawa based their manga on the real thoughts of figures of the time, mixed with imaginary encounters. Here, famous author Soseki Natsume discusses his next novel BOTCHAN, while the adopted stray black cat who inspires his serial I AM A CAT prowls round his garden. These pages read right to left.

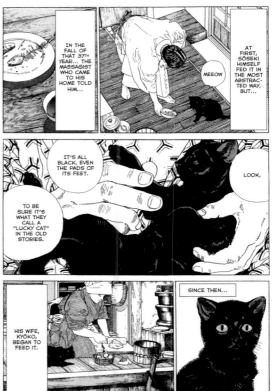

Billie Holiday

Much richer than any simple, factual biography, Argentina's artist-writer tandem José Muñoz and Carlos Sampayo paint an intense portrait of the great jazz singer from her friendship with saxophonist Lester Young to her heroin addiction and tragic end aged 44. The book blends true episodes from her life with a cynical journalist's late deadline to hack out a tribute about her, 30 years after her death. A third strand reveals the brief but special links between "Lady Day" and Muñoz and Sampayo's detective Alack Sinner. Here, he remembers how, when he was nine, she gave him a whole dollar to change a tire. He later discovers that, without knowing it at the time, he was one of the policemen guarding her hospital room.

Ethel & Ernest

His parents had been the models for several of his other books, including WHEN THE WIND BLOWS, but here Raymond Briggs tells their real story from their first chance meeting in 1928 to their touching deaths. Here, far left, Ethel Briggs breaks down when she hears that their only son Raymond will have to be evacuated from London during the Blitz.

VE Day was not a victory celebration for everyone. Enjoying a street party, left, Ernest is brought down to earth by a neighbor's grief. Notice how his paper crown crumples. This book lets us see how the Briggs cope with modernity's exciting and bewildering changes. It serves both as a document of social history and as a son's tender remembrance.

From Hell in focus

> "Jack the Ripper is the 'first tabloid star.' Moore's epic deconstruction, with summaries and echoes of all previous Ripper scholarship, is a monstrous edifice; loud with shrieks and whispers, broken quotes, ghosts, and doppelgangers."
>
> IAIN SINCLAIR

Post-mortem

This book's dedication bears repeating: "To Polly Nichols, Annie Chapman, Liz Stride, Kate Eddowes, and Marie Jeanette Kelly. You and your demise: of these things alone are we certain. Goodnight, ladies." In 1888, Queen Victoria herself orders these five "Daughters of Joy" to be silenced, because they know too much: the man who has fathered a prostitute's child is really Victoria's grandson, second in line to the throne.

From the outset, when this "melodrama in 16 parts" began to be serialized in the second issue of TABOO in 1989, writer Alan Moore promised that, by its conclusion, "the verdict remains open, the history books silent, the noose empty." He described the project instead as "a post-mortem of an historical occurrence using fiction as a scalpel."

Appendices

Unusually for a graphic novel, FROM HELL comes with two appendices: page-by-page notes disclosing which aspects are based on research and which have been deduced or fabricated; and a 24-page comic-strip essay which considers the past and future of "Ripperology."

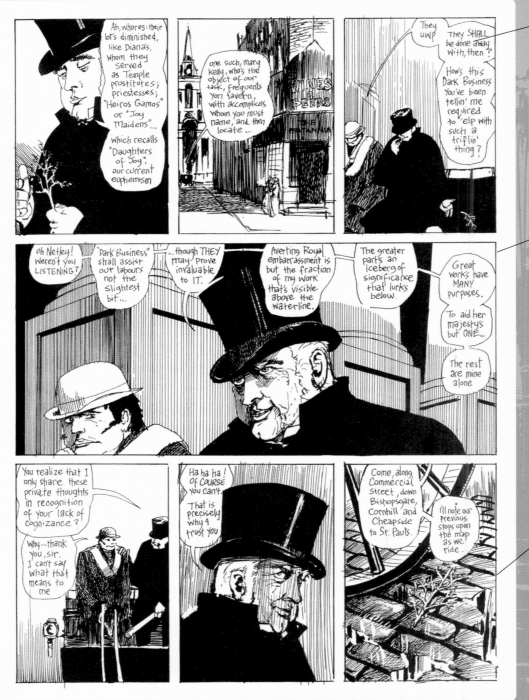

Dark business

The first image we see in FROM HELL is a dead seagull lying on the beach at Bournemouth. It is also the last image, washed away by the tide, like the traces of history. It points to Sir William Gull, Queen Victoria's physician, who, for the purposes of this fiction, is the identity of Jack the Ripper.

Here, Gull freely tells his illiterate driver and accomplice Netley that beneath the cover-up of royal scandal lie much deeper purposes. The significance of this "dark business" is bound up in the route Gull chooses for their carriage journey, which traces a hidden Masonic "pattern of man's control" formed by London's landmarks.

Driving here past Hawksmoor's St. Anne's church in Spitalfields, Gull points out the Britannia pub, a haunt of the prostitutes he plans to kill. On the way, he has been eating grapes whose finished stalk he discards on the street. Gull will offer drugged grapes to his victims.

Moore portrays the Ripper murders as a symbolic act to reinforce man's chaining of womankind, in a battle of sexual politics that spans the centuries to our own.

From Hell

Alan Moore and Eddie Campbell
2000, 1 volume, 576 pages

Rituals

Gull's "important venture" commences, far left. Moore and Campbell speculate that before strangling Polly Nichols, Gull gets her to greet the masked John Merrick, "The Elephant Man," out for a stroll. He makes her hail him as the god Ganesa, and her death becomes a ritual offering.

Far from being without a clue, Inspector Abbeline, left, is inundated with clues, as dozens of people send Scotland Yard letters signed Jack the Ripper. One arrives with a human kidney, addressed "From hell," giving this book its title. Only the reader knows that this letter has come from Gull himself, handwritten by Netley from his dictation.

As in WATCHMEN, and Eddie Campbell's ALEC, FROM HELL is built around the unrelenting "pulse" of a 3-by-3 grid, illuminating changes and links between panels. Far left, Moore takes us closely, mostly silently, through Gull's last killing and mutilation of Mary Kelly. Campbell's deadpan clarity makes the process ghastlier still. At one stage, here, Gull hallucinates that he is in a modern office, where, unseen, unheard, he berates us for ignoring "the black root of history."

Gull's dying visions show his evil living on across the centuries, visiting William Blake and Robert Louis Stevenson, and here, British serial killers, from the earlier "Monster" in the first three panels, to "The Halifax Slasher" 50 years later, to Ian Brady and Myra Hindley after that. As Gull shouts at us, "I am come amongst you. I am with you always!"

Following on from From Hell

Age of Bronze

Whether the Trojan War truly happened or not, every era tells the legend a little differently, from Homer's *ILIAD* to Eric Shanower's carefully researched interpretation. Shanower plays down the interventions of the gods to emphasize the human elements in his expansive 7-volume series. He begins with the lowly cowherd Paris, who learns that he is in fact the son of Priam, King of Troy.

Here, about to return from his mission to Sparta, Paris removes the cloak that has disguised his companion to reveal the beautiful Helen. His insistence that she sails with him and her choice to forsake her husband and homeland will light the flames of war between the ancient city states.

The Plot

Will Eisner unravels the origins of the infamous *PROTOCOLS OF THE ELDERS OF ZION*, first published in Russia in 1905 and supposedly the minutes of Jewish leaders plotting to rule the world. Eisner explains clearly how this crude hoax was forged by Russian secret police to undermine a growing social reform movement opposing the tsar's regime. Here, journalist Philip Graves talks with the editor of the London *TIMES*, which ran his damning report on the *PROTOCOLS* in 1921. Despite the exposé, Eisner learns from a bookseller in 1993, far right, that this "weapon of mass deception" has continued to be published as a tool in very real plots by those who want to seize or hold onto power.

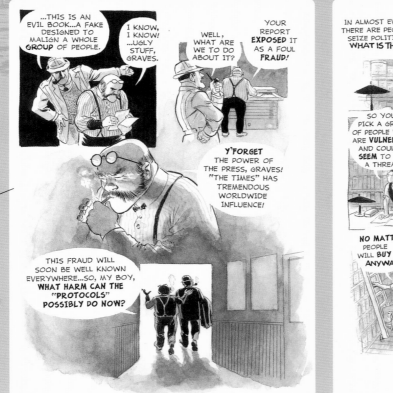

Following on from From Hell

Berlin: City of Stones

Through an ensemble cast of assorted Berliners, Jason Lutes' 210-page book documents eight months in the twilight years of Germany's Weimar Republic, which culminate in the fateful May Day of 1929. Here, far left, seasoned pacifist reporter Kurt Severing and first-year art student Marthe Müller meet as strangers on a train. Notice how, when Kurt asks if she is afraid, Marthe thinks of the soldier she has drawn in her sketchbook. He may be asleep now, but he is a reminder that fascism is stirring in the capital. On their arrival, Marthe is moved by a war amputee begging on the street and notes her feelings in her journal, shown in handwritten captions.

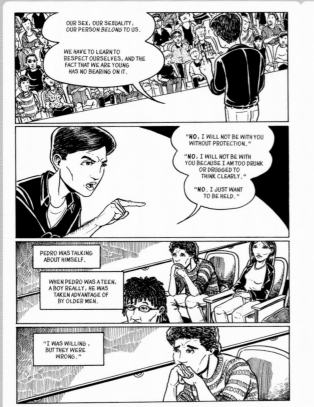

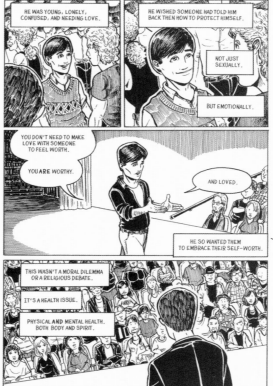

Pedro and Me

Millions of MTV viewers learnt from the Cuban-born immigrant and AIDS-educator Pedro Zamora about the realities of being gay and HIV-positive when he appeared in the 1993 reality show THE REAL WORLD. Among them was Pedro's straight roommate on the show, cartoonist Judd Winick, who created this blend of biography and autobiography as a tribute to his friend and teacher who died aged 22.

Here, while we listen with Winick in the audience to an AIDS 101 talk given by Pedro, the author shares through the captioned commentary his insights into Pedro's vulnerability when he was a teenager and his dedication as an adult to help others.

Passion Beyond Reason

War is looming in Europe. The invading German army is on the march. The year ahead, 1914, looks bleak. What better time could there be for the last remaining guests and staff in Austria's opulent, remote Hotel Himmelgarten, before they leave, to hold a life-affirming orgy? Their ecstasies spill across much of the third graphic novel in Alan Moore and Melinda Gebbie's new *Lost Girls* trilogy. Pausing for breath, the hotel's plump, panting owner-manager Monsieur Rougeur (appropriately the French for blush or flushing), a former forger of erotica in Paris, addresses the entwined celebrants with these exultant words: "Pornographies are the enchanted parklands where the most secret and vulnerable of all our many selves can safely play. They are the palaces of luxury that all of the policies and armies of the outer world can never spoil, can never bring to rubble. They are our secret gardens where seductive paths of words and imagery lead us to the wide, blinding gateway of our pleasure, beyond which things may only be expressed in language that is beyond literature, beyond all words."

Among those "seductive paths of words and imagery" opening up to us in more recent years are a number of exceptional graphic novels. These let us "safely play" with the puzzles and games of temptation and passion and can be seen as modern equivalents of such 18th-century entertainments as European gentlemen's *livres erotiques* or explicit Japanese *shunga* prints. Out of admiration for this lineage, Moore and Gebbie's *Lost Girls* is a deliberate attempt "to create a work of pornography (ordinarily a dull and ugly genre with absolutely no standards) that would be invested with all of those qualities which one might expect to find in any other work of art or literature." Gebbie's illustrations, many of them in layers of soft colored crayon, juxtapose the styles of such major erotic artists from the past as Alphonse Mucha, the Marquis Franz von Bayros, and Gerda Wegener with those of the strange reveries in children's classics. We are invited into a good-natured romp free from care, a "pornotopia" in the utopian tradition of much Victorian erotica.

Similarly looking back, Posy Simmonds reinterprets Gustave Flaubert's 1857 novel *Madame Bovary* as her graphic novel *Gemma Bovery*, in which she re-casts the heroine as a modern English expatriate and Francophile. As her name implies, Gemma's character and fate are similar, yet slightly different to her literary counterpart. Like her, she is bored with her marriage and wants to make her life more glamorous, like the glossy magazines and movies she adores. All of us can recognize Gemma's unrealistic expectations and her longing to make her sexual fantasies real. In her first graphic novel, *True Love* in 1981, Posy Simmonds pointed out the absurdities of British love-story comics by mimicking their overwrought

prose and graphics, with their second-color pink, and showing how they feed the daydreams of avid reader and hopeless romantic Janice Brady, a secretary daydreaming about a torrid office affair.

The things we do for love have been repeatedly explored by cartoonists for satirical or dramatic effect, or a mix of the two. First and foremost is Robert Crumb, notorious for his autobiographical strips in which he admits to his most perverse fantasies, often enacting them, and then publicly castigates himself for them. Other products of first-person sexual candor range from *Unlikely*, Jeffrey Brown's unaffected journal about losing his virginity, to *Peepshow*, a farce about Joe Matt's porn video obsession. There is an element of *schadenfreude* to some of these portraits of desperate male desire, embodied in the tragic artist wrecked by his pillowy model in Dave Cooper's *Ripple,* and in the geek collector besotted with Asian women in Mark Kalesniko's *Mail Order Bride*. In the battle of the sexes, it seems there are no winners or losers, only casualties. In fact, Crumb created his first graphic novel, and his longest at 144 pages drawn in Prismacolor pens, as a barely disguised love token in 1963 when he was 19 and still a virgin. He gave *The Big Yum Yum Book*, a love story between Ogden, a humble frog, and Guntra, a hungry, naked giantess, a happy ending, and gave the finished pages to Dana Morgan to win her heart. Not long after, they were married.

Above: A 1974 collection of John Willie's bondage serials from the 1950s magazine *Bizarre*

Opposite: Posy Simmond's *Gemma Bovery* moves to France in pursuit of happiness

Passion Beyond Reason

Right: Sultry Russian spy Jodelle became a 1960s pop art icon

Below: With her Louise Brooks' bob, Guido Crepax's Valentina

Opposite above: Frédéric Boilet on the beach with his Japanese muse from *Mariko Parade*

Opposite below: "Hetero hunk" Axel from Ralk König's *Maybe, Maybe Not*

The Big Yum Yum Book went unpublished until 1975, by which time Crumb's art and life had altered irrevocably and the hippie counterculture that had adopted him as its reluctant hero was waking up from its dope-fuelled visions of free love. It became clear that the world was not going to be made into a utopia, much less a pornotopia, but that has never stopped people from dreaming that it could be. In the panels of comics, and in between them, artists and writers have been inviting us to wander through their private "enchanted parklands." Legal and moral authorities, however, patrol these "secret gardens" and have frequently objected to any sexual subjects being dealt with in comics. In the past, this forced them to be circulated clandestinely. In America in the 1930s, dealers would hawk so-called "Tijuana Bibles" on the street, in bars, dodging the cops. For many people these pocket-sized, crudely drawn porno parodies of film and strip celebrities also served as basic sex education primers.

From the 1950s, publishers like Irving Klaw, New York's self-styled pin-up king, were prone to crackdowns and prosecutions for selling through the mail their pricey plates of fetishistic comics printed onto photographic paper. The fetish genre's pioneer artist was John Willie, saucy pen-name of John Scott Coutts, born in Singapore, educated in England, and published mainly in America. He was the senior figure in a group of illustrators based around New York from 1946 specializing in drawing bondage and domination. Coutts set up his own magazine, *Bizarre*, in which he first published episodes of his almost quaint "cartoon adventure serials," in the vein of damsel-in-distress cliffhangers, pitting Sweet Gwendoline against the moustached, bungling scoundrel Sir Dystic d'Arcy, a caricature of Coutts himself.

Later, Coutts would sell reprint rights to the strips to other publishers such as Klaw. No women appeared naked or showed a glimpse of pubic hair in them, but in the censorious 1950s, Klaw came under pressure to tone down his products and insisted that Coutts alter his original watercolors to obscure every exposed breast or behind with clothing. Coutts had shrewdly retained an unretouched version which he continued to offer by mail order. He also published an early example of an American erotic graphic novel in 1958, when he compiled the complete 55-page version of his longest serial, *Sweet Gwendoline and the Race for the Gold Cup*, into a $20 book. According to J.B. Rund in the 1974 Bélier Press edition, Coutts "drew only from life or from photographs which he took and processed himself. What he drew was a representation from real life; it was not merely fantasy."

Unbridled, and bridled, fantasy was more the province of Coutts' junior colleagues, such as Gene Bilbrew, signing himself Eneg, or Stanton, born Eric Stanzone, the best-known artist of this persuasion. The roped victims and buxom amazons of pulp magazines and comic books had stirred his interest in drawing in his teens. "Since I was only young and not very successful at the art of love, I invented my own little world of which I am king." At the age of 22, he offered Klaw his services and his 1948 debut *Battling Women* began a 10-year association, developing stories of high-heeled, steely-eyed dominatrixes in tracts like *Girls' Figure Training Academy* and *Madame Discipline*. Most were written by Klaw and others and Stanton used art assistants too, notably his art school classmate and co-creator of Marvel's *Spider-Man* and *Doctor Strange*, Steve Ditko. From 1959 they shared a

studio until the police raided it in 1966 and confiscated and destroyed much of Stanton's artwork. Undeterred, he prospered as his own publisher and artist-for-hire in the 1970s, visualizing the esoteric bespoke fantasies submitted by his varied clientele. What he called his "private commissions for private thoughts" found a much wider readership after Taschen Books reprinted them in the 1990s in a mass-market format.

Promoted by *Playboy*, the sexual revolution of the 1960s hit comics too in magazines and books for adults (and males) only. Publisher Hugh Hefner had always wanted to be a cartoonist, so he lavished close attention and a generous budget on Harvey Kurtzman and his team in 1962 to get the world's most costly and comely dumb blonde, *Little Annie Fanny*. After positive responses to translations of *Barbarella* in 1964, the hip magazine *Evergreen Review* hired Michael O'Donoghue and Frank Springer to devise the endlessly exploited yet virtually silent *Phoebe Zeit-Geist*, hailed by *Oh Calcutta!*'s Kenneth Tynan as "my favorite toy." European creators tended to see their heroines as more than submissive, or non-consenting, sex objects. In 1966, French publisher Eric Losfeld followed up *Barbarella* with another erotic album for intellectuals, *Jodelle,* written by Pierre Bartier, drawn by Guy Peellaert, a Belgian artist from an advertising background, and promptly banned as well. Resembling the singer Sylvie Vartan, Jodelle was a fiery, redheaded Russian spy on a mission in a Las Vegas-style ancient Rome, illustrated in a brash, pop art manner very much of its time. No fancy *Barbarella*-type names for Italian maestro Guido Crepax; he named his cool, enterprising photographer from Milan Valentina, after his 12-year-old niece, and Rosselli, in honor of the anti-fascist Rosselli brothers. Crepax invented erotically charged layouts, sometimes kaleidoscopic, breaking up slight, sensuous movements into clusters of compact panels. He made Valentina's adventures increasingly dream-oriented as she solved the mystery of her personality.

Also in the 1960s, one artist above all was defining a self-confident, positive icon of gay masculinity. After his debut cover of a jolly logger for *Physique Pictorial* in 1957, Touko Laaksonen became better known as Tom of Finland. "I work very hard to make sure that the men I draw having sex are proud men having happy sex." Short on plot, but long on erections, his mainly wordless comics highlighted a lusty biker dressed top-to-toe in black leather named Kake. Like Willie and Stanton, his once-banned comics

have also been republished for general bookstores in a set of five volumes "sized to fit perfectly in one hand." Homoerotic graphic novels now encompass the smart observations of Howard Cruse and Tom Bouden, the hilarity of Germany's Ralf König, the true story of Samuel Delany's taboo romance with a street vendor, the vast *yaoi* manga genre of love stories between boys by women artists intended for Japanese girls, and still more.

Women have made also contributed riches to the medium in the West, starting notably in America's underground during the rise of feminism. Feeling excluded from and exploited by the predominantly male-created comix, a new generation of female cartoonists such as Trina Robbins, Aline Kominsky (later Mrs Crumb), Melinda Gebbie, Phoebe Gloeckner, Roberta Gregory, and the late Dori Seda, got their refreshing, challenging voices heard at last. In the erotic field, their current successors include Kate Worley, writer of *Omaha*, Molly Kiely, and Colleen Coover. Another young rising star is Tokyo's Kan Takahama, who has teamed with French artist Frédéric Boilet to tell his touching fictional break-up with his model.

A future for the adult graphic novel seems assured, although Alan Moore has said that the third *Lost Girls* book may well prove actionable. Flaubert was prosecuted on charges of immorality for writing *Madame Bovary*. He was acquitted, but it reflects how the adult novel was mistrusted then as a new, subversive medium. Graphic novels with sexual content have faced similar prejudices. In January 1995, an individual British Customs official objected to two panels showing Crumb being fellated in his *My Troubles with Women*. Copies were seized and its British publishers, Knockabout Comics, charged under an 1876 act with importing obscene materials. When the case came to court a year later, as a defense witness, I confirmed Crumb's standing as a master satirist in the line of Hogarth and Gillray. Then Knockabout's lawyer Geoffrey Robertson took the three magistrates, one male and two female, through a close reading of the story and put both offending panels into their satirical and self-mocking context. Knockabout were cleared of all charges. This battle ended in victory, but recent convictions of comics in France and Japan suggest that the war will probably never be entirely won. Crumb once said, "It's only lines on paper, folks!!," but he knew well how these lines can come alive in our imaginations. That is their wonderful and seductive magic.

My Troubles with Women in focus

"Through his confessions comes creeping deep understanding of weakness and fear and, unexpectedly, there also comes reassurance: you are not alone. Whatever awful place you go to in your mind, you'll probably find Crumb has passed that way before."

NICHOLAS GARLAND

Fixation

"My whole trouble with women is that I'm too much INTO 'em." More than a recurring theme, women are a dominant, overwhelming fixation in the autobiographical and erotic comix of Robert Crumb, especially women of a certain type and steatopygic build, i.e. with big buttocks.

Crumb's Catholic roots seem to have instilled in him an appetite for guilt and a need to confess his sins regularly. But instead of finding forgiveness in the privacy of the confessional booth, Crumb feels compelled to mull over them again and again by putting them down on paper as comix for all to read.

The ten stories in this collection date from the 1980s and most were created for Crumb's kooky, screwball anthology WEIRDO (28 issues, 1981–93). The rest are taken from his solo title HUP, while this story ran in ZAP in 1980.

It was the first two issues of ZAP, entirely by Crumb, that kickstarted the underground boom in San Francisco in 1967. In early 1968, he and his pregnant first wife Dana sold copies from a baby carriage in Haight-Ashbury. Soon, his LSD-inspired strips would make him into an underground cult hero.

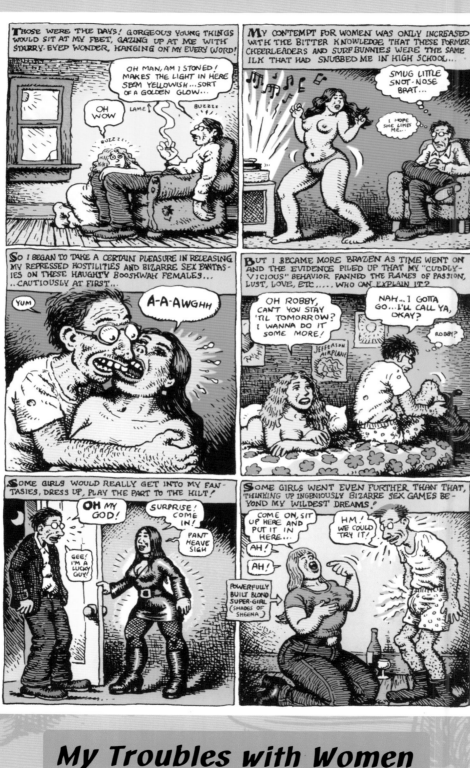

Frustration

In this book's two title stories, Crumb draws himself as a mature sophisticate in dressing gown, a pipe, and slippers as he wistfully recalls his first flush of fame and sexual abandon in late 1960s San Francisco. He admits here to feeling contempt for the young "hippie chicks" who only want to sleep with him now that he has become a famous counterculture figure.

Crumb has had other "troubles with women" who accuse him of sexism and misogyny, but he is always hardest on himself. With self-deprecating honesty, he shows how his conflicted feelings about women grew out of his teenage years, spent in lonely, horny frustration, lusting after girls who ignored him. By the age of 20, he had not even kissed a girl. His hedonistic spree turned into a sort of twisted revenge.

Notice Crumb's footnote on SHEENA, the jungle queen from comic books, played on 1950s TV by the statuesque Irish McCalla, one of Crumb's formative childhood fantasies. Crumb makes ample use of classic cartooning devices: drops of sweat, lines for movement or glowing beauty, and wavering squiggles for that bulge in his shorts.

My Troubles with Women

Robert Crumb
1990, 1 volume, 80 pages

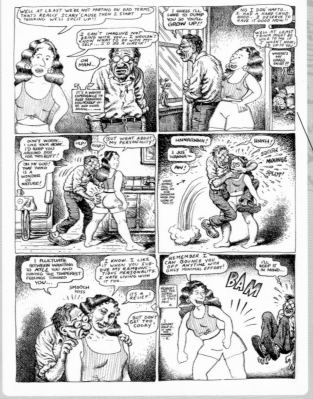

Fetishes

In "Footsy," far left, Crumb thinks back to the rush of puberty and his secret sex games while in class with Jeanette Bates, the girl who sat behind him. These illicit thrills fanned his schoolboy dreams and help explain his adult predilection for women with sturdy legs.

When it comes to courting rituals, left, Crumb's libido makes it impossible for him to play hard to get with women for long. When they recognize his desperate lust, they torment him by becoming unattainable. Crumb draws unflattering self-portraits, exaggerating his scrawny body, big teeth, thick glasses, and shabby clothes. Here he caricatures himself first as Goofy and then as a perverted troll.

"The mind boggles, but let's imagine." Crumb indulges in his wildest fantasies in the absurd "If I Were King," far left. Here, in the guise of a royal painter, he revisits his high school foot fetish with help from his giggly model.

These days, Crumb's few "troubles with women" tend to revolve around his personable wife, Aline Kominsky-Crumb, who has been with him since she was 23, and their daughter Sophie, seen here in the back room, now grown up and a cartoonist herself. Aline and Robert co-create three stories in this book, each writing and drawing themselves within the same panels. Here, Francophile Aline is invited to spend summer in Paris and Sophie is coming too. The Crumbs' unique "jam" comix let them air their dirty laundry and let us inside their sparky, unconventional marriage.

Following on from My Troubles with Women

Ripple

"Fine artist seeks non-professional model, $15 an hour." Balding, asthmatic smoker and hack illustrator Martin Deserres wins a grant to produce his "Eroticism of Homeliness" paintings. Martin hires Tina, young, large, very shy, and seemingly malleable to his every fantasy. From her first session for him, right, he has already fallen helplessly in lust with her.

Martin's neediness and Tina's new unpredictability let her turn the tables on him, far right. Canada's Dave Cooper examines their games of obsession and control by having Martin, still psychologically ravaged three years later, write his side of the story. His notes and doodles appear in red, his recollections in blue.

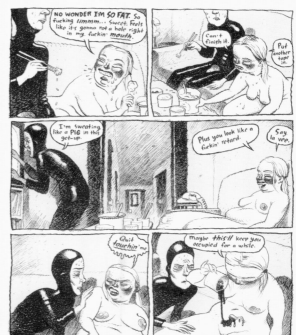

Unlikely

"To her, for being first." Jeffrey Brown dedicates his tender, candid graphic autobiography to Allisyn, the girl with whom he lost his virginity. He employs no captions to give an author's voice wise with hindsight, only the immediacy of "young adult" love retold across 227 pages, all of six sparse, disarming panels.

Brown seems to keep few secrets, here taking us into the privacy of their fumbling love-making. No scene lasts longer than ten pages—many are single pages—but somehow, as Ira Glass of NPR's THIS AMERICAN LIFE says, "they're surprising, even though half the moments in the book are ones you've probably experienced yourself."

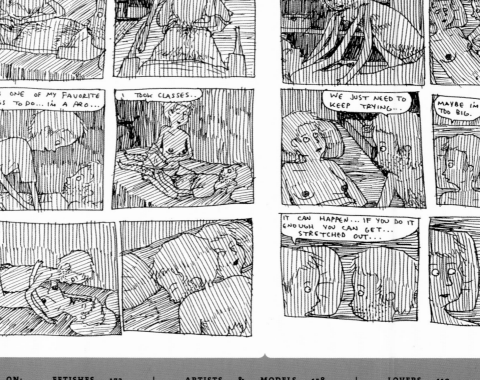

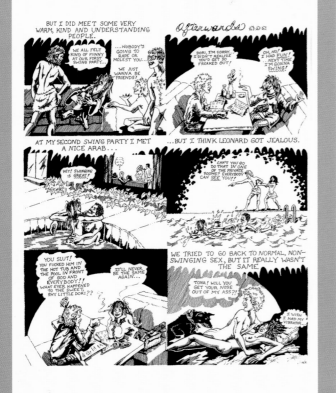

Dori Stories

The life of Dori Seda burned briefly but dazzlingly as San Francisco's most perceptive and shameless comix confessionalist of the 1980s. To placate her boyfriend, sweet Dori goes with him to her first "swing party," far left. Her nerves soon give way to having fun. The new, experienced Dori no longer finds normal sex with him as satisfying, and the final straw is an attack of crabs. This story ends with Dori in bed with "the true love of my life," her male doberman Tona, though Dori stressed that this was all in jest and she never had an unnatural relationship with her dog. Still, she shows Tona getting turned on by sniffing her dirty clothes, left. Combined with her cat Dracula's poop, their stench drives people out of the laundromat.

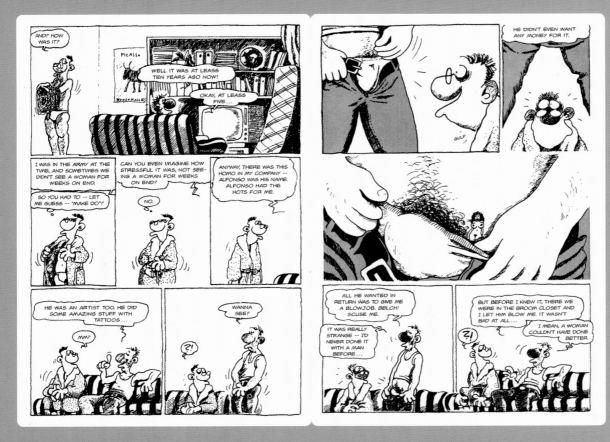

Maybe... Maybe Not

In 1994, this broad, teasing comedy of sexual confusion by Germany's cult graphic novelist Ralf König was adapted into the country's largest-grossing movie since Marlene Dietrich's THE BLUE ANGEL. In an effort to win back his ex-girlfriend, serial philanderer Axel has to join a men's support group to get in touch with his sensitive side. Through this, he winds up moving in with gay acquaintances Norbert and cross-dresser Walter. Despite being a sexist boor, Axel becomes their "hetero hunk" and the object of their mostly unrequited desire. Norbert gets his hopes up here, when Axel lets slip that he may not be so straight and narrow after all.

Gemma Bovery in focus

Destiny

"Gemma Bovery has been in the ground three weeks." The opening sentence tells us that this expatriate English blonde is destined to die here in Normandy; the mystery is how, why, and was it an accident?

From the first page, we also learn that our narrator, intellectual local baker Raymond Joubert, harbors secrets about Gemma's death and feels to blame for it "up to a point" because he "tempted the fates."

This ex-publisher and bibliophile pompously almost believes he can will people into enacting the kind of grandiose dramas in his beloved literary masterpieces, as if he can make life imitate art. After all, Joubert does not sound so very different from Flaubert, author of MADAME BOVARY.

Inspiration

Posy Simmonds is very English but studied at the Sorbonne in Paris. She explains: "I first read MADAME BOVARY when I was 13 or 14. I've read it twice since then. I decided to use it after I saw a woman on holiday in Italy. She was young, very pretty, and was giving this guy such a hard time by yawning. She looked desperate, surrounded by Prada shoe bags, and she reminded me of Madame Bovary."

Adultery

Earlier this evening, Raymond had spied Gemma's "obedient van" driving up to the chateau of handsome, engaged aristocrat Hervé. Now at the Boverys' for dinner, Raymond cannot spot any hint of her adultery. But he grows smug when he notices a lovebite on her neck.

Oblivious to the banal chatter, Gemma goes over her first liaison with Hervé only hours before. Notice how we enter Gemma's large, multi-panel thought balloon from her detached presence at the table, upper right, and leave it to join her, lower left, closely watched by Raymond as the guests depart.

Posy Simmonds puts another thought balloon, Hervé's, inside Gemma's to show how, unknown to her, her jest about a girlfriend prompts him to think of his fiancée Delphine.

You don't need to know any French to enjoy this story. Here, Gemma's remarks help to explain Hervé's questions. Elsewhere, key French texts are "subtitled" in English; the others are fairly obvious or not vital. Notice also how, instead of intrusive outlined balloons, the pointers from floating text show dialog more discreetly when used on white backgrounds.

Gemma Bovery
Posy Simmonds
1999, 1 volume, 106 pages

I sent Gemma an envelope. As soon as it disappeared in the box, I remember feeling a rush of self-disgust. I couldn't believe myself, to sink so low as to send anonymous mail. Now, reading her account of how she received it, I feel even worse. It was not only base, it was cruel, indefensible.

When the *poste* arrived Gemma was upstairs preparing for her adulterous weekend, cutting little plastic tags out of new lingerie. In an hour she would leave for Calais. By the end of the day she would be in London with Hervé.
That she had misgivings about the trip is clear from her diary of the day before.

Three nights together – maybe it's a mistake. Just too much – we might not get on ..might run out of things to say. I so want it to be a love thing but maybe it is just a BED thing. I'm such a fool, it was perfect. Should've left it as it was. Terrified now I'll screw it up.

Thanks Justin...

Had to lock myself in the bathroom – Justin's always so nosy about letters. I had a really terrible feeling about it. Address was typed in caps ..to Madame Bovery. Local postmark. Posted yesterday. Didn't want to open it

Inside she would have found two pages photocopied from an English translation of *Madame Bovary*, with several sentences marked in yellow highlighter. All from the letter Madame Bovary's lover sends her on the day of their elopement, ending it all.

Anh!

Be brave, Emma, be brave! I do not want to ruin your life Believe me, I shall never forget you. I shall always be deeply devoted to you. But who can doubt that one day, sooner or later, these ardent feelings of ours would cool? We should have grown tired of one another... I will be far away when you read these sad lines. I wanted to get away as soon as I could, so as not to be tempted to see you again... Emma, forget me. Why did I have to know you? Why were you so beautiful?Adieu. Adieu!..............

It's a joke..don't **BELIEVE** it!..... Hervé... *he* wouldn't!.. not like this...he **wouldn't**!!

How **DARE** he!? How *dare* he tell me like this!!?.... **DUMP** me! Dump me like this..!

Oh God ...is this the way they do it in France ?... ...so bloody cultured, they do it with **literature**!?

Following on from Gemma Bovery

Veils

Pat McGreal's VEILS hints at what Orientalist painters might have come up with if they had created comics using today's digital arts. For Victorian newly-wed Vivian, disenchanted with her sullen husband, their visit to an Arabian city introduces her to unfamiliar sensualities when she is invited into the Sultan's harem. In the company of concubines, this stiff English rose begins to lose her inhibitions and agrees to let Pakize and the others decorate her body in henna. Where will Vivian's voyage of self-discovery lead her? Artists Stephen John Phillips and José Villarrubia fuse antique tinted photos with erotic "fumetti." Parallel to Vivian's story, Rebecca Guay paints the tale of an earlier Western woman who bore the Sultan a child.

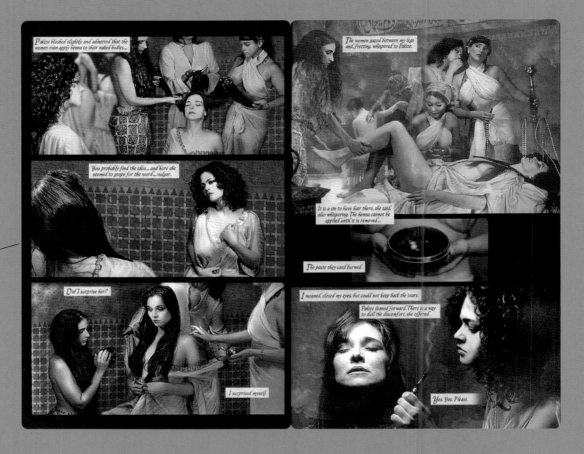

The Blue Notebook

"There aren't any curtains in your windows." It's the morning after their first night together and Louise is falling for dark, shy Victor. Little does she know that he has become obsessed with her, ever since he started stealing glimpses of her naked in her apartment from his passing train. But his fixation becomes clear, far right, when Louise is mysteriously sent Victor's private journal. Completing this love triangle is cocky "stud" Armand, Louise's previous lover, whom she swiftly dumped, and who, like Victor, has also been spying on her. Parisian André Juillard stokes their rivalry for her affections, which leads to a death and an arrest for murder.

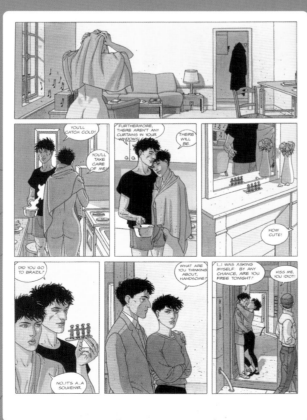

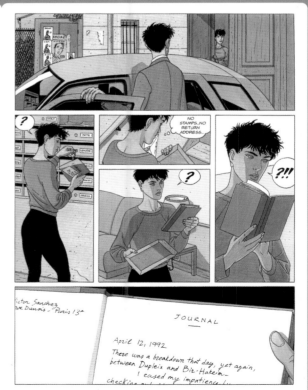

Mail Order Bride

Monty Wheeler is Canadian, 39, still single, still a virgin. A geek who never grew up, he now runs a comics and toy store and lives over it with his vast collection. All that's missing is a wife. Monty has "yellow fever," so he answers an ad in one of his Asian porn mags and orders Kyung Seo from Korea. Problems flare up when Kyung fails to be the china doll and sex kitten he ordered. Kyung wants to leave her past behind. Here, far left, she defies Monty's plea to wear her hair down.

To assert herself, left, she befriends Eve, a liberated Asian photographer, and starts modeling for her in the nude. Mark Kalesniko examines how cowardice and dependence keep two lonely people trapped in a loveless marriage.

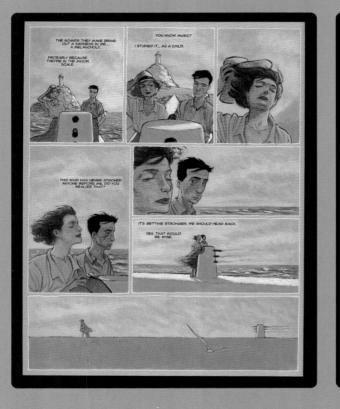

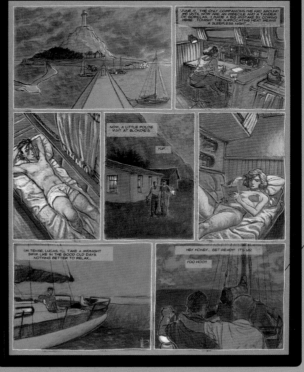

Streak of Chalk

They say it's a bad omen if three boats are anchored to this tiny island marked on no map, merely a "streak of chalk" in the Atlantic. Other streaks of chalk, and paint, promises of love, plaster the pier wall. On a return trip, Ana believes that one message was left for her and decides to wait for its mystery writer to find her.

But can it be Raul, far left, if this is his first time on the island? Or one of the coarse mariners, left, from a third boat who decide to pay Ana a call? Galician Miguelanxo Prado builds a palpable atmosphere of expectancy, isolation, and brooding desires in his lush pastels, the island's abandoned lighthouse symbolizing male impotence.

Lost Girls in focus

"In *Lost Girls*, the blend of Alan's European heritage and Melinda's countercultural Americana, fueled by the artistic merger of a female and male creator, is ripe with promise and potential ."

STEPHEN R. BISSETTE

Older children

"We can't disown the girls we were, we can't let them remain lost to us." So says Lady Alice Fairchild about a quest with Mrs Wendy Potter and Miss Dorothy Gale to rediscover their "lost girl" selves, lost in Wonderland, Neverland, and Oz. They do this by sharing their most intimate stories at the Hotel Himmelgarten, or "heaven garden," on the Austrian border in 1913.

Revisiting these classics, Alan Moore and Melinda Gebbie make no claim that authors Carroll, Barrie, and Baum intended anything sexual in them, but by treating these books as encoded sexual histories they open up a range of story ideas.

As Moore said, "If you are trying to say something to a wide audience about the onset of adolescence, what better characters to use than Alice, Wendy, and Dorothy, universal symbols of different types of children."

Their tales are so familiar that we can't help imagining how their eroticized version will play out. Moore and Gebbie do not want to talk about these characters, but "about human beings, and our capacity for fiction and sexual fantasy, the subjective world inside us all."

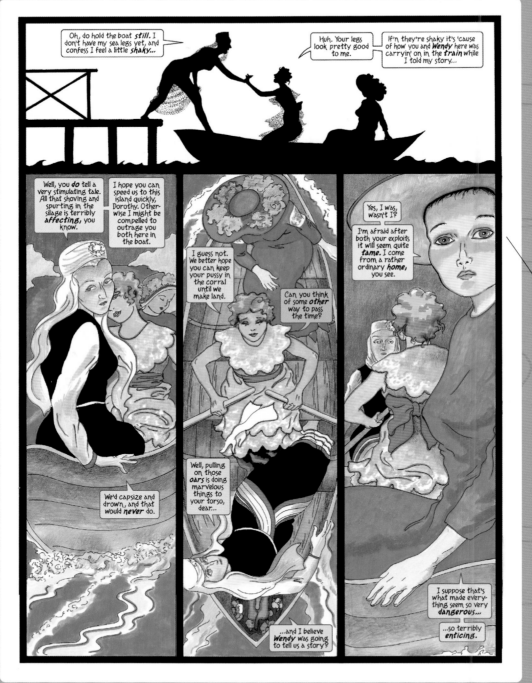

Telling tales

Off on a summer outing, Dorothy helps Alice onto the boat that will carry the three women to an almost tropical island on the Bodensee. The crossing provides a chance for Wendy to tell them more about her youth.

Their outfits hint at their personality. Alice, the oldest, dresses exotically and wears her white hair long. Country girl Dorothy likes frills and bows and keeps her arms bare, while prudish Wendy is covered head to toe, even sporting a large hat and gloves.

The women's stories excite and empower them, while Austria lurches towards war. Alice stresses the roles imagination can play: "Sometimes it traps us, sometimes it's what sets you loose. Beautiful and imaginative things can be destroyed. Beauty and imagination cannot. They blossom, even in wartime."

For Alice and the rest, another source of stimulating reading is the hotel manager's "White Book." Monsieur Rougeur made his money as a Parisian forger of erotica. In his book can be found Moore and Gebbie's "forgeries" in the styles of Beardsley, Schiele, von Bayros, Wegener, and other erotic artists of the past.

Lost Girls
Alan Moore & Melinda Gebbie
2006, Slipcased set of 3 volumes, 240 pages

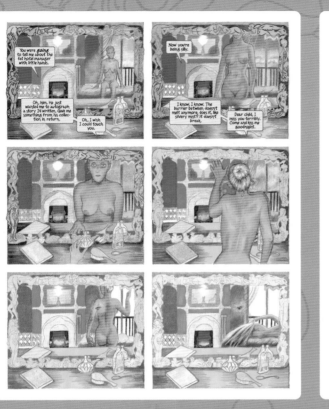

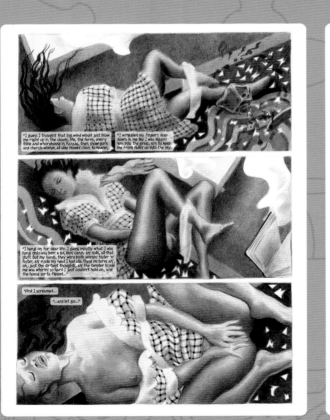

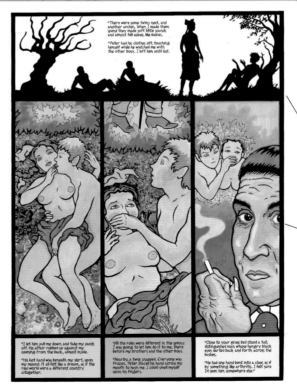

Souvenirs

Alice travels everywhere with her looking glass and brings it with her to the hotel. It was her doorway to desire, "a strange land one discovers as a child where nothing makes the slightest sense." No longer able to step through it, she must content herself with talking to and kissing her first love, her own reflection, far left. The action in the first and last chapters and elsewhere is made visible in this suggestively framed mirror.

Oval panels like reflective mirrors, pools, eyes, and perhaps rabbit holes, distinguish the chapters in which Alice recounts her past. Here, as a curious girl attracted to Mrs Regent, she finds herself drawn into the Red Queen's love games.

Dorothy is an open book, so her flashbacks fill panels as broad and expansive as a cinema screen or a Kansas wheat field. Here, far left, at the same moment when the deadly tornado threatens to carry her and the house aloft, Dorothy's world turns upside down as she experiences "the twister inside," her first orgasm.

The souvenirs of the more reserved Wendy aptly start each page concealed as a silhouette. Here, she recalls Peter Pan awakening her sexuality further in the spinney, while the claw-handed Captain Hook walks by. Shadows, some with minds of their own, feature in the PETER PAN story. In one scene in LOST GIRLS, their shadows behind them on the bedroom wall perform acts which Wendy and her passionless older husband secretly long to do.

Following on from Lost Girls

Butterscotch

Besotted with vain prima ballerina Beatrice, a meek and mild physics professor tells another dancer, Honey, about his magic skin cream, which makes him invisible, so that he can get closer to his dream woman. But Honey can smell his cream's telltale butterscotch scent and decides to thwart his innocent crush. Here, to hide from Beatrice, this naked "Invisible Man" has cleaned and exposed his face and neck so that he resembles a lifelike statue of a bust on the wall. But how much longer can he keep still and emotionless, while Honey is turning the rest of him on? It's what you can't see but have to imagine that makes these escalating embarrassments by Italy's Milo Manara amusing and arousing.

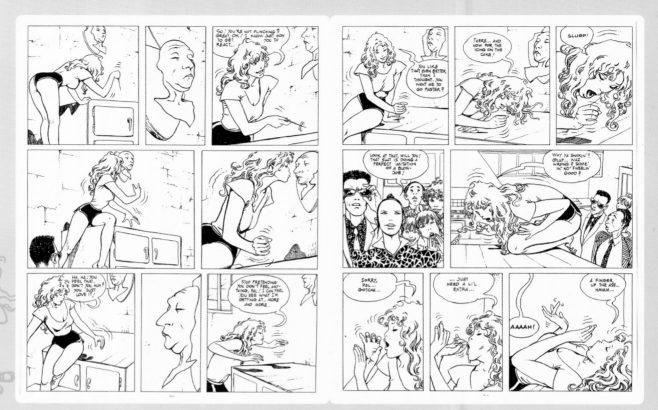

Casanova's Last Stand

He may be 73 and nearing his end, but legendary lover Casanova plans one last grand seduction of the Countess Lascivia, and to do it he ropes in Klutz, his inexperienced underling. Here, to fire Klutz's ardor, Casanova makes him read about another of his many past conquests from his memoir, MY LIFE.

On this occasion, it involves a wealthy Venetian voyeur and his mistress. Notice how English cartoonist Hunt Emerson repeats the one panel and the phrase "everything arranged," so we can spot the eyes moving in the portrait. He also piles up sight gags like the drowned cat and the fancy lights and mirrors.

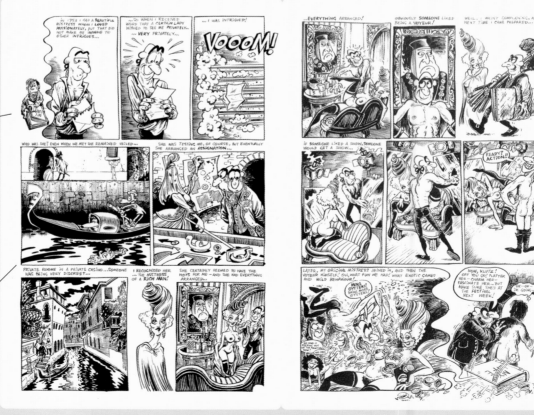

Following on from Lost Girls

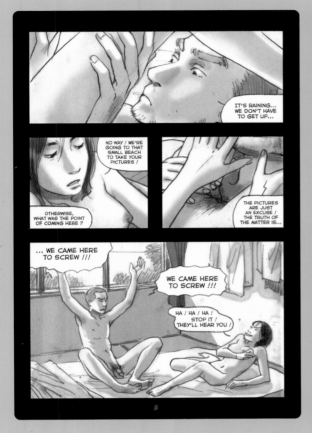

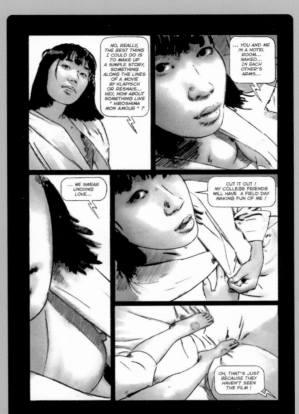

Mariko Parade

It was like finding a kindred spirit when rising talent Kan Takahama discovered the French author Frédéric Boilet in Tokyo. Both wanted to explore the subtleties of the human heart in comics. Boilet's YUKIKO'S SPINACH was autobiographical fiction, a love letter to Mariko, his model and muse. He invited Kan to collaborate on this sequel, the story of his and Mariko's tender break-up on a seaside photo shoot.

Kan, far left, draws the couple waking up in their "respectable" guesthouse whose rooms have no keys, while Frédéric, left, recalls discussing storylines with Mariko. This touching East-West fusion, hailed as "La Nouvelle Manga," affirms: "A flower is never more beautiful than at the very moment it begins to fade."

Bread and Wine

Dennis is a homeless Irishman from Brooklyn who sells books from his blanket on New York's 72nd Street. When a black, bearded literature professor and science-fiction writer, Samuel R. Delany, buys a book from him, it's the start of a complex, tender, and lasting relationship between two very different men. Here, on their first stay in a motel, Dennis cleans himself up. Before he can take a shower, though, he needs to have two baths, because it's his first time in a private bath in six years. "Then we held each other ... for a couple of days." With passion and compassion, Delany gently shares this taboo-breaking true story, drawn by Mia Wolff, about bringing his partner from the street into his life.

Afterthoughts

Michael Chabon won a Pulitzer Prize in 2001 for his novel *The Amazing Adventures of Kavalier & Clay*, a brew of factual recreations and fictional intrigues about a talented partnership working in American comic books during and after the Second World War, based partly on Joe Simon and Jack Kirby. Inspired by Jim Steranko, Chabon gave Kavalier escapology skills which lead him and Clay to create their masked champion, The Escapist. For many refined novel readers, it was probably their first step behind the scenes of the boisterous, arcane, and sometimes sleazy business of four-color thrills. In a further twist, Chabon has contributed to a new comic book devoted to The Escapist. Other big names in literature are also revealing their enthusiasm for comics and graphic novels, from Dave Eggers, Zadie Smith, and Jonathan Lethem to Nick Hornby, Philip Pullman, and Alex Garland, who disclosed that he initially wrote and drew his novel *The Beach* as a graphic novel. Some in the word-loving literary world reeled in 2001 when Chris Ware won the *Guardian*'s First Novel Award for *Jimmy Corrigan*, a controversial decision that apparently divided the jury.

The graphic novel's increasing sophistication and acclaim seems to be finally fulfilling the predictions by Goethe and Updike, and the aspirations of Richard Kyle, Will Eisner, and the rest. But is there a danger of becoming too fixated on appealing to adults and no longer attracting younger readers? Chabon thought so, when he addressed the San Diego Comic-Con, America's largest "gathering of the clans," in 2004. He warned: "Children did not abandon comics; comics, in their drive to attain respect and artistic accomplishment, abandoned children. And for a long time we as lovers and partisans of comics were afraid, after so many long years of struggle and hard work and incremental gains, to pick up that old jar of 'greasy kid stuff' again, and risk undoing it all. Comics have always been an *arriviste* art form, and all upstarts are to some degree ashamed of their beginnings. But frankly, I don't think that's what's going on in comics anymore. Now, I think, we have simply lost the habit of telling stories to children. And how sad is that?"

Chabon called on creators and publishers to win back the junior audience before it is too late. Clearly, children are the future, and without them where will the next generation of adult readers come from? Luckily, comics are not just for adults any more. A number of creators now have kids of their own and have jumped at the chance to devise fresh, engaging graphic novels for children. Publishers like Scholastic, Hyperion, Penguin, and First Second are targeting the young and young adult sector. Putting aside their cutting-edge *Raw* magazine, in 2000 Art Spiegelman and Françoise Mouly invited children's book authors like Maurice Sendak, J. Otto Seibold, and Barbara McClintock to devise comics for their series of deluxe *Little Lit* hardbacks. The biggest boom has been the invasion of manga, digest-size, black-and-white paperbacks of up to 200 pages from Japan. Often boosted by animation and games, these are captivating youngsters, notably teenage girls, who had been largely ignored by the superhero-dominated larger publishers. This in turn is driving more Western creators to work in this format.

Another blossoming field is "webcomics," cutting out all the middle men and putting the creator in direct contact with the reader. Serializing graphic novels on the internet, such as *MegaTokyo*, *Shutterbug Follies*, and *Scarygoround*, is a great way to build up a massive global readership. Gradually, different systems of subscriptions and micro-payments are making online comics creation commercially viable for artists. While the majority tend to stick to screen-format single pages, others are trying all kinds of unique avenues for hyperlinks, limited animation, and multiple paths through stories. Liberated from print and paper, the very physical shape of a comic is thrown wide open by what tireless campaigner Scott McCloud hails as "the unlimited canvas" of the web. More debatable is what happens when you add animation or sound. Are the end products still comics or do they become something else? Interestingly, for all the advantages of virtual comics, many artists and readers still aspire to a printed book version as somehow more "real."

As a rule, any transfer from one medium to another results in something being "lost in translation." You only have to look at the variable track record of film versions of recent graphic novels, for example, *From Hell* which was given "a happy ending," and *League of Extraordinary Gentlemen*, which lost the plot entirely. As for adaptations of works of literature into comics, they

tend to be no exception to this rule. Founded by Russian Jewish immigrant Albert Kanter in 1941, the fondly remembered but controversial *Classics Illustrated* may have helped some students pass their English Literature classes. Despite painter Louis Zansky's vigorous art, the demands of condensing a book like *Moby Dick* down to less than 64 pages left room for little more than Ahab's obsession and battle with the whale. No wonder educators used to be sceptical at best, branding them "Classics Desecrated." A different approach was taken in Britain in the 1980s by Oval Projects. They insisted on staying faithful to Shakespeare's plays and keeping his words complete and uncut, aiming them at being used in the classroom. The book format with more pages and painted art was a help, but the challenge remained that the Great Bard wrote for the stage, not the comics. Though I have omitted adaptations from this book, I have listed some here that have enhanced the original by playing to the specific strengths of comics. Occasionally, some things can be "found in translation." You might call these "Classics Illuminated." That might describe Robert Crumb's next magnum opus, a personal but wholly accurate adaptation of the *Book of Genesis*.

Those old *Classics Illustrateds* used to end with the cheery advice to seek out and enjoy the original. In the same way, if reading some of the "clips" in this book has whetted your appetite, then use the following pages to explore further and read the whole graphic novel for yourself. The biggest range is usually in specialist comics stores, although many bookstores stock graphic novels extensively. A handful of the works recommended here are not in print, but should be available and affordable secondhand, online, or via eBay. Otherwise, you can always try your library. Who would have thought that librarians would become advocates of graphic novels, when fifty years ago they were among the staunchest opponents of comic books? It has helped that graphic novels attract the elusive younger reader into the library, notably teenage boys, who tend to read less than girls or not at all. It also helps that graphic novels are so popular, because they boost the libraries' vital "issue" figures. There's no excuse for not trying graphic novels now that you can borrow them from libraries for free.

Prejudices persist and comics can still ring alarm bells. "Child murder, incest and rape ... is this really how our schools should be encouraging boys to read?" This was the headline in the British newspaper the *Mail on Sunday* in November 2004. It was intended to stir up a middle-class moral panic at the promotion of manga, wrongly described as "graphic Japanese comic books infamous for the violent and pornographic content of their adult versions," into school libraries by The Reading Agency. The charity's initiative was to recommend specific titles strictly suitable for teenagers aged 13 to 16, many of them reluctant readers, and it proved very popular and effective.

This modern scare story sounds a lot like the British debate in the 1950s in the Houses of Parliament about another foreign menace: American comic books. Recorded in *Hansard* in 1952, Sir Hugh Lucas-Tooth, Joint Under-Secretary for the Home Department, commented in the House of Commons: "The peculiarity of the publications we are now considering is the emphasis they place on violence as such. Second—and this I think is of great importance—they have reduced the letter-press [typeset text] to almost insignificant proportions. The ordinary 'comic,' while it may not be of very much value in itself, did at least teach the children using it to read, but with these publications it is almost unnecessary to be able to read in order to get a sense of what is being depicted. They also use a crude and alien idiom to which all of us take exception." Mounting pressure resulted three years later, on May 6 1955, in the Children and Young Persons (Harmful Publications) Act, banning the publication and sale of American comic books.

None of those politicians could have imagined how those "harmful publications" would survive and evolve over the past fifty years. Certainly, none could have dreamt of an adult graphic novel like *V for Vendetta* extolling a modern counterpart of the 17th-century anarchist Guy Fawkes. Nor that in its adaptation to the big screen, the directors, the Wachowski brothers, would manage to secure permission to film a night-time riot outside the Houses of Parliament itself which climaxes with the buildings being blown sky high. In theory, that law from 1955 is still on the statute books today, although you would never know it.

Resources

Where will you go next? These pages give you some leads to pursue your interests from this book on the internet and in books and magazines, and suggestions for some resources that you might enjoy exploring.

Featured publishers' websites

To find out more about many of the graphic novels spotlighted in this book, you can visit the websites of their publishers. To find out which publisher has published the graphic novel that interests you, check the page number in the acknowledgments listed overleaf on page 188 and then look up the site below. A few of the former, as well as smaller publishers and imprints such as Catalan Communications, Epic, Fleetway, and Ignite!, do not have their own online presence.

:01 First Second: www.firstsecondbooks.com
Aardvark-Vanaheim: www.followingcerebus.com
Abiogenesis Press: www.millidge.com
Active Images: www.activeimages.com
Alfred A. Knopf: www.randomhouse.com
Alternative Comics: www.indyworld.com/altcomics
America's Best Comics: www.dccomics.com
Avatar Press: www.avatarpress.com
Blast Books: www.lastgasp.com
Byron Preiss Visual Publications: www.bpvp.com
Cartoon Books: www.boneville.com
Colonia Press: www.coloniapress.com
CPM: www.centralparkmedia.com
Dark Horse Books: www.darkhorse.com
DC Comics: www.dccomics.com
Drawn & Quarterly: www.drawnandquarterly.com
Eddie Campbell Comics: www.eddiecampbellcomics.com
El Capitán: www.straybullets.com
Fanfare/Ponent Mon: www.ponentmon.com
Fantagraphics Books: www.fantagraphics.com
Four Walls Eight Windows: www.4w8w.com
Frog, Ltd.: www.northatlanticbooks.com
The Harvill Press: www.harvill.com
Henry Holt: www.henryholt.com
Homage Comics: www.dccomics.com
Humanoids, Inc.: www.humanoids-publishing.com
Hyperion Books: www.hyperionbooks.com
ibooks, inc.: www.komikwerks.com
Image Comics: www.imagecomics.com
Jonathan Cape: www.randomhouse.co.uk
Juno Books: www.lastgasp.com
Kitchen Sink Press: www.deniskitchen.com
Knockabout Comics: www.knockabout.com
Last Gasp: www.lastgasp.com
Lightspeed Press: www.lightspeedpress.com
Little, Brown and Co.: www.twbookmark.com
Marvel Comics: www.marvel.com
Metaphrog: www.metaphrog.com
NBM Publishing: www.nbmpublishing.com
Orion Books: www.orionbooks.co.uk

Pantheon Books: www.randomhouse.com
Penguin Books: www.penguin.co.uk
Rebellion: www.2000adonline
Rip Off Press: www.ripoffpress.com
Sasquatch Books: www.sasquatchbooks.com
Scholastic Books: www.scholasticbooks.com
Slave Labor: www.slavelabor.com
Strip Art Features: www.safcomics.com
Titan Books: www.titanbooks.com
Top Shelf Productions: www.topshelfcomix.com
Typocrat Press: www.typocrat.com
Vertical Inc.: www.vertical-inc.com
Viz Media: www.viz.com
WildStorm: www.dccomics.com
W.W. Norton & Co.: www.wwnorton.com

Suggested further reading

If you're curious to learn out more about graphic novelists, here are a number of insightful monographs.

The Comics Journal Special Editions and *Library Series*, Fantagraphics Books: Oversized, square-format specials feature interviews with Joe Sacco, Jim Woodring, Art Spiegelman, and many more, while the *Library Series* compiles the magazine's interviews with Jack Kirby, Frank Miller, and Robert Crumb

Conversations, University Press of Mississippi: Superb series compiling revealing interviews across graphic novelists' careers. Subjects so far are Carl Barks, Robert Crumb, Milton Caniff, and Charles Schulz. Edited by M. Thomas Inge (www.upress.state.ms.us)

The R. Crumb Handbook, MQ Publications: Part autobiography, part celebration by Crumb with Pete Poplaski (www.mqpublications.com)

Will Eisner: A Spirited Life, the definitive, authorized biography by Bob Andelman, and *Eisner/Miller*, Charles Brownstein's book-length interview (www.darkhorse.com)

The Extraordinary Works of Alan Moore, TwoMorrows Publishing: Extensive interview by George Khoury, biography, and bibliography, rare and unpublished scripts and art (www.twomorrows.com)

Hanging Out With the Dream King, Fantagraphics Books: Interviews with Neil Gaiman and his collaborators

The Library of Graphic Novelists, The Rosen Publishing Group: A series of six hardback biographies of Coleen Doran, Will Eisner, Neil Gaiman, Joe Sacco, Art Spiegelman, and Bryan Talbot (www.rosenpublishing.com)

Pocket Essentials: Packed bargain guides cover Crumb, Moore, and Tintin (www.pocketessentials.com)

Chris Ware, Yale University Press/ Laurence King: Dan

Raeburn's revealing analysis of Ware's techniques (www.yalebooks.com or www.laurenceking.co.uk)
The Mindscape of Alan Moore, a mind-expanding, feature-length movie directed by Dez Vylenz is available on DVD (www.shadowsnake.com)

Graphic novel reviews and histories

Perceptive coverage, both archived and up-to-date, can be found at these websites and related links:

www.angelfire.com/comics/gnlib/media/index.html (with advice on graphic novels in libraries)
www.artbomb.net
www.bugpowder.com
www.comicsreporter.com
www.comicsworthreading.com
www.thefourthrail.com
www.graphicnovels.brodart.com/links.htm
www.graphicnovelreview.com
www.grovel.org.uk
www.indyworld.com/indy
www.ninthart.com
www.page45.com
www.readyourselfraw.com (also great for artists' links)
www.sequart.com
www.sequentialtart.com
www.time.com/time/columnist/arnold (new feature every two weeks)

These print magazines also cover new releases and topics:
Comics Focus (www.soaringpenguin.co.uk)
The Comics Journal (www.tcj.com)
Comics International, where my monthly "Novel Graphics" column appears (www.qualitycommunications.co.uk)
International Journal of Comic Art (www.ijoca.com)
Red Eye (www.enginecomics.co.uk)

Other guides to and histories of graphic novels include:
101 Best Graphic Novels, Stephen Weiner's basic A-to-Z survey, and *The Rise of the Graphic Novel*, his concise, introductory history, from NBM
The Slings & Arrows Comic Guide, an overwhelming 800-pages of critics' plaudits and pans about more than 5,000 titles (www.slingsandarrowspublishing.com)
Comics, Comix & Graphic Novels (www.phaidon.com), Roger Sabin's well-illustrated overview, and *Adult Comics: An Introduction* (www.routledge.co.uk)
Pictures & Words by Roanne Bell and Mark Sinclair, and my history of *Manga: 60 Years of Japanese Comics* (www.laurenceking.co.uk)

Creating your own graphic novel

There are plenty of "How To" manuals that promise instant success. Here are some guides to help you get started, get better, and get into print. First, a few core books that every aspiring graphic novelist should read:
Understanding Comics, *Reinventing Comics*, and the forthcoming *Making Comics*, all by Scott McCloud from Harper Collins (www.harpercollins.com).
Comics & Sequential Art and *Graphic Storytelling* by Will Eisner, the master, Poorhouse Press, Tamarac, Florida.
The Education of a Comics Art, Michael Dooley and Stephen Heller, Allworth Press (www.allworth.com).
Alan Moore's Writing for Comics, Avatar Press.

Some may find the tips and demos in these books helpful:
The Complete Idiot's Guide to Creating a Graphic Novel by Nat Gertler & Steve Lieber (www.idiotsguides.com)
Visual Storytelling by Tony Caputo and *The Making of a Graphic Novel* by Prentis Rollins (www.wgpub.com)
Writing and Illustrating the Graphic Novel by Mike Chinn, Barron's Educational (www.barronseduc.com)
Also of interest are the interviews in *Artists on Comic Art* and the two volumes of *Writers on Comics Scriptwriting*, Titan Books, while the magazines *Draw!* and *Write Now!* are worth exploring too (www.twomorrows.com)
The National Association of Comic Art Educators (www.teachingcomics.org) and Cartoon Classroom (www.cartoonclassroom.org) are the American and British contacts to find courses and teachers, while The Xeric Foundation provides grants to American creators who want to self-publish (www.xericfoundation.com).
The Center for Cartoon Studies offers a two-year course in White River Junction, Vermont (www.cartoonstudies.org).

Festivals and conventions

Approachable and accessible, these gatherings let you meet the writers, artists, publishers, and readers:
USA: www.comic-con.org (San Diego); www.comic-con.org/ape/ (San Francisco); http://go.to/icaf (Washington, DC); www.moccany.org (New York); www.spxpo.com (Bethesda, MD).
UK: http://caption.org/ (Oxford); www.comicexpo.net (Bristol/Brighton); www.ica.org.uk (ComICA, London); www.ukwebcomixthing.co.uk (London).
Europe: The Mecca and Cannes of comics, the Angoulême International Festival is the biggest in the world outside of Japan (www.bdangouleme.com). Other festival cities include: Lucca, Italy; Haarlem, Holland; Bergen, Norway; Luzern, Switzerland; Barcelona, Spain; Erlangen, Germany.

Thanks

Many people have helped to make this book possible. I particularly want to thank Peter Stanbury for his ideas, patience, and creativity, Karen Ings for initiating this project, and Phoebe Clapham, Bill McCreadie, Piers Burnett, and Peter Colley at Aurum Press for their encouragement.
My thanks to all the writers, artists, publishers, and friends for help and encouragement, including: Nick Abadzis, Paul Baresh, Tony and Carol Bennett, Peter Boyce, Peggy Burns, Eddie Campbell, Les Coleman, John Dunning, Steve Edgell, Sylvia Farago, Laura Fountain, Dan Franklin, all the guys at Gosh! (the best comic shop in London), Volker Hamann, Ferg Handley, Stephen Holland, Andrew James, Nick Jones, Nadia Katz-Wise, Dennis Kitchen, Ali Kokmen, Andy Konky Kru, Guy Lawley, Dominique Le Duc, Christian Lewis, Dennis McGirk, Joel Meadows, Terry Nantier, Didier Pasamonik, Soulla Pourgourides, Dominic Preston, Byron Preiss, Ian Rakoff, Amiram Reuveni, Richard Reynolds, Stephen Robson, Harri Rompotti, Roger Sabin, Mark Siegel, Dez Skinn, Richard Starkings, Chris Staros, Fredrik Strömberg, Kim Thompson, Eric Verhoest, Kate Warden, Brett Warnock and Patrizia Zanotti.

Acknowledgements

Copyright credits are listed below by their page number in each chapter. When there is more than one copyright on a single page, these are listed clockwise starting with A from the top left. Copyright holders' names are given first as the creator(s) and/or publishers. Creators' names are followed, where applicable, by the names of the book's publishers. If the book has been translated into English, any additional copyright of the translation is indicated by "T." Where there are different editions, American publishers are given first, followed by British.

COVER © Daniel Clowes, originally drawn for the cover of *Karikatur*, the German edition of *Caricature*, published by Reprodukt (www.reproduktcomics.de).
TITLE SPREAD 2 & 3: © Dylan Horrocks, Drawn & Quarterly.

CHAPTER 1
7: © Rodolphe Töpffer/ T © Dick & Fitzgerald.
10 & 11: © Chester Brown.

CHAPTER 2
12: © Art Spiegelman/ Pantheon/ Penguin.
13: A © Jean Giraud-Moebius/ Starwatcher Graphics/ Epic (Marvel)/ Titan. B © Art Spiegelman/ Pantheon / Penguin. C © Raymond Briggs/ Jonathan Cape. D © DC Comics/ Titan Books. E © Gilbert Hernandez/ Fantagraphics. F © DC Comics/ Titan.
14: A © Jim Woodring/ Fantagraphics. B: © Robert Crumb/ Last Gasp/ Knockabout. C © Ed Brubaker & Michael Lark/ DC Comics. D © Estate of Will Eisner/ Baronet/ W.W. Norton & Co. E © Enki Bilal/ Les Humanoides Associés S.A./ T © Humanoids, Inc. F: © Dave Sim/ Aardvark-Vanaheim.
15: A © Seth/ Drawn & Quarterly. B © Alan Moore & Eddie Campbell/ Knockabout. C © Charles Burns/ Pantheon/ Jonathan Cape. D © Daniel Clowes/ Fantagraphics/ Jonathan Cape. E © Joe Sacco/ Fantagraphics/ Jonathan Cape. F © Harvey Pekar & Drew Friedman/ Four Walls Eight Windows.
16: A © Alan Moore & Melinda Gebbie/ Top Shelf. B © Tezuka Productions, All Rights Reserved/ T © Yuji Oniki & Vertical Inc. C © David Hine/ Active Images. D © L'Association/ Pantheon/ Jonathan Cape. E © Keiji Nakazawa/ Shueisha Inc./ T © Project Gen/ Last Gasp. F © Frank Miller, Inc./ Dark Horse/ Titan.
17: A © Posy Simmonds/ Pantheon Books/ Jonathan Cape. B © Hugo Pratt/Cong S.A./ Editions Casterman/ T © The Harvill Press. C © DC Comics/ Titan. D © Chris Ware/ Pantheon/ Jonathan Cape. E © Jaime Hernandez/ Fantagraphics. F © DC Comics/ Titan.
18 & 19: © Craig Thompson/ Top Shelf.

CHAPTER 3
20: A © Al Davison/ Active Images. B © Wilhelm Busch. C © Craig Thompson/ Top Shelf. D © Lynda Barry/ Sasquatch.
21: © Phoebe Gloeckner/ Frog, Ltd.
22: © Bryan Talbot/ Dark Horse.
23: A © Justin Green/ Last Gasp. B © Paul Hornschemeier/ Dark Horse.
24 & 25: © Chris Ware/ Pantheon/ Jonathan Cape.
26: A & B © Justin Green/ Last Gasp. C © Lynda Barry/ Sasquatch.
27: A © Max Cabanes/ Editions Casterman/ Catalan/ Fleetway Editions. C & D © Craig Thompson/ Top Shelf.
28 & 29: © L'Association/ Pantheon/ Jonathan Cape.
30: A & B © Al Davison/ Active Images. C & D © Paul Hornschemeier/ Dark Horse.
31: A & B © Bryan Talbot/ Dark Horse. C & D © Neil Gaiman & Dave McKean/ Dark Horse.
32 & 33: © Daniel Clowes/ Pantheon/ Jonathan Cape.
34: A © Phoebe Gloeckner/ Frog, Ltd. B © Nabiel Kanan/ NBM.
35: A © Kiriko Nananan/ Magazine House/ T © Ponent Mon/ Fanfare. B © Debbie Drechsler/ Drawn & Quarterly.

CHAPTER 4
36: A © Carlos Sampayo & José Muñoz/ T © Catalan/ Titan. B © Tribune Media Services, Inc. C © Howard Cruse/ DC Comics/ Paradox Press. D © Michael Rabigliati/ Drawn & Quarterly.

37: © Jaime Hernandez/ Fantagraphics.
38: A © Estate of Will Eisner/ W.W. Norton & Co. B © Julie Doucet/ Drawn & Quarterly.
39: © Ben Katchor/ Little, Brown & Co.
40 & 41: Estate of Will Eisner/ W.W. Norton & Co.
42: A © Ben Katchor/ Little, Brown & Co. B & C © Howard Cruse/ DC Comics/ Paradox Press.
43: A & B © Carlos Sampayo & José Muñoz/ T © Catalan/ Titan. C & D © Eddie Campbell.
44 & 45: © Jaime Hernandez/ Fantagraphics.
46: A © Carol Swain/ Fantagraphics Books. B & C © Michael Rabigliati/ Drawn & Quarterly.
47: A & B © Julie Doucet/ Drawn & Quarterly. C © Rumiko Takahashi/ Shogakukan, Inc./ T © Viz Media.
48 & 49: © Gilbert Hernandez/ Fantagraphics.
50: A © Jerome Charyn & François Boucq/ Editions Casterman/ T © Catalan/ Titan. B © Dave McKean/ NBM/ Titan.
51: A © Alan Moore & Oscar Zarate/ Avatar Press. B © Kyle Baker/ DC Comics/ Paradox Press.
52 & 53: © Seth/ Drawn & Quarterly.
54: A & B © Dylan Horrocks/ Drawn & Quarterly. C © Jiro Taniguchi/ T © Ponent Mon/ Fanfare.
55: A © Phillippe Dupuy & Charles Berberian/ T © Drawn & Quarterly. B © Jessica Abel/ Pantheon.

CHAPTER 5
56: A © Vittorio Giardino/ Norma/ T © NBM. B & C © Victor Dancette & Edmond François Calvo. D © IPC Media Ltd./ Titan. E © L'Association/ Pantheon/ Jonathan Cape.
57: © Lorenzo Mattotti/ Editions du Seuil.
58: A © Sam Glanzman/ Epic (Marvel). B © Joe Kubert/ ibooks, inc.
59: A © D.C. Thomson & Co., Ltd. B © Mark Alan Stamaty/ Alfred A. Knopf.
60 & 61: © Art Spiegelman/ Pantheon/ Penguin.
62: A © Vittorio Giardino/ Norma/ T © NBM. B © Estate of Will Eisner/ DC Comics/ W.W. Norton & Co.
63: A © Joe Kubert/ ibooks, inc. C © Cosey/ Editions Dupuis/ T © NBM.
64 & 65: © Keiji Nakazawa/ Shueisha Inc./ T © Project Gen/ Last Gasp.
66: A © IPC Media Ltd./ Titan. B & C © Garth Ennis & John McCrea/ Fleetway.
67: A © Lorenzo Mattotti/ Editions du Seuil/ Catalan/ Penguin. B & C © Sam Glanzman/ Epic (Marvel).
68 & 69: © Joe Sacco/ Fantagraphics/ Jonathan Cape.
70: A © Jean-Marc Thevenet & Baru/ Editions Albin Michel/ T © Drawn & Quarterly. B & C © Ted Rall/ NBM.
71: A & B © L'Association/ Pantheon/ Jonathan Cape. C & D © Mark Alan Stamaty/ Alfred A. Knopf.
72 & 73: © Hayao Miyazaki/ Tokuma Shoten.

CHAPTER 6
74: A © DC Comics/ Titan. B © DC Comics. C © Jinxworld, Inc./ Marvel Comics. D © Juke Box Productions/ Homage Comics.
75: © DC Comics.
76: A © Marvel Comics. B © DC Comics.
77: © America's Best Comics, LLC.
78 & 79: © DC Comics/ Titan.
80: A & B © Marvel Comics.
81: A © Jinxworld, Inc. B © DC Comics/ Titan.
82 & 83: © DC Comics/ Titan.
84: A © Juke Box Productions/ Homage Comics. B & C © Pat Mills & Kevin O'Neill/ Titan.
85: A © America's Best Comics/ Titan. B & C © DC Comics/ Titan.

CHAPTER 7
86: A © Carla Speed McNeill/ Lightspeed Press. B © Estate of Jean-Claude Forest/ Eric Losfeld. C © Bryan Talbot/ Dark Horse. D © Mike Mignola/ Dark Horse/ Titan.
87: © François Schuiten/ Editions Casterman/ NBM.
88: © Jean Giraud-Moebius/ Starwatcher Graphics/ Epic (Marvel)/ Titan.
89: A © Enki Bilal/ Les Humanoides Associés S.A./ T © Humanoids, Inc. B © Mike Mignola/ Dark Horse/ Titan.
90 & 91: © Jean Giraud-Moebius/ T © Starwatcher Graphics/ Epic (Marvel)/ Titan.
92: A & B © Bryan Talbot/ Dark Horse. C & D © Carla Speed McNeill/ Lightspeed Press.

93: A © Hayao Miyazaki/ Tokuma Shoten/ T © Viz Media. B © François Schuiten/ Casterman/ NBM.
94 & 95: © Enki Bilal/ Les Humanoides Associés S.A./ T © Humanoids, Inc.
96: A © Katsuhiro Otomo/ Mashroom Co. Ltd./ Kodansha/ T © Dark Horse/ Titan. B © Rebellion.
97: A © Howard Chaykin, Inc./ Image. C & D © Brian K. Vaughan & Pia Guerra/ DC Comics/ Titan.
98 & 99: © DC Comics/ Titan.
100: A © Jeff Smith/ Cartoon Books/ Scholastic. B © Jeff Smith & Charles Vess/ Cartoon Books.
101: A © Mike Mignola/ Dark Horse/ Titan. B & C © Ian Edgington & D'Israeli/ Dark Horse.

CHAPTER 8
102: A © Hideshi Hino/ T © Blast Books. B © Russ Jones Productions/ Ballantine. C © Gary Spencer Millidge/ Abiogenesis Press. D: Alan Moore & Kevin O'Neill/ America's Best Comics/ Titan.
103: © Charles Burns/ Pantheon/ Jonathan Cape.
104: A © Kazuo Umezu/ Shogakukan, Inc./ T © Viz Media. B © Hideshi Hino/ T © Blast Books.
105: A © William M. Gaines, Agent, Inc. B © DC Comics/ Titan.
106 & 107: © David Hine/ Active Images.
108: © DC Comics/ Titan.
109: A © Alan Moore & Kevin O'Neill/ America's Best Comics/ Titan. B & C © Steve Niles/ Dark Horse/ Titan.
110 & 111: © Charles Burns/ Pantheon/ Jonathan Cape.
112: A & B © Hideshi Hino/ T © Blast Books. C & D © Gary Spencer Millidge/ Abiogenesis Press.
113: A © Alex Baladi/ Atrabile/ T © Typocrat Press. C & D © Jeff Nicholson/ Colonia Press.

CHAPTER 9
114: A © Max Allan Collins & Richard Piers Rayner/ DC Comics/ Paradox Press/ Titan. B: Respective copyright holders. C © Brian Michael Bendis & Marc Andreyko/ Image. D © Chris Reynolds/ Penguin.
115: © John Wagner & Arthur Ranson/ Rebellion.
116: A © James Steranko/ Byron Press Visual Publications, Inc./ Pyramid. C © Benjamin Legrand & Jacques Tardi/ Editions Casterman/ T © NBM.
117: A © DC Comics/ Titan. B © Brian Azzarello & Eduardo Risso/ DC Comics/ Titan.
118 & 119: © Ed Brubaker & Michael Lark/ DC Comics.
120: A & B © Paul Grist/ Dancing Elephant/ Image. C © Brian Michael Bendis & Marc Andreyko/ Image.
121: A © Daniel Clowes/ Pantheon/ Jonathan Cape. B © Hyun Se Lee/ T © CPM.
122 & 123: © Frank Miller, Inc./Dark Horse/ Titan.
124: A & B © Max Allan Collins & Richard Piers Rayner/ DC Comics/ Paradox Press/ Titan. C & D © Igor Tuveri/ T © Drawn & Quarterly/ Jonathan Cape.
125: A © Phillippe Thirault, Marc Riou & Mark Vigouroux/ Les Humanoides Associés/T © Humanoids, Inc. B © David Lapham/ El Capitán.
126 & 127: © DC Comics/ Titan.
128: A & B © Benjamin Legrand & Jacques Tardi/ Editions Casterman/ T © NBM. C © Chris Reynolds/ Penguin.
129: A © Brian Azzarello & Eduardo Risso/ DC Comics/ Titan. B © I before E, Inc./Homage Comics.
130 & 131: © Hugo Pratt/ Cong S.A.

CHAPTER 10
132: A © Junko Mizuno/ T © Viz Media. B © Charles Ross & Marie Duval. C © Jules Feiffer/ Fantagraphics. D © DC Comics/ Titan. E © Metaphrog.
133: © Jim Woodring/ Fantagraphics.
134: A © Estate of Harvey Kurtzman/ Kitchen Sink Press; B © Editions Albert-René/ T © Orion. C © Claire Bretecher/ T © Methuen.
135: © Peter Bagge/ Fantagraphics.
136 & 137: © Jim Woodring/ Fantagraphics.
138: A © Kim Deitch/ Pantheon. B © Francesca Ghermandi/ T © Fantagraphics.
139: A © Hendrik Dorgathen/ T © André Deutsch. B © Junko Mizuno/ T © Viz Media.
140 & 141: © Dave Sim/ Aardvark-Vanaheim.
142: A & B © Joan Sfar & Lewis Trondheim/ Editions Delcourt/ T © NBM. C © Metaphrog.
143: A © Estate of Harvey Kurtzman/ Kitchen Sink

Press. B & C © Gilbert Shelton/ Rip Off Press/ Knockabout.
144 & 145: A © Harvey Pekar, Joyce Brabner, Robert Crumb, Frank Stack, Joe Zabel, Gary Dumm & Bill Knapp/ Four Walls Eight Windows.
146: A © Peter Bagge/ Fantagraphics. B © Jules Feiffer/ Fantagraphics.
147: A & B © Manu Larcenet/ Editions Dargaud. T © NBM. C © Andi Watson/ Slave Labor.
148 & 149: © Raymond Briggs/ Jonathan Cape.
150: A © Peter Milligan & Brendan McCarthy/ Tundra UK. B © Claire Bretecher/ T © Methuen.
151: A & B © DC Comics/ Titan. C & D © Aaron McGruder, Reginald Hudlin & Kyle Baker/ Crown.

CHAPTER 11
152: A © Carlos Sampayo & José Muñoz/ T © Fantagraphics. B © Richard Doyle. C © Christophe Blain/ Editions Dargaud/ T © NBM. D © Chester Brown/ Drawn & Quarterly.
153: © Hugo Pratt/ Cong S.A., originally the cover of *Reddition* magazine 26 (www.reddition.de).
154: A © Hermann/ T © Strip Art Features. B © Hergé Moulinsart.
155: © Raymond Briggs/ Pantheon/ Jonathan Cape.
156 & 157: © Hugo Pratt/ Cong S.A./ Editions Casterman/ T © NBM & The Harvill Press.
158: A & B © Charlier & Giraud/ Editions Dargaud/ T © Starwatcher Graphics/ Epic (Marvel)/ Titan. C & D © Christophe Blain/ Editions Dargaud/ T © NBM.
159: A & B © Glenn Dakin/ Top Shelf. C & D © John Neufeld/ Alternative Comics.
160 & 161: © Tezuka Productions, All Rights Reserved/ T © Yuji Oniki & Vertical Inc.
162: A & B © Chester Brown/ Drawn & Quarterly. C © Natsuo Sekikawa & Jiro Taniguchi/ T © Ponent Mon/ Fanfare.
163: A © Carlos Sampayo & José Muñoz/ T © Fantagraphics. C & D © Raymond Briggs/ Pantheon/ Jonathan Cape.
164 & 165: © Alan Moore & Eddie Campbell/ Eddie Campbell Comics/ Knockabout.
166: A © Eric Shanower/ Image. B & C © Estate of Will Eisner/ W.W. Norton & Co.
167: A & B © Jason Lutes/ Drawn & Quarterly. B & C © Judd Winick/ Henry Holt.

CHAPTER 12
168: A © Pat McGreal, Stephen John Philips & Rebecca Guay/ DC Comics. B © Estate of John Scott Coutts/ Bélier Press/ Taschen. C © Hunt Emerson/ Knockabout. D © André Juillard/ Editions Casterman/ T © NBM.
169: © Posy Simmonds/ Pantheon/ Jonathan Cape.
170: A: Pierre Bartier & Guy Peellaert/ Eric Losfeld/ Grove Press. B © Estate of Guido Crepax.
171: A © Frédéric Boilet/ T © Ponent Mon/ Fanfare. B © Ralf König/ Rowohlt/ T © Ignite! Entertainment.
172 & 173: © Robert Crumb & Aline Kominsky-Crumb/ Last Gasp/ Knockabout.
174: A & B © Dave Cooper/ Fantagraphics. C © Jeffrey Brown/ Top Shelf.
175: A © Don Donahue/ Last Gasp. C © Ralf König/ Rowohlt/ T © Ignite! Entertainment.
176 & 177: © Posy Simmonds/ Pantheon/ Jonathan Cape.
178: A © Pat McGreal, Stephen Jogn Philips & Rebecca Guay/ DC Comics. B © André Juillard/ Editions Casterman/ T © NBM.
179: A & B © Mark Kalesniko/ Fantagraphics. C & D © Miguelanxo Prado/ Norma/ T © NBM.
180 & 181: © Alan Moore & Melinda Gebbie/ Top Shelf.
182: A © Milo Manara/ Editions Albin Michel/ T © NBM. B © Hunt Emerson/ Knockabout.
183: A & B © Frédéric Boilet & Kan Takahama/ T © Ponent Mon/ Fanfare. C & D © Samuel R. Delany & Mia Wolff/ Juno Books.
192: © Jim Woodring/ Fantagraphics.

All illustrations are copyright their respective copyright holders and are reproduced for review and historical purposes. Any omission or error should be reported to the publisher so that it can be corrected in any future edition.

Index

The Last Word

Frank and Pushpaw reading, by Jim Woodring

"No book ever ends
When it's full of your friends"

Roald Dahl
The Giraffe, The Pelly, and Me